CW00802814

THE EMPRESS AND I

For Henry, Sophie, and Shannon

Donna Stein

THE EMPRESS AND I

How an Ancient Empire
Collected, Rejected,
and Rediscovered Modern Art

SKIRA

Cover
*The Shahbanou and Donna
Stein Discussing Bellmer
Photograph During
Installation*, 1977 (detail)
Gelatin silver print
© Jila Dejam

Design
Marcello Francone

Editorial Coordination
Emma Cavazzini

Copy editor
Emanuela Di Lallo

Layout
Marina Boer

First published in Italy
in 2020 by
Skira editore S.p.A.
Palazzo Casati Stampa
via Torino 61
20123 Milano, Italy
www.skira.net

ISBN: 978-88-572-4434-1

Distributed in USA, Canada,
Central & South America
by ARTBOOK | D.A.P. 75,
Broad Street Suite 630,
New York, NY 10004, USA.
Distributed elsewhere in the
world by Thames and Hudson
Ltd., 181A High Holborn,
London WC1V 7QX, United
Kingdom.

CONTENTS

6 *Foreword*

9 1. The Most Prized Modern
 Artwork in Tehran

13 2. Iran in the 1970s

19 3. My First Visit to Iran

33 4. My Second Visit and First
 Acquisitions

49 5. Working for Iran in
 New York

91 6. Moving to Tehran

103 7. Inside the Private
 Secretariat of Her Imperial
 Majesty

129 8. Trouble in Paradise

153 9. The Plot Thickens

169 10. Free at Last

191 A Seed Planted
 with Love Never Dies
 Interview with Farah Pahlavi

214 Documents

268 Index

276 Acknowledgments

FOREWORD

I said farewell to the Empress and her court in 1977, but more than forty years later I remain haunted by my memories of the sights and smells of Iran, as well as the immense kindness and occasional small-mindedness of its vivacious people. It is now time to tell the story of the complementary goals of two women of the same generation from very different cultures—an Iranian Empress who was a pioneering art patron and an adventurous American art curator. As the Empress[1] told me in 1990 in the first substantial interview she gave in exile, "I have loved art since my childhood and considered beauty life's principal pleasure."[2]

The treasure trove of modern art that I selected and her Private Secretariat acquired for less than one hundred million dollars[3] is now worth billions, but what this book intends to measure in historical, cultural, and aesthetic terms is the value of what became a core collection of the Tehran Museum of Contemporary Art. Along the way, the reader will hopefully gain a sense of what it was like for an American feminist who came of age in the 1960s to live and work beneath the wheels of a Near Eastern monarchy facing impending political upheaval.

Back in the 1960s and 1970s, professional curators were understood to be behind-the-scene decision makers rather than globetrotting cultural impresarios. I was hired by the Private Secretariat of Her Imperial Majesty, the Shahbanou of Iran to quietly fulfill the goal of creating a cultural

dialogue between East and West. I began this task by formulating a draft acquisition policy that mapped a path to an inclusive and exemplary international collection of nineteenth- and twentieth-century modern art of the highest quality. Because I was a foreigner working largely in secret, my leadership role in the formation of the National Collection has never been fully acknowledged. My bosses at the Private Secretariat, to whom I nominally reported (as well as subsequent caretakers of the Tehran Museum of Contemporary Art where the collection remains in deep storage) have boldly grabbed the credit for my aesthetic choices. In addition, numerous errors by sloppy journalists including factual mistakes, egregious exaggerations, misleading photo captions, and continuous inconsistencies have proved to be self-propagating.

Thus I have finally written *The Empress and I* to correct the record by citing previously confidential documents and sources. Drawing on contemporaneous records from my energetic communications with art dealers, auction houses, and professional colleagues at the time, this memoir attempts to make sense of an art-collecting anomaly, which came about during a time of extraordinary change in Iran that profoundly changed me.[4]

Donna Stein
Los Angeles, 2019

[1] Hereafter, I will use "Empress" to refer to Her Imperial Majesty, the Shahbanou of Iran. The distinction between Queen and Empress is often confused. Farah Pahlavi was not named Empress until 1967. Therefore, in my text, I tried to differentiate the time periods by using Queen before that time and Empress afterwards.

[2] See Interview, 192.

[3] Bob Colacello, "Farah Pahlavi," *Interview*

Magazine, January 9, 2014, http://www.interviewmagazine.com/culture/farahpahlavi/

[4] The creation of a personal historical narrative where art, politics, and professional development combine depends on what is included and what is not. Please be aware that I have taken the liberty of condensing my "cast of characters" to protect privacy and safety concerns of those who remain in Iran.

Installation at TMoCA before
museum opening with
Kamran Diba, Farah Pahlavi,
and David Galloway looking
at Jackson Pollock's *Mural
on Indian Red Ground* hung
on the wall, partially still
under plastic, October 1977
© Jila Dejam

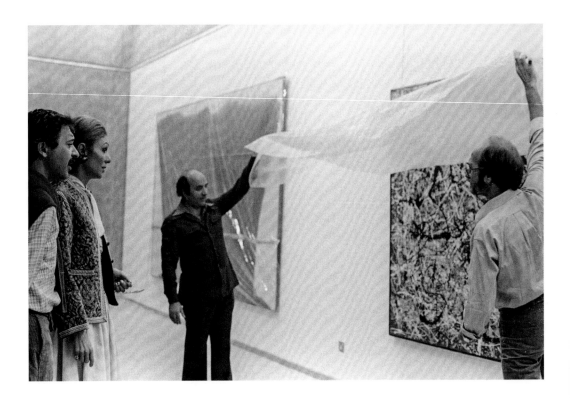

1. THE MOST PRIZED MODERN ARTWORK IN TEHRAN

Jackson Pollock's *Mural on Indian Red Ground* (1950, p. 55) is unquestionably the most prized modern artwork to enter the Iranian National Collection held by the Tehran Museum of Contemporary Art (TMoCA). I vividly remember my visit to the home of William Rubin in May 1975 with three of my Iranian colleagues to consider and study this masterwork for possible acquisition. Subsequently, Dr. Karim Pasha Bahadori, the director of Her Majesty's Private Secretariat, sought an opinion about the painting from well-known gallerist Leo Castelli, whom he had met during his May visit to New York. Castelli wrote back in early July, "Apart from two other important paintings that may or may not come up for sale and that would probably cost two million dollars or more, this painting seems to be the best available one."[1] Furthermore, the prominent Swiss art dealer Ernst Beyeler considered this Pollock to be one of the finest works that had passed through his hands.[2]

Pollock's desire to paint movable canvases that functioned as both easel and mural-scaled wall pictures gave birth to large frieze-like works. *Mural on Indian Red Ground* was painted in 1950 during the artist's most productive year, in which he made fifteen drawings and fifty-five canvases that are universally considered the acme of his oeuvre. Here, the artist's improvisational energy was evoked through the poured and layered interaction of lines and brilliant colors that resulted in an intricate pattern of space and movement as he worked on the canvas spread out on the floor. Art historian and curator William Rubin, the former owner of this New York School masterpiece, identified the true worth of the artist at the apex of his career, saying, "Pollock's overall style combined the majestic impact of its immediately perceived singleness of image with a maximum of remarkable delicate local variations in texture, drawing and color."[3]

This legendary painting *Mural on Indian Red Ground* was lent to Japan in 2012, where it was displayed in an exhibition celebrating the 100th anniversary of the birth of Jackson Pollock, at the National Museum of Modern Art in Tokyo and at the Aichi Prefectural Museum of Art in Nagoya. Insured for $250 million by Christie's,[4] when the painting arrived back at the

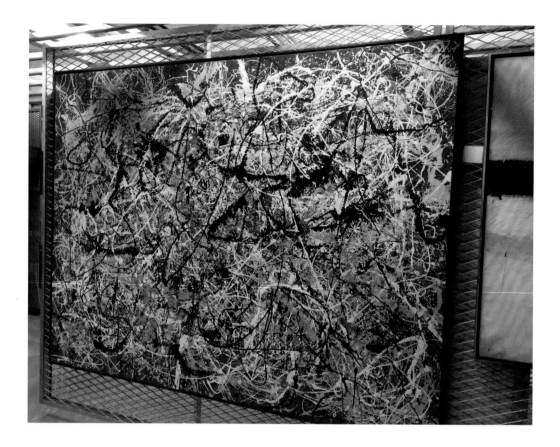

View of storage rack showing Jackson Pollock's *Mural on Indian Red Ground* and part of a Franz Kline painting, March 2015 © Beth Rudin DeWoody

Tehran airport, it was held hostage by Iran's customs service for fees owed to the Ministry of Culture, which remains in charge of TMoCA to this day. After complex inter-agency negotiations, the painting was finally released and returned to storage in the museum safe and sound.

In recent years, this iconic Pollock painting was included in numerous TMoCA exhibitions, such as *Expressions of Contemporary Art in the World*, a 2014 temporary exhibition showcasing important masterpieces by American artists from the collection. A year later, *Comprehensible Mentality*,[5] which comprised works associated with Abstract Expressionism, Tachisme, Post-painterly Abstraction, and Lyrical Abstraction by American and European artists from the collection featured the Pollock painting. In conjunction with *Farideh Lashai: Towards the Ineffable*, a retrospective in November 2015,[6] works from the international collection, including the Pollock, were hung throughout the exhibition to suggest reference points for Lashai's paintings. More recently in 2017, when an eagerly anticipated gesture of cultural diplomacy was cancelled at the last minute, TMoCA presented *Berlin–Rome Travelers*, part of the planned traveling exhibition in which *Mural on Indian Red Ground* was included for the enjoyment of the local population.

In the fall of 1977, when the Tehran Museum of Contemporary Art was inaugurated to great fanfare, few people in Iran thought there was even a remote possibility that the Shah would be overthrown. He had an army of more than half a million men and was surrounded by thousands of Imperial Guards. When US President Jimmy Carter visited Tehran on New Year's Eve that year, he wrongly called Iran "an island of stability in a troubled region of the world."[7]

[1] Letter dated July 3, 1975, Leo Castelli Gallery records, Correspondence, Smithsonian Institution, Archives of American Art, page 2 of 72, https://edan.si.edu/slideshow/viewer/?eadrefid=AAA.leocast_ref9129. Another undated note in Castelli's hand suggests the price was $850,000.

[2] Christopher de Bellaigue, "Lifting the Veil," *The Guardian*, October 7, 2005.

[3] William Rubin, "Jackson Pollock and the Modern Tradition," in *Jackson Pollock: Interviews, Articles, and Reviews*, II (New York: The Museum of Modern Art, 2000), 130–31.

[4] Arsalan Mohammed, "Iran and the art of détente," *Financial Times*, December 4, 2015.

[5] September 15 – November 6, 2015.

[6] November 2015 – February 26, 2016; email confirmation from Nahid Evazzadeh, Tehran Museum of Contemporary Art, October 29, 2019.

[7] Sattareh Farman Farmaian with Dona Munker, *Daughter of Persia: A Woman's Journey from her Father's Harem Through the Islamic Revolution* (New York: Bantam Press, 1992), 290.

Map of Iran

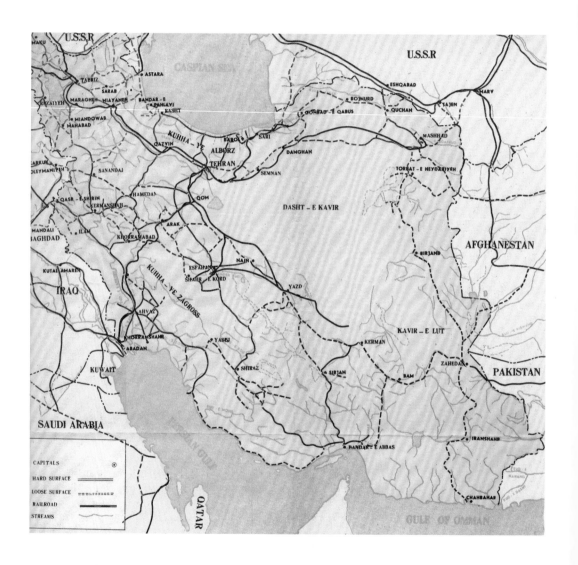

2. IRAN IN THE 1970s

Like most Americans, I was naïve when it came to the realities of the contradictory political and ideological trends that transformed Iran after my departure in 1977. Little did I realize that those dramatic changes would have an on-going impact on my life nor could I predict the manner in which the art objects that I gathered would be perceived and valued by Iranian citizens in the twenty-first century. Prior to describing my collecting adventure of a lifetime, some historical background is necessary to provide an illuminated context for my own travels, travails, and triumphs.

Known as the "Land of the Lion and Sun," Iran geographically forms a land bridge between continents, stretching nearly one thousand miles from the Caspian Sea and the Alborz Mountains on the northern border to the Zagros Mountains and the Persian Gulf to the south. Historically, this high-altitude plateau in Central Asia served as a natural fortress, although it didn't impede caravans along the two major trade routes named for silk and spice. Instead of separating cultures, the plateau provided fertile ground for cultural, commercial, and population exchanges.[1]

The ancient Persian Empire (Achaemenid Empire c. 550–330 BC) was founded by Cyrus the Great, one of the most benevolent leaders the world has ever seen. King Cyrus ruled most of Western and Central Asia based on human rights with social justice and individual liberty, and his vast empire has been considered the earth's first superpower.

Despite centuries of foreign conquest starting with the Greeks under Alexander the Great, followed by Arabs, Turks, and Mongols, and despite its tribal and ethnically diverse population, Persian culture has continually reasserted its distinctive character down through the centuries. Because of its highly cultivated way of life in art, architecture, philosophy, music, and literature, Persia has generally been regarded as the greatest civilization in the Near East.

Mohammad Reza Shah (1919–1980) admired and referenced his nation's nearly three thousand years of recorded history in an effort to transform his semi-feudal country into a modern industrial state during one generation. After he had been on the throne for twenty-six years, a formal

Coronation of the Shah (Emperor) and Shahbanou (Empress) took place on October 26, 1967 at the fabled Golestan Palace. Lavish celebrations at Persepolis followed in 1971 to commemorate 2,500 years of the Iranian monarchy, with the intention of positioning "the Pahlavi monarchy and the reign of the Shah in particular within an imperial narrative that stretched back to the ancient Achaemenid Empire."[2]

The 1970s were a time of rapid social change and governmental experimentation. By the beginning of the decade, the effects of the Shah's 1963 visionary social and economic plan called the White Revolution represented an attempt to formulate a third road between capitalism and communism.[3] To modernize his nation and restore Iran to its former greatness, the Shah advanced provincial land reform, the privatization of state industries, nationwide increases in literacy, and a new respect for women's rights including the right to be educated, own property, and terminate an unwanted pregnancy. His Majesty constructed dams and a power grid, as well as implementing other technological infrastructure projects throughout the country. He built schools and libraries and supported all efforts to abolish illiteracy. By 1977, literacy had climbed to 50% from a low in 1963 of 17%. As the historian Andrew Cooper observed, "Iran's success in reducing illiteracy attracted the attention of educators from around the world"[4] and Iran was quickly becoming "a regional hub for industry, science and medicine."[5]

The nationalization of the Iranian oil industry in March 1951 and rising prices initiated twenty-two years later by OPEC (the Organization of Petroleum Exporting Countries) increased revenues from two hundred million dollars a year to nearly twenty billion dollars by 1975.[6] This windfall transformed a formerly impoverished nation into the world's second-largest oil producer and helped Iran achieve a position as the strongest military power in the region. Perceived as an important regional ally against the Soviet Union during the Cold War, Iran also received substantial foreign aid from the West, especially the United States.[7] According to the World Bank, by 1976 the GDP annual growth rate was a phenomenal 17.6%.[8] Substantial population growth was facilitated by lower infant mortality, longer life expectancy, and greater access to medical care. With the 1975 Algiers Accords, the Shah was also effective in quelling his contentious relationship with Saddam Hussein and Iraq.

Nevertheless, nothing the Shah did was ever enough and serious problems continued to plague the country throughout the 1970s.[9] Land reform was not entirely successful. Small plots of land were distributed that did not yield much of a living and villagers didn't have the knowledge to repair their new equipment. Because villages lacked permanent health workers and medical clinics,[10] thousands were abandoned. The surge of migrants from the countryside overwhelmed cities like Tehran as numerous shanty-

towns popped up seemingly overnight. Two-thirds of the population in the country still earned less than seventy dollars per month, even though Tehran resembled San Francisco in the days of the gold rush. By 1975, Tehran's population grew to more than four million people. The number of cars doubled to at least one million in the capital before the end of the decade. High inflation, by some accounts nearly 25% annually by the late 1970s, "was triggered mainly by the undue injection of oil income into the Iranian economy."[11] Corruption flourished in an environment in which temptations were great and regulations too lax.

Because of corruption and the flow of villagers into the cities, ordinary necessities of life became harder to obtain, causing shortages of food, goods, fuel, and power. Great quantities of essential goods had to be imported from foreign sources, but transportation facilities were inadequate and cargos of perishables rotted on the docks for months. Worse still, Iran's workers never received the share of company profits as promised in 1963 by the Shah's human development campaign. As the decade progressed, persecution of Bahá'ís, Jews, Christians, Zoroastrians, and other minorities intensified, although these had been tolerated in Iran for centuries. A censored press kept the populace in a kind of informational limbo, surrounded by an insidious curtain of false promises and aggressive propaganda.

As early as 1971, the Shah recognized the danger of Islamic Marxism when his Shia powerhouse state began to receive reports and rumors of leftist guerrilla activities in Iran. At the same time Ayatollah Ruhollah Khomeini (1902–1989), contrary to the clergy's apolitical stance, led protests against the Shah's secular reforms and was banished from Iran in 1964. Nevertheless, he attacked the monarchy from exile in Najaf, Iraq. He called the Shah an "enemy of Islam" for his display of imperial self-glorification at Persepolis and for selling oil to Israel, which Khomeini considered Iran's greatest enemy. Khomeini's bid for power challenged the very soul of Shia orthodoxy.[12] Ironically, gifted Iranian students who had been sent to the United States and Western Europe on scholarships to learn the skills needed to modernize Iranian society also challenged the Shah's power.[13]

In March 1975, contrary to his oft-stated desire to improve the political system and encourage a greater measure of democracy, the Shah "did away with the façade of constitutionalism,"[14] abolished the two-party system and replaced it with the Imperial Rastakhiz or "Resurgence" Party led by the Prime Minister. However, by 1977, the Shah began to introduce reforms, relax press censorship and permit criticism of his ministers, "taking hesitant steps toward the restitution of a constitutional government."[15] He also allowed the International Red Cross to conduct inspections inside prisons. Amir-Abbas Hoveyda (1919–1979) was dismissed as the head of state. Subsequently, the premiership was changed frequently—perhaps in the hopes of

diminishing political anarchy; but over the years the Shah had consciously created a leadership vacuum that he could not surmount.

The growing discontent of some clerics and large landowners and the impatience of students and intellectuals fueled the growing dissatisfaction. Opposition to the US-backed Shah and Western ignorance of Shia Islam grew steadily in the year before the 1979 revolution.[16] The first riots in Tehran against Jews and Bahá'ís began in January 1978. An anonymous article in a Tehran newspaper, generated by the Shah's Ministry of Information led by Karim Pasha Bahadori and entitled "Iran and the Red and Black Imperialism," accused the clergy, namely Ayatollah Khomeini and his followers, of working with international communism to destroy the White Revolution. Journalist Colin Smith of Britain's *Observer* newspaper filed a dispatch in May 1978 in which he observed: "Much of the religious protest movement seems to be aimed against the growing secularism of a society where, because oil has made possible what the Shah's father only dreamed of doing, changes that took centuries in Europe have been telescoped into a couple of decades."[17]

Another cycle of violence began in spring. As the Moslem religion required commemorations for forty days after a death, religious fanatics used this mourning ritual following deaths in their community to continuously attack symbols of "Westernization," such as foreign banks, luxury hotels, liquor stores, and movie houses that showed Western films. A tragic event occurred in Abadan on August 20, 1978 when some four hundred and thirty people, mostly women and children, died in a fire at the Rex Cinema, the doors of which had been mysteriously locked. This brutal attack was the worst arson since World War II.[18]

In early September, a huge demonstration in Tehran called for Khomeini to take over the country and create an Islamic Republic. A massacre of protestors by the Shah's forces at Jaleh Square in downtown Tehran, known as "Black Friday," shattered all possibility of compromise. At the request of the Iranian government, Saddam Hussein forced Khomeini out of Najaf to try to suppress the flow of anti-Shah propaganda.[19] Deported from Iraq, the cleric was refused entry into Kuwait, Lebanon, Libya, and Algeria, and finally was persuaded by some of his aides to go to France, which proved to be a very favorable development for his movement. Khomeini's public relations machine, now ensconced in the City of Light, was able to broadcast his threats and false promises around the world with the help of a compliant international press.

In November, rumors circulated that the Shah was seriously ill. His fragile health was considered a state secret that remained hidden from the Empress and the public alike until 1977 when it became too serious to ignore. During his last months in power, lacking the strength and clarity

of mind to fight against the downward cycle of corruption, oppression, and the failure of the government's economic policies, the Shah decided to avoid further bloodshed by leaving his country to seek medical treatment in exile and avert an impending civil war. As the Shah forecast in the last year of his reign, "If the security and the stability of Iran were to be destroyed, the consequences would not be limited only to Iran, or to the sensitive region of the Middle East, they would usher the world into a global crisis."[20] In retrospect, the Shah and Shahbanou's departure and exile from Iran on January 16, 1979 was a watershed event that transformed the future of the Near and Middle East, as well as the future of the rest of the world, by bringing about the advent of Political Islam.

[1] Abbas Amanat, *Iran: A Modern History* (New Haven: Yale University Press, 2017), 1.

[2] Ibid., 664.

[3] See Interview, 204.

[4] Andrew Scott Cooper, *The Fall of Heaven: The Pahlavis and the Final Days of Imperial Iran* (New York: Henry Holt and Company, 2016), 128.

[5] Ibid., 498.

[6] Elton Daniel, *The History of Iran* (Westport: Greenwood Press, 2001), 160–61.

[7] Tino Sanandaji, "The Iranian Economy," November 12, 2010, https://tino.us/2010/11/the-iranian-economy/

[8] Thanks to Dr. June Taboroff for these World Development Indicators in an email of November 28, 2018.

[9] Cooper, *The Fall of Heaven*, 199.

[10] Sattareh Farman Farmaian with Dona Munker, *Daughter of Persia: A Woman's Journey from her Father's Harem Through the Islamic Revolution* (New York: Bantam Press, 1992), 268.

[11] Amanat, *Iran, A Modern History*, 655.

[12] Afshin Matin-Asgari, *Both Eastern and Western: An Intellectual History of Iranian Modernity* (Cambridge University Press, 2018), 14.

[13] Ibid.

[14] *The Economist*, November 18, 2017, 78.

[15] Cooper, *The Fall of Heaven*, 145.

[16] Najmeh Bozorgmehr in *Financial Times*, February 4, 2019, 9.

[17] Cooper, *The Fall of Heaven*, 335.

[18] Nazila Fathi, "How the Shah of Iran Failed the Political Battle for Minds," *The Washington Post*, September 1, 2016.

[19] Amanat, *Iran, A Modern History*, 719–20.

[20] Farah Pahlavi, *An Enduring Love: My Life with the Shah, A Memoir* (New York: Miramax Books, 2004), 423.

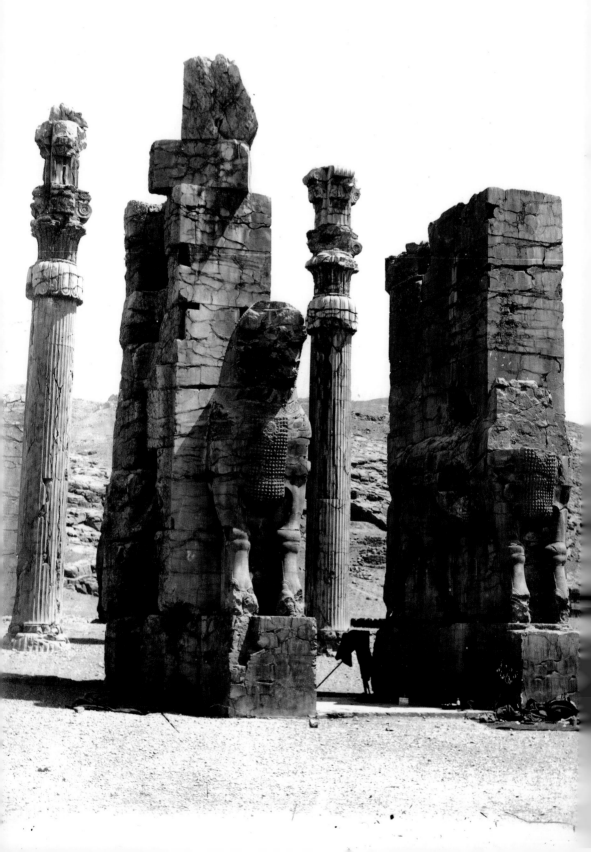

3. MY FIRST VISIT TO IRAN

After working for six years on the curatorial staff of the Museum of Modern Art in New York City, I received a National Endowment for the Arts Fellowship for Museum Professionals to study "The Art and Architecture of World's Fairs and Their Cultural Impact." The grant enabled me to visit Tehran for the first time in 1973 as I traveled west around the world for research. I was deeply impressed by the sprawling capital city with a flat southern plain and a mile-high northern section. In the city's center the architecture seemed Westernized and the well-paved streets were wide. The oldest buildings dated from the nineteenth century, but most structures looked as if they had been constructed in the past five years, and like the government that had made them possible, many were already crumbling into dust.

I was surprised to learn that there were more than four million people living and working in Tehran and its infrastructure was clearly inadequate for such a substantial population. Instead of sewers, for example, the masses depended on *jubes*, a system of deep open channels on each side of a road. Water for washing and other household uses flowed from the imposing snow-covered Alborz Mountains that surrounded the city into these running gutters directly from small dams. The *jubes* were not very clean, but they didn't stink to high heaven like the canals of Venice.

A visit to the crown jewels at the Central Bank of Iran (Bank Markazi) and a dazzling array of diamonds, emeralds, rubies, and sapphires gave me an inkling of the unbridled opulence and power of Iranian monarchs through the ages.[1] This impression was confirmed during my visits to the Museum of Ancient Iran (Iran Bastan, opened in 1937), the Golestan Palace, and the Museum of Anthropology. Housed within palace gardens, the Museum of Anthropology showcased the zeitgeist prevailing at different stages of Iran's history. At the food markets in Shemiran in the northern part of the city, I began to learn about how Iranian cuisine negotiates opposing flavors to equilibrium that one day proved impossible in Iranian politics, but that is ahead of our story.

I flew to Shiraz, an oasis in the southwest known for its gardens, and walked through the bazaar, which was very colorful since many tribal

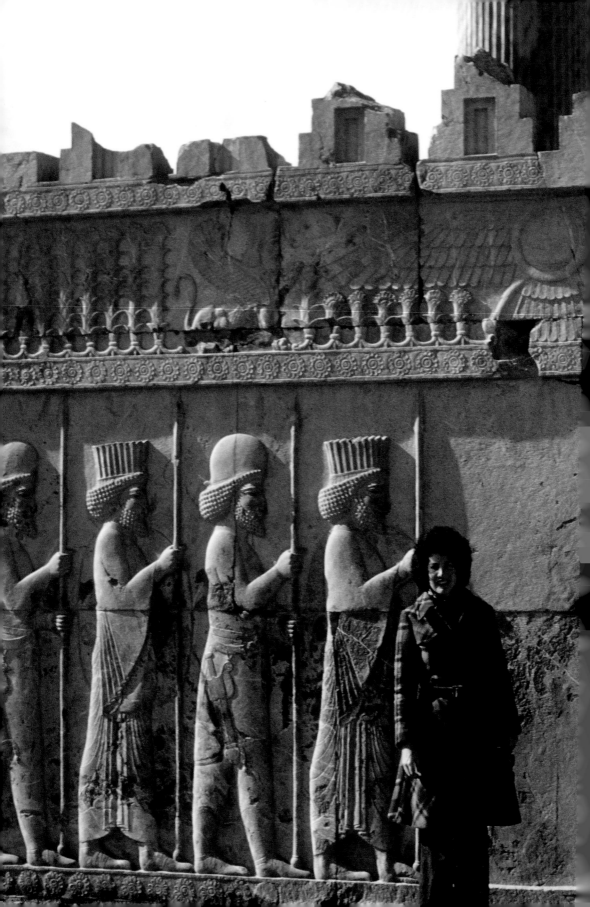

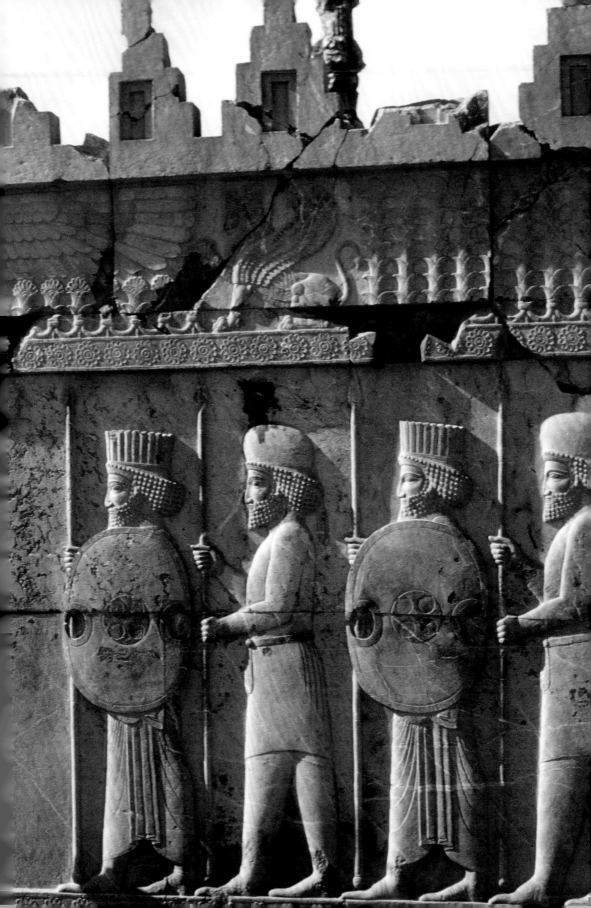

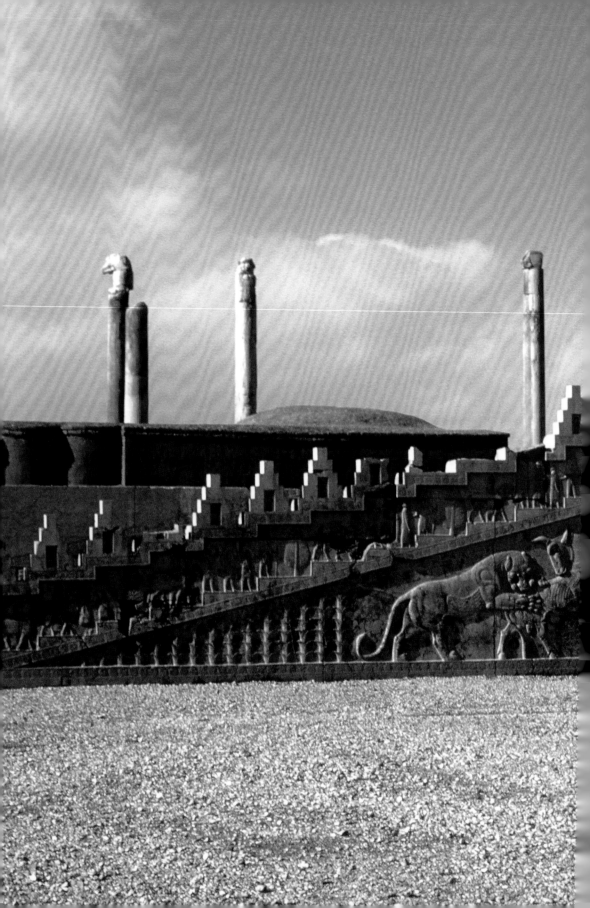

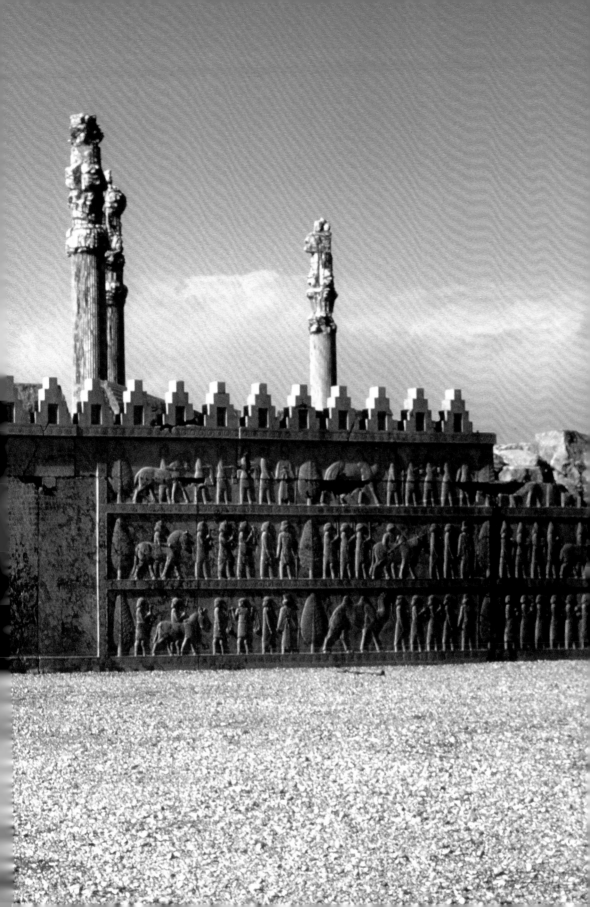

pp. 22–23
The Northern Staircase
of Apadana Palace,
Persepolis, 1973
Color slide
© Donna Stein

Two women washing
clothes in a *jube*, 1975
Gelatin silver print
© Donna Stein

Antoine Sevruguin,
*Allah Verdi Kahn Bridge
over Zayandeh River*,
Isfahan, c. 1902
Albumen print
Eugene J. Koop in Persia
Archives, National History
Museum, New York

people were in town for shopping. The Kurdish women were dressed in long skirts, many layers thick, and wore lots of jewelry—bracelets, necklaces, and headdresses made of beads and gold coins. All the textiles were multicolored and brilliant. The women often used shimmering materials as the top layers of their many skirts. Over everything, they wore "chadors," large pieces of fabric that enveloped their bodies from head to toe for modesty.

The next day I visited the tombs of Hafez (1315–1390) and Saadi (1208 – c. 1291), two of Persia's greatest poets. On my last day I rose early and went to the ruins of Persepolis, the legendary ancient city. The ceremonial capital of the Achaemenid Empire, dating from the time of Darius I, was awe-inspiring. The site is on a terraced hilltop overlooking a valley. I walked among the ruins, silently, immersed in the grand architectural spaces. The monumental stairways were very well preserved and the sculptural bas-reliefs depicting citizens bringing tribute to the Shah were beautifully carved. That same day I visited a spectacular mosque in Shiraz. I took off my shoes, donned a chador and entered Shah Cheragh, where every interior surface, including the magnificent dome, was covered with mirror mosaics pieced together in elaborate faceted patterns.[2]

Later that afternoon I flew to Isfahan, probably Iran's most beautiful city, built during the reign of Shah Abbas between 1598 and 1629 as a new capital. Many Safavid period mosques, palaces, and public buildings, jewels of Islamic art and architecture, are well preserved. The Zayandeh River and many inlets flow through the city, a commingling of land and water unlike most other cities in Iran. I went to the central Naqsh-e Jahan Square, one of the largest plazas in the world, second only to Tiananmen Square in Beijing. At the four cardinal points of the royal square are stunning UNESCO world heritage sites dating from the seventeenth century—Ali Qapu Palace, King's (Blue) Mosque, Queen's Mosque, and the entrance to the Imperial Bazaar. The palace pavilion, the official entrance to the vast royal residential quarters, is six stories high and at the top has a large porch where Shah Abbas entertained noble guests and watched

polo games and other sports. Restored over ten years before my visit, it is known as the forty-column palace, probably because of the reflection in the long rectangular pool that multiplies the number of tapered wooded columns on the portico's façade. The two mosques are almost completely covered from floor to dome with tiles and mosaics in floral, abstract, and calligraphic patterns. The colors are predominantly blue, white and yellow. The Queen's Mosque (Lotfollah) was built as a sacred place for the ladies of Shah Abbas's harem. Shah's Mosque, the pinnacle of Safavid architecture, is truly enormous. Isfahan also has one of the largest and most interesting bazaars, extending for more than five kilometers.[3]

More relevant to the story of how I was motivated to consider working in Iran, I renewed my acquaintance with Fereshteh Daftari, whom I previously met in New York. Petite, refined, and part of the elite "1,000 families," Feri worked for the Private Secretariat of Her Imperial Majesty (*Daftar-e Makhsus Olay Hazrot*) and had interned at the Museum of Modern Art to learn about curating and the business of running a museum. We met in 1972 while she conducted research in the museum's Department of Prints and Illustrated Books, where I was a young assistant curator. I vividly remember watching a massive parade on television one evening in Tehran and Feri telling me to my amazement that it was a fully orchestrated event. Apparently, workers were required to participate—waving flags, cheering, and chanting. For the first time I became conscious of how different living under a monarchy must

View of Ali Qapu (Chehel Setun), Isfahan, 1973
Color slide
© Donna Stein

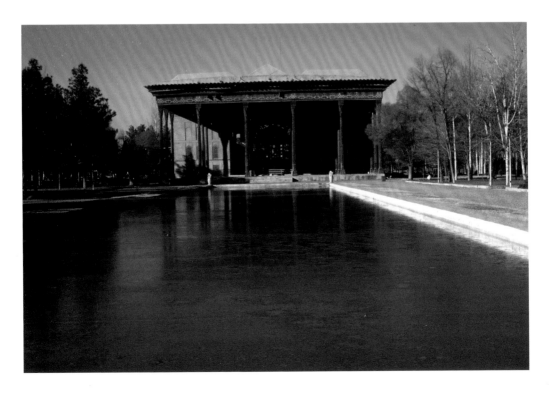

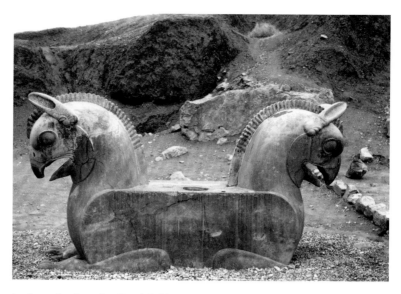

be from the freewheeling life I knew in the United States. I didn't know it at the time, but our budding friendship would change my life.

Feri and I corresponded during 1973 and 1974, incrementally building our friendship. One morning, back in New York, I was running out to an Italian class when I noticed that the mailboxes were uncharacteristically full. I stopped to see if there was anything important and found a thick airmail letter from Feri, whom I hadn't heard from in a while. Much to my surprise, she outlined the possibility of a trailblazing job opportunity, which would mean my return to Iran for an extended period of time. I literally jumped for joy, bobbing up and down in my high heels, as I read the letter. She wrote:

> *I have not heard from you for a long time and do not know what you are exactly doing right now. But I wish to discuss with you an idea that I have. As you already know, the project of the Tehran Museum of Modern Art is being realized and the building is nearing completion. The museum shall have a prints department. I would like to suggest you to our office as a curatorial candidate for that department. Before doing that I would like to first inquire whether you would be willing to accept that job and what would your salary requirement and conditions be. I suppose that the job would entail a contract for a certain limited period such as a year or more.*
>
> *The job would mainly consist of:*
> *1. preliminary study*
> *2. determining the movement from which the collection should start*
> *3. drawing a policy*

Tachara (Winter Palace),
Persepolis, 1973
Color slide
© Donna Stein

4. purchasing prints that would represent the various movements and tendencies up to the present day

5. suggesting and maybe ordering the materials needed to preserve the prints (e.g. type of matting, solander boxes, etc.)

6. cataloguing the prints

7. organizing exhibitions

8. writing catalogues

9. ordering books on prints

10. setting up files

11. training Iranians to run the department after your departure.

You may be interested to know what other departments there will be in that museum. So far the program is not definitive. I presume that there will be a permanent collection of modern Iranian art and that great emphasis will be placed on temporary exhibitions of modern Western painting and sculpture. In case you are interested, please send me a letter or preferably a report, which I would then bring to the attention of His Excellency Dr. Bahadori, the Head of Her Imperial Majesty's Private Secretariat. I would be very happy to answer any questions you may have and sincerely hope that you will be interested to cooperate with us. I am anxious and looking forward to hearing from you.[4]

I wrote back immediately. I sent her my resume, and filled her in on my latest activities, which included serving as art consultant for the RCA Corporate Art Collection, writing for *Art News*, *Leonardo*, and *Popular Photography*, working with French photographer Lucien Clergue and American graphic artist and illustrator Fritz Eichenberg, and representing Milanese

graphic art publisher Sergio Tosi, who published the work of Cy Twombly, Jean Tinguely, Joe Tilson, and Man Ray, among others. I indicated that my responsibilities in New York, mainly teaching, ended about mid-January, and I would then be free to change my environment and begin actively working on a new project.

I also asked her many questions. I decided to wait for some of those questions to be answered before writing a letter that would be suitable for Feri to submit to her boss, His Excellency Dr. Karim Pasha Bahadori. I had no idea what the standard of living was like in Tehran, so it was difficult for me to know what to request as my salary. I wanted to know if I would be expected to speak Farsi. Would it be very difficult for me as a foreign woman alone? Would I need a car? How soon would the museum be ready for occupancy? How much the government would be willing to invest toward the purchase and organization of a print collection? What kind of print collection already existed? Would the focus of the collection be Iranian or international?

I didn't hear from her again for some time. At the beginning of November, I wrote her another letter, which contained even more questions. I was really curious about the job for the more I thought about that possibility the more it interested me. I wanted to know if she had spoken with her boss about the possibility of hiring me. How soon would the job be a reality? Would they want someone to work on the project before the museum was finished? And when did they expect the building to be completed? In my second letter I mused, "It would be a good idea for anyone who will be taking over the print department to have a chance to discuss storage and organization of the collection prior to the time the interior is completed. That way, the most efficient interior could be prepared without complications or redoing at a later time."[5]

I was also eager to expand my own interests and asked if there were any art photographers in Iran. I wrote, "One idea for the print department might be to include the history of photography. The Metropolitan Museum collection is organized that way and so are other museums. The cost of photographs is not that much and it is still possible to acquire historical photographs since they were often not done as unique examples."[6] With a department dedicated to "works on paper" the organization of the new collection would follow the direction of many museums throughout the world in recognizing current artistic practices.[7]

I informed Feri about an upcoming print sale at Parke-Bernet, saying, "It should give some indication as to the present auction market. One thing was shown at the previous unique-object auctions—prices are down. This could be just the right moment to buy, for the economy here and in Europe is depressed."[8]

On Sunday morning, November 10, 1974, I received a telephone call from Feri's boyfriend. He had just arrived in New York City from Paris where he had been with Feri, who was in France for the month of October. He told me she had received my letter, but because of a mail strike in France was unable to answer. He said that she was on her way back to Tehran and that I would hear from her shortly, and I did. Feri told me that if I were to go to Tehran for an interview, it would have to be before the beginning of the year because Her Imperial Majesty and thus Dr. Bahadori, a key court advisor, would be in St. Moritz from the beginning of January until March. She prepared me for the possibility of traveling to Tehran around Christmas.

In the meantime, I researched the Shah and Shahbanou of Iran. I learned that the Empress was born in Tehran in 1938 into a family of diplomats. She was an only child raised by her mother, who was widowed when Farah Diba was only nine years old. She attended private Italian and French schools before moving to Paris in 1957 to study architecture at the École Spéciale d'Architecture. She was introduced to Mohammad Reza Shah Pahlavi (r. 1941–79) in the spring of 1959 during a reception held at the Iranian Embassy in Paris. That summer, when she returned to Tehran on break from her studies, they began courting in earnest. Their marriage took place later that year, when Farah was twenty-one years old. They had four children: HIH Crown Prince Reza (b. 1960), HIH Princess Faranaz (b. 1963), HIH Prince Ali-Reza (1966–2011) and HIH Princess Leila (1970–2001).

Empress Farah was the first Iranian royal to be given the title of "Shahbanou" and the first to be named regent in the event her husband died before their first child, Crown Prince Reza, turned twenty-one. As a working queen, she concentrated on culture, education, and social welfare, i.e. the issues most in need of reform. This discrete feminist was born into a culture that rejected the idea that women could wield power, yet she was not afraid to act on her own and was comfortable with innovation. To the best of my knowledge, she was among the only Iranian royals who really wanted to know what challenges common people faced in their everyday lives and was always available to help solve problems.[9] She was especially committed to the welfare of the most vulnerable subjects—women, children, the elderly, and the sick. During her reign women played an increasingly important role in public life: with the support of her husband, they occupied key government positions serving as legislators, ministers, ambassadors, lawyers, and judges.

Farah Pahlavi was the principal patron of twenty-five educational, social, artistic, and cultural organizations that were instrumental in humanizing the Pahlavi dynasty, forming a third tier of the White Revolution, the

Shah's comprehensive national development plan of 1963.[10] The Empress started Iran's equivalent of a National Trust and was the driving force behind historical preservation of the country's religious and cultural heritage, including its magnificent historic architecture. She sponsored and funded museums throughout Iran to showcase Qajar art (1781–1925), carpets, and Iranian modern and contemporary art. Under her direction, the government repatriated hundreds of historic Persian artifacts from foreign museums and private collections (paintings, ceramics, glass, bronzes, and miniatures) and showcased them in local institutions that somehow managed to survive the revolution and appear to have thrived under theocratic rule. In addition, Farah Pahlavi helped revive Iranian theater arts through her support for the City Theater of Tehran. She also subsidized cultural centers, national and international festivals, including a decade of groundbreaking avant-garde performances at the Shiraz Arts Festival (1967–77), which provided cross-cultural creative opportunities for Western and Iranian artists alike. As one admiring critic commented, "The creative activity featured at the festivals reflected the most forward-looking international efforts presenting Iran to the world as pioneering and open."[11] The Empress also championed and invested in research, exploration, and scientific institutes. Her goal was to learn from the experience of the West without emulating it.

Time passed with nary a word from Iran. Finally, Feri responded to my inquiries and thankfully answered most of my questions. She informed me that language would not be a major problem because "Everybody speaks English at my office. I even write my reports in English," she explained. "And as to whether you would encounter difficulties as a foreign woman . . . I should not think you would encounter many more problems than a Persian woman. This would require a long discussion though. You would need a car if you don't live within walking distance to the office. The museum is not finished yet and I cannot tell you how soon the building will be ready for occupancy, certainly not before spring."[12]

As regards available purchase funds, Feri told me "no figure is available and I doubt that it will become any clearer. I believe that the person in charge would have to give an estimate on which the office will then base its decision. The focus of the collection should be international. When I wrote to you," confided Feri, "I had only been talking in general terms to the office, asking whether there were any objections to the employment of foreigners. The answer was no. This is why I thought of you right away. It is hard for me to say how soon the job would be a reality. It would all depend on the procedures taken. If it is decided that you first come to interview in Tehran and write a report it may happen very soon. I believe that were you to get the job your presence would be needed before the completion of the building so that you could work with the architect."[13]

I was naturally wondering how much I would get paid, but Feri also was not in a position to give me a definitive answer: "I am not qualified to make any judgment, but will let you know about the reaction in Tehran as soon as I submit my report, which means within the next few days . . . I certainly hope that everything works out in the best possible way," she continued, "and that we will be able to gather a team of young and enthusiastic people to get the museum off the ground."[14]

Another month passed and the wait was excruciating. I finally received word from Feri that she had submitted both her report and my curriculum vitae to His Excellency Dr. Bahadori and he was ready to proceed. Cables flew back and forth. I sent a terse telegram stating "Arrangement fine. Await ticket." Finally the date was set for my departure on Friday, December 20, 1974 with a stay through January 1, 1975. In retrospect, it all happened quickly, because within two weeks of being officially asked, I was in Tehran. I had been so busy completing pending projects and teaching before I left America that I didn't have time to fully consider what it would mean to live and work under a monarchy for an extended period of time. The night I landed in Tehran for the second time it began to dawn on me what a huge leap into the unknown I had taken with my eyes wide shut.

[1] Letter to parents, January 10, 1973.

[2] Letter to parents, January 18, 1973.

[3] Ibid.

[4] Letter from F. Daftari, September 20, 1974.

[5] Letter to F. Daftari, November 5, 1974.

[6] Ibid.

[7] Donna Stein, "How a Former Museum of Modern Art Curator Assembled an International History of Photography Collection for Iran in the 1970s," in *The Indigenous Lens? Early Photography in the Near and Middle East* (Boston: Walter de Gruyter GmbH, 2018), 328.

[8] Letter to F. Daftari, November 5, 1974.

[9] Sattareh Farman Farmaian with Dona Munker, *Daughter of Persia: A Woman's Journey from her Father's Harem Through the Islamic Revolution* (New York: Bantam Press, 1992), 268–70.

[10] Afshin Matin-Asgari, *Both Eastern and Western: An Intellectual History of Iranian Modernity* (Cambridge University Press, 2018), 191 and 195.

[11] Robert Gluck, "The Shiraz Arts Festival: Western Avant-Garde Arts in 1970s Iran," *Leonardo*, 40, 1 (2007): 20–28.

[12] Letter from F. Daftari, November 9, 1974.

[13] Ibid.

[14] Ibid.

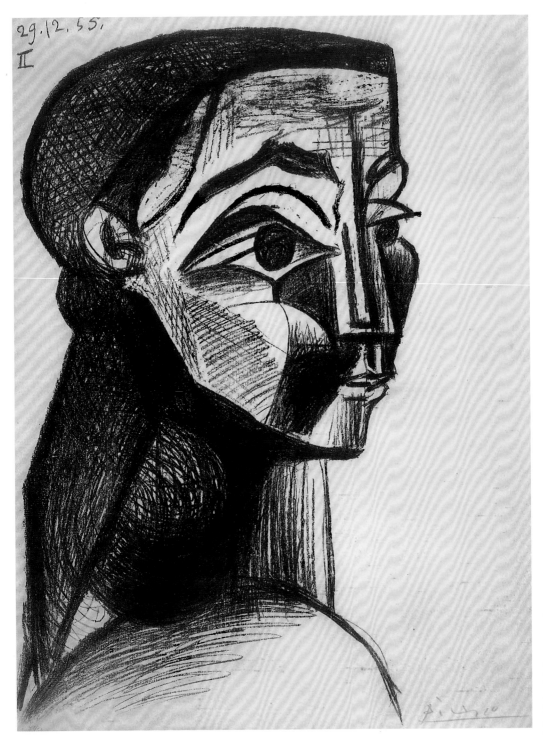

Pablo Picasso, *Portrait
de femme II*, 1955
Lithograph, 65.5 x 49 cm

4. MY SECOND VISIT AND FIRST ACQUISITIONS

Feri was waiting for me at the airport. All she had to do was mention we were from Her Imperial Majesty's Private Secretariat and airport security allowed me to pass through customs inspection unhindered. My friend had reserved a room for me at the Marmar Hotel around the corner from the office, but it turned out to be a dive. When Feri checked it out previously, the hotel staff apparently showed her a very nice accommodation, but the room the hotel staff selected for their American VIP guest was small, dirty, and musty.

The next morning a car picked me up and I was taken to the art fair near the Hilton Hotel. My courier informed me this was the first significant international art fair showcasing twentieth-century art ever presented in Tehran. The official opening had been the previous day. At the entrance to the fair, I met Feri and Layla Diba, an eighteenth- and nineteenth-century Iranian art expert who, like me, had studied at New York University's Institute of Fine Arts. After graduation, Layla had married the Empress' first cousin Mahmood Diba and was now working in her Private Secretariat, but would eventually become the director of Tehran's Negarestan Museum, showcasing eighteenth- and nineteenth-century Iranian art.[1] Layla was gracious and exuded an air of privilege accruing from her family connection to the Empress. Both Layla and Feri had been tasked with identifying paintings and sculptures that would be appropriate for the new museum of modern art and they eagerly solicited my advice. Numerous French and front-line Persian art dealers in modern and contemporary art[2] had rented booths in the two exhibition halls, but after inspection I had to diplomatically inform my teammates that, after careful consideration, I didn't see many masterpieces.

As soon as we finished our walkthrough of the fair, Feri and I changed my accommodations to a nicer hotel. During lunch at the Latin Quarter, a restaurant known for its French food, Feri gave me a candid rundown on all the people I would be meeting in the next few days—who they were, what they did, what their background was, and what she thought of them.

In due course, Feri arranged a tour of the new museum site. Galleries, library, auditorium, and a restaurant were under construction in Laleh

(formerly Farah) Park in the middle of Tehran, located just north of the campus of Tehran University. By the time we arrived it was drizzling and the ground was muddy. The funding for the museum had been secured earlier that year and by December the exterior of the Neo-Brutalist structure was almost complete, but still without doors and windows. Inside the partly finished building, some of the wall partitions were in place, but none of the flooring had been installed yet.

Kamran Diba, another of the Empress' many cousins, was the architect of the museum and eventually became Her Majesty's choice for the founding director. Two associates from his office were onsite overseers of the construction process and they toured us through the building. Diba's design for the three-story structure knowingly represented an amalgam of Persian and Western styles. As the Empress told me in 1990, "In preserving our old ways, we could not forget we are living in modern times . . . We had to learn from our past, but at the same time, allow contemporary-inspired ideas to flourish."[3]

The copper-clad roofline was arguably derivative, its clerestory windows set into quarter-circle concrete forms running the length of the galleries referenced the Fondation Maeght in Saint-Paul-de-Vence designed by Spanish architect Josep Lluís Sert. The towers suggested the centuries-old *badgirs* or wind catchers found in dryer areas of Iran that provide a natural source of ventilation, although here they were decorative and not functional, but still a source of light. The central atrium and spiral ramp system reversed the direction of Frank Lloyd Wright's Solomon R. Guggenheim Museum in New York: a series of interconnected galleries and smaller chambers radiated outward from the main atrium that spiraled downwards. Many of the rooms agreeably looked out onto an outdoor courtyard with surrounding gardens. When we reached the last of the nine galleries on the lowest floor, our guides proudly informed us there was only one large restroom in the entire facility as they pointed to a space, causing me to roll my eyes.

To his credit, Kamran Diba had followed Reyner Banham's three principles of New Brutalism: formal legibility of plan, clear exhibition of structure, and valuation of materials for their inherent qualities "as found."[4] However, the museum was definitely not laid out in an intuitive, visitor-friendly way. The main walls were poured concrete with a rough rock surface that would make it hard to hang art for changing exhibitions. In addition, the staff offices were cramped and lacked private space for off-line conversations or quiet study. I was surprised by the lack of understanding about what was desirable in a museum facility. After inventorying and documenting the design issues we had identified on the tour, Feri and I visited the new Deputy Cultural Attaché to the Italian consulate from Rome. She

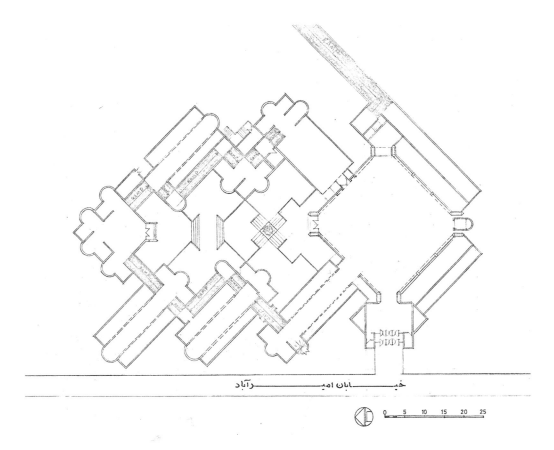

خــــــــابان امیـــــر رآبــاد

0 5 10 15 20 25

TMoCA museum plan

lived in one of the Saman buildings, a fashionable complex near the new museum consisting of two towers, where Feri hoped I would be able to rent a convenient apartment.

I spent the next morning at the Secretariat located in a non-descript three-story building on a side street in the center of town. A modest bronze plaque identified its importance with the insignia of the Empress. I was taken into a storeroom in the back of the building to examine some twenty-five prints that had already been acquired. What struck me right away was that the Iranians had accumulated a few famous names like Joan Miró, Pablo Picasso, and Victor Vasarely. Although the lithographs by Picasso, for example, featured images of women who resembled the Empress, they were definitely not significant examples of his best printmaking. I also inspected an Hyperrealist collection of sixteen paintings and two sculptures that had been recently acquired from a Paris dealer at the recommendation of Kamran Diba, even though Feri had argued against the purchase.[5] I found these selections also questionable because there were too many works covering a relatively insignificant moment in time. In addition, first-rank realist painters like Chuck Close, Robert Bechtle, Gerhard Richter, Konrad Klapheck, John de Andrea, or Audrey Flack were not represented. It seemed to me that the

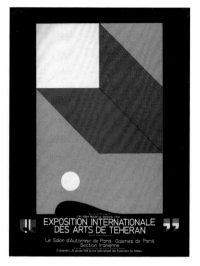

Iranians had a lot of money to spend, wanted to do it fairly quickly and as quietly as possible. Since everything was usually announced publicly, there apparently was a secret budget for their art projects. They were beginning to make important purchases but what they had was of minimal interest.[6]

Later that afternoon, Feri, Layla, and I returned to the International Art Fair and carefully studied more acquisition alternatives on behalf of Her Majesty. We focused particularly on the large Galerie Maeght booth, to see whether there were specific artworks we could propose for the National Collection, in part to reward the gallery for helping to bring the art fair to Tehran. After taking our leave of the fair, we went to Layla's house, where we wrote a report substantiating our recommendations for works by Wassily Kandinsky, Georges Braque, Alberto Giacometti, Jesús Rafael Soto, and Hans Hartung, the first major acquisitions aligned with my proposed collecting approach. I proceeded to dictate a succinct narrative for the artists, justifying their validity and importance in the art-historical context. While Layla and Feri contributed some excellent suggestions and helped me articulate a few key points, it became clear that I was there to provide the expertise they lacked at the time.

That night we attended a dinner party of about twenty-five people who gathered to celebrate the birthday of Feri's brother. Among the guests at the party was Kamran Diba, whose modest stature in no way suggested the size of his ambition. Feri took the opportunity to confer with him in a corner of the dining room and diplomatically describe various issues we had identified regarding the functionality of his museum. Delicious traditional food including kabobs, stews, and rice specialties were served buffet-style. Everyone at the party spoke English and French, but when they talked among themselves, they understandably did so in Farsi. That realization gave me a feeling I would have to buckle down and learn their language.

Feri and I met Kamran back at the museum site on Christmas day. We toured the facility, pointing out various potential flaws in his design. The architect was receptive to addressing many of our suggestions. When we got to the washrooms, we reiterated that it was problematic having only one in terms of visitor comfort and staff convenience. Kamran looked slightly sheepish when he confessed that he had always been ashamed that some parts of Tehran smelled like sewers and that was why he was chary about mucking up his beautiful museum.

That night I was invited to Layla and Mahmood Diba's house for a lavish holiday dinner for twelve. The festive evening started with drinks, including eggnog and hors d'oeuvres, followed by caviar with vodka, turkey and all the trimmings, several vegetables, and wine, two elaborate desserts and champagne and then tea, the national drink, imbibed by everyone ten to twelve times a day. About midnight, a group of us continued on to Kamran Diba's home for drinks. And if it seems to my readers that I was now living life in a Near Eastern version of the fast lane, it's probably because that's all too true.

The next morning, I went to the Private Secretariat for my meeting with the big boss, His Excellency Dr. Karim Pasha Bahadori, the chief of staff and right-hand man to Her Majesty.[7] Feri was part of that initial meeting in his office on the top floor of the Secretariat. Of medium height and elegantly attired, he was seated behind an imposing mahogany desk as we entered. On the wall to his right was a large photographic portrait of Her Majesty. I used this opportunity to shape and define a draft work plan. I explained that building a national collection required a vision and not just unlimited amounts of cash. We talked about the scope of the project in relation to a timetable—when the museum would be ready, when the exhibit program would begin, what it would mean to have a department of works on paper (drawings, prints, illustrated books, and photographs) and how important the works on paper collection would be in relation to the remainder of the collection. I wanted to know how broad a reach the collection would have. Was it to be mainly American and European art or more evenly international? Would there be any censorship? Were there any artists to avoid? I also asked if Dr. Bahadori wanted me to also consult on the interior display of objects as well as the storage and library facilities. Finally, I attempted to get him to identify a direct supervisor, but typically that was an internal political hot button issue that was never resolved to my satisfaction.

My interview lasted for over an hour and included a discussion of an International Council of Museums (ICOM) "Report on the International Meeting of Experts Convened for the Purpose of Creating a Group of Museums for the Farah Pahlavi Foundation," which underscored the committed

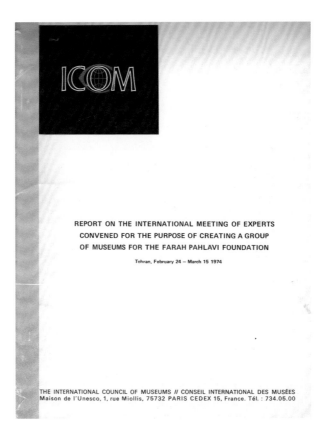

REPORT ON THE INTERNATIONAL MEETING OF EXPERTS
CONVENED FOR THE PURPOSE OF CREATING A GROUP
OF MUSEUMS FOR THE FARAH PAHLAVI FOUNDATION

Tehran, February 24 – March 15 1974

THE INTERNATIONAL COUNCIL OF MUSEUMS // CONSEIL INTERNATIONAL DES MUSÉES
Maison de l'Unesco, 1, rue Miollis, 75732 PARIS CEDEX 15, France. Tél. : 734.05.00

approach the Empress had taken to advance her cultural programs. She believed that "From a national perspective, aesthetic considerations have a powerful impact on progress, renewal of self-determination, social integration, and quality of life."[8] I learned that she was eager to assemble an exemplary collection beginning with Impressionism, and that I would be advising on acquisitions for the Tehran museum as well as a sister institution in Shiraz that would combine modern art with some archaeological contents.[9] Dr. Bahadori and I seemed to be in agreement about direction, scope, program, and a focus on aesthetic excellence rather than quantity.

I lobbied for a department dedicated to works on paper, expanding my purview and convincing Dr. Bahadori that once it was established, the organization of the new collection would follow the direction of many museums throughout the world in recognizing current artistic practices. Because each generation reveals its own image, it would have been a distortion to represent any one medium in isolation. By the 1960s, artists were no longer confined by technique, and traditional boundaries between art media had dissolved. Indeed, many contemporary painters and sculptors were using photographs and video to document their experiences in non-pictorial art forms, such as happenings, conceptual art, earthworks, and other

process-situational media. Thus, in my view, it was not the medium but the aesthetic intention that validated a work of art and endowed it with historical merit.[10]

For Iran, making a serious commitment to the art of photography required imagination and the willingness to accept some intellectual risks, because in 1975, few institutions or private collectors around the world acquired and exhibited photographs. By creating a historical survey of the medium, the Secretariat, on behalf of the new museum, seized the opportunity to take a leading role in an under-collected and burgeoning art form.[11] However, I was told to limit my selections in this medium as compared to prints. Many years later, in my 1990 interview with the Empress, Farah Pahlavi stated that Iran was similar to other developing countries in that it "had to break loose from the tyranny of resistance to change and the inertia of underdevelopment."[12] Luckily for me, Dr. Bahadori reported that the Empress also believed that change required cultural transformation.

Feri and I, and sometimes Layla, reviewed artworks that had been offered for purchase, including proposed acquisitions from Knoedler Gallery in New York and various Paris galleries. We wrote several reports: one addressed all the work that had been submitted to the Secretariat for purchase through transparencies; another for the Maeght material; and yet another regarding possible acquisitions from other galleries at the International Art Fair. Braque's bronze sculpture *Hymen* (1957, p. 41), Kandinsky's oil painting *Tensions claires* (1937, p. 40), and several works by Giacometti, including the bronze sculptures *La Cage* and *Grand buste* (1950–51 and 1956, p. 43) as well as *Yanaihara* (1960, p. 42), an oil on canvas from 1960, were purchased from the Galerie Maeght. The Private Secretariat also acquired Soto's *Canada* (1969, p. 44) from Galerie Denise René and Hartung's *T 1973 E 13* (1975, p. 45) from Galerie de France following our recommendations.

I was particularly pleased with the Giacometti acquisitions, which were exceptional examples of the artist's methods and subject matter. I thought the oil portrait of Japanese professor of philosophy Isaku Yanaihara (1918–1989), a specialist on the writings of Sartre, Genet, and Camus, whose book *L'Etranger* he translated into Japanese, was especially apt. Giacometti and Yanaihara met in 1955 and developed a close friendship. Yanaihara was one of the artist's favorite models for numerous drawings and paintings because of his sheer ability to remain absolutely motionless, patiently posing for long periods. Not only was *Yanaihara* a fine example of the artist's painting style, but also an inspired depiction of a major scholarly figure from Asia.

On the Saturday before leaving, I had two appointments with the elusive Dr. Bahadori. He told me that he intended to give me a letter of agreement in lieu of a proper contract. He requested that I write yet another report specifying my responsibilities, how we would work together side

Wassily Kandinsky,
Tensions claires, 1937
Oil on canvas, 89 x 116 cm

Georges Braque,
Hymen, 1957
Bronze, 75.5 cm high

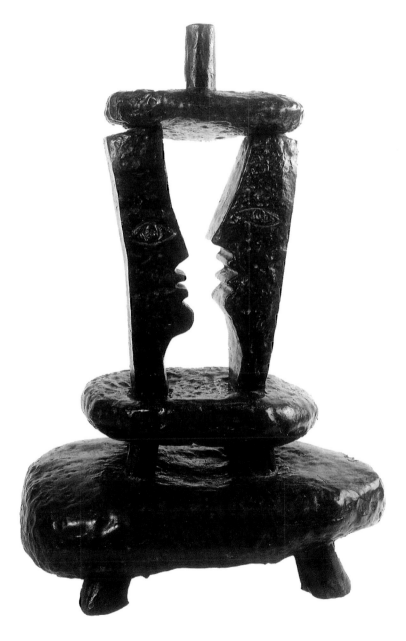

Alberto Giacometti,
Yanaihara, 1960
Oil on canvas, 84 x 73 cm

Alberto Giacometti,
La Cage, 1950–51
Bronze, 175 x 33.5 x 34 cm

Alberto Giacometti,
Grand buste, 1956
Bronze, 56.5 x 32.5 x 15 cm

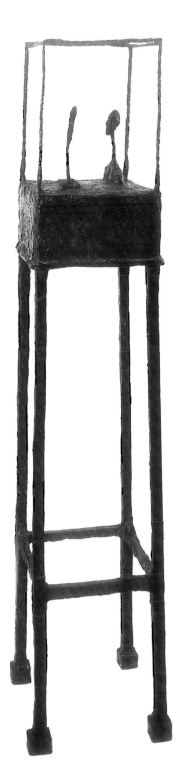

Jesús Rafael Soto,
Canada, 1969
Oil on hardboard and
wire, 157 x 158 cm

by side in pursuit of agreed upon goals and objectives. I was confused and upset over the lack of a contract, since that was what I was expecting based on Feri's initial letter. Although a letter of agreement was legally binding, typically the law did not enforce it. That evening, Feri organized an elegant dinner party for ten people in my honor. After a marvelous meal that included quail, I went back to my hotel and created a document that would serve as the basis of the proposed agreement letter.

The next afternoon I had a follow-up meeting with Dr. Bahadori. He kept me waiting for an hour as he negotiated with a representative from Galerie Maeght. Finally, I was invited into his office, where he informed me that due to the press of events, he had not yet reviewed my draft. He riffled through everything I had given him quickly, looked up and said he would see me on Tuesday, my last day in Tehran, and give me an answer at that time.

I appeared as promised in time for our meeting on Tuesday only to find that Dr. Bahadori was not in the office. He telephoned me later that afternoon and informed me he generally accepted my proposal and wanted to discuss my salary requirements. He sounded upset when I again asked for $25,000 per year and did not seem to accept that there could be such a big difference between the requirements of an international art expert and

the Iranian nationals who manned his typewriters and adding machines. Nevertheless, Dr. Bahadori indicated he would send me a letter of agreement good for one year that confirmed my letter of intent with an attached photocopy, which would serve in lieu of a formal contract. I brought up the subject of moving expenses and a round trip airfare. He responded by saying that he could not underwrite moving expenses or a round trip airfare. Instead he offered to pay for books and equipment that might be needed for my work. To assuage my dismay, he reassured me that my talents would be very well used and he and the Empress very much wanted to benefit from my evident expertise.

After this disturbing telephone conversation, I felt depressed and not at all certain this was a job I wanted. I could see that the position had the potential of being very exciting and challenging, but I also realized that the post was so undefined and the Iranian bureaucracy so formidable and indecisive that it would be very hard for someone accustomed to a more straightforward and supportive work environment to make the adjustment. Clearly it was time to head back home and think things over. New Year's eve was my last night in Tehran that year and Feri took me to the only Chinese restaurant in the city. We had a relaxed and enjoyable dinner and spoke more openly about our lives than ever before.

On my way back to New York, I stopped in London to see friends and family. Everyone I visited seemed astonished to learn that I might be moving to Iran. Most considered the prospect thrilling, because Tehran was booming while the economy was ghastly everywhere else. They seemed eager to know if Tehran had been internationalized and had modern conveniences; that made me think about the planned absence of convenient restrooms at the museum. When I talked about the problematic nature of the bureaucracy, they brushed aside my concerns, predicting that my work for Her

Hans Hartung,
T1973 E13, 1975
Oil on canvas,
111 x 180 cm

Majesty's Private Secretariat would be a professional stepping stone—and at the very least, a life changing experience.

After reorienting and organizing myself, I immediately got back to work on my lecture for the annual meeting of the College Art Association on "World's Fairs as Miniature Test Cities." I also visited private art dealer Richard Benedek, because I wanted to look at an early Kandinsky tempera painting called *Frühe Stunde* (1906). I didn't think some of the transparencies I had carefully studied and analyzed in Tehran were nearly as interesting as the original works I had seen at Benedek's before my trip. I wrote Feri to tell her that the Benedek Kandinsky and Piet Mondrian were important paintings, in good condition and with reasonable asking prices, and I sent her transparencies. I was happy to have identified a first-rate Mondrian, because the Private Secretariat was considering for purchase another work by this artist that had been poorly restored.[13] I also cautioned Feri that Iran must be very careful about who it deals with because there was no shortage of second-rate material on the market and prospective acquisitions needed to be carefully scrutinized "in the flesh."

Several days later, I got a call from my old friend Robert Wilson, who had performed several times in Iran. He told me he had been asked to design a Western theater in Tehran and establish a creative laboratory school similar to the one he founded in New York.[14] It turned out that Wilson was going to Tehran the following week and we talked about my experiences thus far. I suggested that he contact Feri, and wrote to remind her that Wilson's pioneering theatrical performances had been the talk of the Shiraz Festival.[15]

I finally received a letter of agreement from Dr. Bahadori. My brother, who is a lawyer and happened to be visiting me in New York City, acidly commented, "This is the most barren legal document I have ever seen." Nevertheless, the Iranian government met my modest salary request of $25,000 per year and offered me a first-class ticket to Tehran. They also agreed to pay for shipping any materials I thought I might need for my work.

Once I got it through my head that Dr. Bahadori had actually acceded to most of my requests, I realized that deep down I wanted to go to Tehran. The next day my brother helped me draft a letter of acceptance, adding a few additional deal points, including spending my vacation during the month of August in Italy, where I had previously committed to teach a class on the history of printmaking at a graphic workshop affiliated with Pratt Institute. I concluded my acceptance letter with, "It is a great pleasure for me to associate with Her Imperial Majesty's Private Secretariat for this worthwhile and dynamic artistic program." So I reassured Dr. Bahadori while promising "my very best efforts on Her Majesty's behalf."[16]

I wrote thanking Feri for advocating on my behalf and for her friendship. "I am scared to death by my decision," I told her, "but pleased also, for I think that it could be the job of a lifetime. I don't expect Tehran to be the center of the world (like New York City seems to be), but who knows. I keep hearing rumors about other Americans that might come to the Secretariat—Daniel Robbins, who is supposed to be very nice, just completed his PhD from the Institute of Fine Arts, New York University on Albert Gleizes. I also heard about Jim Elliott, whom I know casually, very nice, now director at the Wadsworth Atheneum Museum of Art in Hartford, originally from Los Angeles. Also, everyone seems to know that I plan to go to Iran. It's wild. I only decided for sure two days ago and have been telling only family and close friends."[17]

After I shared my good news with Feri, she informed me that my salary would be more than any departmental director in the Private Secretariat. She also indicated she thought Dr. Bahadori was probably reluctant to refer to my position as that of a curator, because only Iranian nationals are ever granted titles. "His position is political, and, in actuality, you will be doing a curator's work," she explained.[18] Feri also told me that Dr. Bahadori expected me to spend the first two months of my contract in New York scouting potential acquisitions and pursuing what I had outlined in my report; however, he refused to give me a letter of introduction because that was against the rules of the Secretariat. Among the preparatory tasks I was expected to accomplish during this initial period were researching and writing a program for the department; selecting and ordering books for an art history library; making contacts for acquisitions; initiating an acquisition program; investigating and purchasing conservation, matting, and storage supplies for the department; conducting architectural research; and attending auctions.

Nevertheless, it was totally amazing how fast news traveled about my overseas assignment. Two magazines I contributed articles to regularly, *Art News* and *Print Collector's Newsletter*, got wind of my new appointment, but I didn't know what I should say or how much I could tell. While working on a lecture in the MoMA Library, I bumped into a writer I knew who told me that he had heard from someone in the Print Department that I was going to Tehran. I couldn't believe that strangers had heard the news so quickly. Apparently, someone at the Metropolitan Museum of Art asked one of my former colleagues in the Print Department, "Have you heard there's this American girl who's going to start a new museum in Tehran?" After that experience I felt a little freer about telling people that I was going off to Tehran to work in Her Imperial Majesty's Private Secretariat and that forced me to field prying questions that I wasn't at all sure how to answer. How did the Empress get to you? What are your qualifications? Did you call her, or did she call you?

[1] I recently learned from a podcast Layla Diba made for Asia House, London (Episode 3, "Art in Peril," 2020) that the Negarestan Museum was closed and the collection dispersed by the Islamic Republic in February 1979 in an effort to erase some of the good work the Pahlavi Dynasty accomplished.

[2] According to the English language newspaper *Tehran Journal*, by December 1974, the Ministry of Culture and Arts had set new rules establishing that art gallery owners must hold degrees in art or appoint a qualified person as manager.

[3] See Interview, 193

[4] Rayner Banham, "The New Brutalism," *Architectural Review*, December 1955; as quoted in *Los Angeles Times*, January 13, 2019, F7.

[5] Email from F. Daftari, June 7, 2015.

[6] Letter to parents, December 26, 1974.

[7] I recently learned through publicly available CIA reports that Bahadori's patron, Prime Minister Amir-Abbas Hoyveda, placed Bahadori in his position at the Secretariat to "screen any petitions to the Empress to make sure she had only limited ability to take independent action." Apparently, the Empress was aware of this politically motivated practice.

[8] See Interview, 194.

[9] Renowned Finnish architect Alvar Aalto had been commissioned to design the museum and a site was found that he preferred in Shiraz. When he died in 1976, the project was canceled.

[10] Donna Stein, "How a Former Museum of Modern Art Curator Assembled an International History of Photography Collection for Iran in the 1970s," in *The Indigenous Lens? Early Photography in the Near and Middle East* (Boston: Walter de Gruyter GmbH, 2018), 328.

[11] Ibid., 328–29.

[12] Donna Stein, "For the Love of Her People: An Interview with Farah Diba About the Pahlavi Programs for the Arts in Iran," in *Performing the Iranian State: Visual Culture and Representations of Iranian Identity* (London: Anthem Press, 2013), 77. See Documents. See also Interview, 194.

[13] Letter to F. Daftari, January 9, 1975: "I saw both pieces and they are very good, important works in good condition. I also think the prices are decent. The information on the Kandinsky is enclosed. It is really spectacular. It is not signed on the front, but I don't know about the back. The Mondrian is quite a good piece and has not been tampered with . . . I have heard that the Galerie Malingue Mondrian is over-painted and poorly restored; apparently all the Sidney Janis paintings were not restored well; also, that is the reason that the Paris Museum Malingue mentioned in his offering did not want this particular painting. I can't tell you the source now, but it's trustworthy. Dealers know what is on the market and before I could say anything Benedek mentioned that the Malingue painting was available."

[14] Email from Robert Wilson, April 3, 2019.

[15] Letter to F. Daftari, January 9, 1975.

[16] Stein acceptance letter to His Excellency Dr. Bahadori, January 15, 1975.

[17] Letter to F. Daftari, January 16, 1975.

[18] Letter from F. Daftari, January 6, 1975.

5. WORKING FOR IRAN IN NEW YORK

Thanks to Feri's analytical skills, I now understood a lot more about the internal politics of the Private Secretariat. On February 15, 1975 I began my new job. Before long I started bi-weekly Farsi lessons. I conferred with mentors and scholars including Walter Hopps, William S. Lieberman, and Dr. William Rubin,[1] and began dropping into New York galleries, private dealers, and bookstores to identify appropriate art works for possible acquisition as well as key reference books for what would soon become the first encyclopedic art history library in modern Persia. This new job put my education and experience into action. Iran needed someone to evaluate works from an art historical perspective: this urgency offered me a golden opportunity to adapt my knowledge and curatorial skills to an ancient culture while scouring the known universe for masterworks irrespective of cost!

My recommendations for purchases should encompass the history of modern art, from Impressionism until the present, by internationally noteworthy artists. Eventually, the collection would include the whole spectrum of technical possibilities in art making. Besides designing plans for curatorial policy, purchasing, supervision of cataloguing, supervision of care and storage of collection, exhibitions, publications, organization of research and information files, development of education programs, training of staff, I was asked to initiate international contacts for acquisitions and exhibition.

Feri informed me that Kamran Diba was reluctant to change the space designated for the museum's offices, but he was ready to rethink space allocation within the assigned area for the staff. I raised the possibility of commissioning Japanese-American sculptor Isamu Noguchi to design a sculpture garden for the new museum. She wrote back that Firouz Shirvanloo, the director of the Art and Culture Department at the Private Secretariat, was very enthusiastic about the idea. So I had a dinner with Noguchi, who expressed substantial interest in the prospect of creating a site-referential Persian landscape.

I now made it a habit to forward to Feri and staff annotated sales catalogues from various auction houses and marked book lists that I regarded

as essential for future research. I recommended *Photography Source and Resource*, for example, as an excellent reference for photography in the US. I included a mimeographed catalogue from Light Impressions Corporation, a clearinghouse for books on photography, and carefully checked the listings. In the meantime I got to go shopping for great art books—with cost as no object.

Construction of the museum was progressing apace and I was surprised when Feri wrote she had reported to Kamran Diba that many royal courtiers were buzzing about the virtues of limiting the collection to Iranian modern art only. She was very upset because it contradicted everything we had been told; so she asked Kamran to brief the Empress right away knowing he badly wanted a pluralistic modern art collection and was very convincing whenever he addressed this crucial subject. Feri gently cautioned me not to speak with any journalists prematurely by reminding me that the Private Secretariat's watchwords were secrecy and discretion.

When Feri finally had time to study the Kandinsky transparencies from Knoedler and Benedek side by side, she felt frustrated by the absence of elementary research material. "We don't even have the Will Grohmann book on Kandinsky," she complained, but I told her that would soon change. She also asked me to inquire at the Klaus Perls Gallery, where I had worked as a graduate student, as to whether Chaïm Soutine's *Woman in Red* (c. 1922)[2] was still available and at what price.[3] That was the day I realized I could be a credible scholarly go-between that would save my Iranian colleagues from the indignity of being perceived as mindless Middle Eastern buyers with pockets stuffed with petrodollars.

In response to Feri's query, I looked at Kandinsky's *Frühe Stunde* out of the frame. I told Feri it was relined on new canvas, which was not particularly unusual, and appeared not to be cut down, as I feared because of a discrepancy in the measurements from Grohmann and other early catalogues. However, it seemed that these mistakes were perpetuated unknowingly. This big and imposing canvas was luminous and beautiful, a bit fragile on the upper right part of the canvas but otherwise in fine condition. I also informed her that Benedek bought the work from Fischer Fine Art Limited in London and that it was rare to find a work from this early Russian period on the market.[4]

In an official letter from Feri on behalf of His Excellency Dr. Bahadori, I was given the procedures to follow while identifying possible acquisitions:

Regarding the purchasing of prints, the procedure will be as follows: 1. You will select the prints; 2. You will contact the gallery or whatever source, and inform them about your interest in purchasing the selected prints for a museum in Iran; 3. You should ask them to send an offi-

cial letter to the office (to me). In the letter the following information should be stated: a) Name of the gallery; b) Complete information on the selected prints; c) Market or usual price; d) Special price for our museum (this does not mean that the gallery can offer a high price as the market price, so that the special price would actually equal the usual price, since prices can be checked); e) For payment the office will contact the firm directly.

As for the purchasing of materials for the facility (matting, special glue, glassine paper, etc.), a similar procedure will be followed:

1. You should make a list of all the needed materials and have it approved by the Office

2. Make an estimate of the amount of supplies the museum needs

3. Ask the firms to send us their special price for the amount of material you suggest

4. For payment the office will contact the firms directly.[5]

All the American dealers I spoke with were concerned about the time between selection and decision, payment procedures and methods of shipping. I wrote Feri asking if payment would be made after receipt of goods or upon invoicing. I realized that the dealers were unable to reserve artworks of superb quality without a confirmation of interest, since those works were in demand by other museums. I counseled they would be more willing to offer choice objects and reserve items if they didn't have to "immobilize" important stock for a long period of time. From my perspective, holding in reserve selected material, especially works under 500 dollars (e.g. prints and photographs) was not exactly fair to a businessman, especially if the material was sent to Iran, out-of-stock for several months, and then possibly returned. For that reason, I asked Feri to clarify payment and shipping procedures.

Feri also requested that I gather information about museum organization, administration, and procedures, including charters, personnel policies, and acquisition policies. I met with several experts and collected useful material from the Museum of Modern Art, the Metropolitan Museum, the Guggenheim Museum and the Whitney Museum. I was confident that this information would provide helpful guidelines for managing the proposed Iranian museum of modern art. She also asked me to list possible experts whom I considered particularly knowledgeable about modern art, prominent scholars in their respective fields that the Iranians could consult as advisors on an as-needed basis. I identified an international group of discriminating intellectuals with a wide range of tastes and interests, but cautioned that it was important to recommend public figures whose position would not present a conflict of interest, pointing out that the art

world is very small and anyone with commercial interests should not be part of any advisory committee. I counseled that too many cooks could spoil the broth and that as few as three disinterested professionals could be enough to make appropriate recommendations.[6]

I asked Feri to check on the protocol of getting a work permit, as it would be important for my tax records. She responded that I should use my visitor's visa, which was good for one year. She advised me not to worry because once I was ensconced in Tehran the Secretariat could expedite permits in a heartbeat.[7] I was glad to learn she had spoken to Dr. Bahadori about Isamu Noguchi but she cautioned that since there was a possibility that this idea may not be approved at his level or rejected by the Empress, I should not raise expectations when speaking to Noguchi.

All in all, I was juggling items as fast as I could while preparing for a seemingly momentous intercontinental move. Luckily, I found a former colleague and friend at the Museum of Modern Art who wanted to sublet my New York apartment. In the meantime, I'd need some new clothes but I wasn't sure if women could walk the streets of Iran wearing revealing, sleeveless dresses or shorts, or what might be appropriate for evening wear or for work in and around the office and court. Happily, I had Feri to advise me on all matters great and small. I consulted an astrologer who only knew where and when I was born. When he read my chart the day before I left for Tehran, he told me that I had lived in Persia as a teacher during a past life.

Following the recommendations of several friends and colleagues, I called the State Department to get briefed on filing requirements for Americans living and working abroad. I was advised to bring along certified copies of my birth certificate, transcripts and diplomas in case I had to apply for any legal papers, or in the event my citizenship was ever challenged. My counselor suggested I notify the Passport Office that I had been appointed to a position with the Iranian government describing the services I would soon render. I naively followed his advice and was astonished and confounded to be awakened early one morning by a friendly voice from the Federal Bureau of Investigation. After a brief interview, the FBI agent wished me safe travels and we said goodbye.

I was enjoying my Farsi lessons and it felt really good to be studying a language and knowing I would soon be speaking it in the course of everyday life. I let Feri know that Bob Wilson signed a three-year contract and would come to Iran in June. In a recent communication with Bob, however, I learned that his contract to found a theater school in Tehran never materialized.[8]

When I next heard from Feri, I was disappointed to learn that Kamran vetoed the idea of working with Noguchi on the museum's sculpture garden.[9] On the positive side, we received the go ahead from Dr. Bahadori

to purchase books I recommended from the various book dealers. Never-theless, I was again disappointed when Dr. Bahadori declined to approve the purchase of *Der Blaue Reiter Almanach* (1912) from the Lucien Gold-schmidt Gallery for $1,000 because he thought the price was too high.[10] In retrospect, it seems apparent that Dr. Bahadori felt he needed to assert some authority, however this publication was a seminal key monument in modern art publishing and his arbitrary and capricious decision proved to be a costly mistake. I wasn't surprised when he requested that I submit a budget for acquiring a first-rate print collection. I told him the time lapse between any proposal and a final decision was a critical factor. Suffice it to say, we lost out on a number of exceptional works on paper, including a fine example of a characteristic Morandi still life etching and an unusual Pissarro fan painted in gouache due to our impossibly cumbersome and ill-defined acquisition process.

In his fascinating memoir *Making the Mummies Dance*, the museum director and scholar Thomas Hoving recounts how Richard Ettinghausen, renowned Islamic historian and head of the Islamic Department at the Metropolitan Museum of Art, had been asked by the Empress of Iran for advice on how to develop a nationwide network of art museums. Hoving believed such a venture might be a good business opportunity and asked Dr. Ettinghausen to make arrangements for various members of the Metro-politan Museum staff, including Ettinghausen, Hoving, and deputy director and curator-in-chief Théodore Rousseau, to visit the Near East in 1974, where they toured Sasanian and Islamic monuments in and around Shiraz, including Persepolis. Unfortunately, Hoving's expected meeting with the Empress was cancelled for unknown reasons. Shortly thereafter, during a second trip on which he was accompanied by Stuart Silver, head of the De-sign Department and Richard Morsches, deputy director for Administrative Affairs, Hoving met with the Empress after inspecting several museums in varying stages of construction with his team.[11] Even though I was led to believe that at different times Mr. Hoving and other curators on his staff were consulted privately about purchase prices and quality,[12] according to Hoving, "The Met never became a consultant to the government of Iran or the Empress."[13] However, Stuart Silver, admired for his dramatic installa-tion designs, told me he served as a consultant to the Iranian government for the Carpet Museum of Iran in Tehran.[14]

All the dealers I spoke with about the new museum of modern art in Iran considered the creation of an ideal museum an enviable task. Tatyana Grosman (1904–1982), the founder of the distinguished graphic workshop Universal Limited Art Editions (ULAE), went further when she said that I must feel like I am living out a fable from the Arabian Nights.[15] I relished the opportunity to guide many of her fellow dealers and art publishers in

their submissions to the Private Secretariat, making sure they followed the requested formalities.

When I heard that Iranian artist Monir Shahroudy Farmanfarmaian (1923–2019) was having her first solo exhibition in the United States at the Jacques Kaplan/Mario Ravagnan Gallery in New York City, I decided to attend the opening. I introduced myself and it was immediately apparent that Monir already knew that the Private Secretariat had hired me. She was very friendly and warmly invited me to give her a call as soon as I settled in Tehran. She also made a special effort to introduce me to other well-known Iranian artists at the opening, including Ghasem Hajizadeh and Marco Grigorian (1925–2007); this occasion marked an auspicious beginning of three lifelong friendships. Although I had traveled to Iran in 1973 and 1974, I had little knowledge of contemporary Iranian art and found it difficult to contextualize Monir's work. However, as I grew to know Monir and her family in Tehran and understood more about the history of art in the country, I appreciated her innate creativity and the important role she had as an astute collector of Persian antiquities, tribal artifacts, and traditional folk art as she traveled around Iran, and how her avid collecting and knowledge of Persian motifs impacted her own art practice.

Feri wired me in mid-April that Dr. Bahadori would be coming to New York City in May and that he wanted me to extend my stay in America through the end of the month.[16] Feri called me when the Shah and Shahbanou's party arrived in Washington, DC and said that she and Dr. Bahadori would be in New York beginning on May 19.

Leading a delegation of influential Iranians including Dr. Bahadori, former UN Ambassador Mehdi Vakil (1959–1970), and Fereshteh Daftari around New York City to view proposed acquisitions I had reserved in all media—paintings, sculptures, tapestries, drawings, graphics, and photographs—was an eye-opening experience.[17] For nearly two weeks I was with my Iranian colleagues morning until night. As artworks were acquired, they were sent to J. H. Guttmann Picture Frame Corp. in New York City for framing, crating, and shipping.

My mentors had recommended various dealers they had worked with over their careers. I had winnowed down the list to concentrate on those I felt had the best selection at the most reasonable prices. We visited various galleries, including Lucien Goldschmidt (for drawings, monotypes, prints, and limited edition books); E. V. Thaw & Co. (for paintings, sculptures, and prints); Klaus Perls Gallery (for paintings, sculptures, and tapestries); Robert Schoelkopf (for photographs); Howard C. Daitz (for photographs); and Associated American Artists (for prints). I had informed out-of-town dealers such as Universal Limited Art Editions from Bayshore, Long Island (for prints and illustrated books), Robert M. Light from Boston (for prints) and

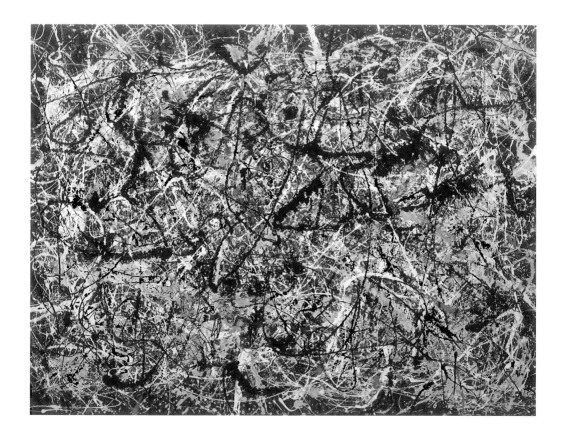

Jackson Pollock, *Mural on Indian Red Ground*, 1950
Oil and enamel on board, 183 x 243.5 cm

Graphics International in Washington, DC (for photographs), who brought their inventories to New York City for special presentation. We also visited private collections (e.g. William Rubin to see Jackson Pollock's *Mural on Indian Red Ground*, 1950) and artist studios (e.g. Neil Jenney and Manoucher Yektai).

These visits were an important opportunity for the Iranians to meet and connect with first-rate public and private dealers in various modern media. During the course of two weeks, the acquisition team purchased more than one hundred and twenty-five objects I had selected in all media.

Eugene V. Thaw (1927–2018) was regarded as one of the most influential collectors, scholars, and astute dealers of the twentieth century. At his gallery, the Iranians decided to buy Picasso's large synthetic cubist painting *Open Window on the Rue de Penthièvre in Paris* (1920, p. 56);[18] Picasso's *Baboon and Young* bronze sculpture (1951); the third state of Picasso's memorable, large etching and aquatint *Weeping Woman* (1937, p. 58), which is dedicated in pencil and was a gift from the artist to his biographer Sir Roland Penrose; and Van Gogh's rare lithograph *Worn Out: At Eternity's Gate* (November 1882, p. 59) from the collection of Nelson Rockefeller, the former governor of New York and vice president of the United States. I was

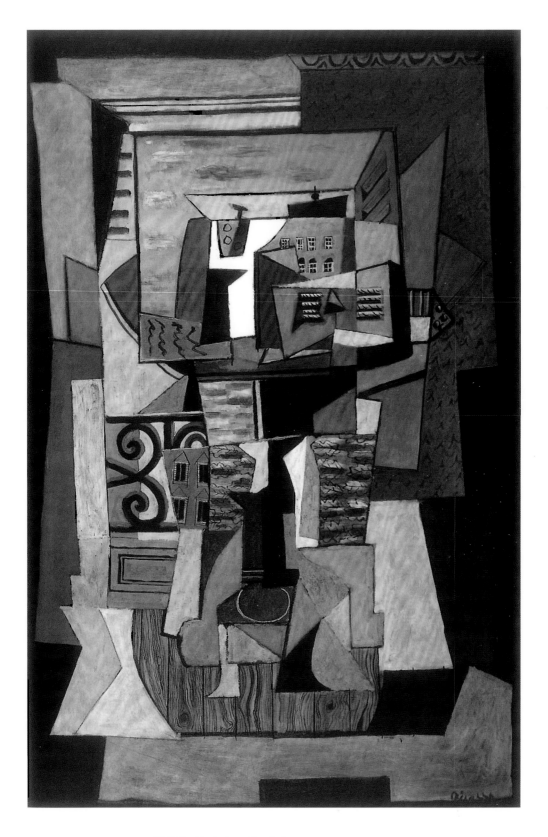

Pablo Picasso, *Weeping Woman*, July 2, 1937
Drypoint, etching, and aquatint, 68.6 x 49.2 cm

Pablo Picasso, *Weeping Woman I*, July 4, 1937
Drypoint, etching, and aquatint, 34.7 x 24.7 cm

Pablo Picasso, *Weeping Woman II*, July 4, 1937
Drypoint, etching, and aquatint, 34.7 x 24.5 cm

 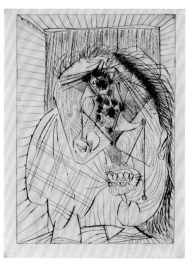

Vincent van Gogh, *Worn Out: At Eternity's Gate*, November 1882
Lithograph, 56 x 37 cm

Alexander Calder,
The Orange Fish, 1946
Painted metal mobile,
74.5 x 109.5 cm

fascinated to learn that not only did Penrose own the large-format etching of *Weeping Woman*, a motif at the intersection of Picasso's personal and political passions that had supplanted for a short time the odalisques in his oeuvre, but that he had also acquired a powerful painting of the same name that was based on Picasso's muse and lover, the photographer Dora Maar.[19]

Klaus Perls Gallery specialized in French art of the School of Paris, but also represented American artists like Alexander Calder. There, the visitors from Tehran purchased Picasso's tapestry *Secrets (Confidences) or Inspiration* (1934–35); Derain's *L'Age d'or* (1904–5); and Calder's large mobile *The Orange Fish* (1946, pp. 60–61). Robert Light (1929–2016), a private print dealer recommended to me by E. V. Thaw, offered superb impressions of Toulouse-Lautrec's *The Clowness Cha U-Ka-O at the Moulin Rouge* (1897); Rodin's drypoint *Henry Becque* (1885); two hand-colored etchings by Ensor: *The Cathedral* (first plate, 1886) and *Entrance of Christ into Brussels* (1898; a large painting for this composition is now owned by the Getty Museum); and Delaunay's rare cubist lithograph from 1925, *Window on the City* (1925, p. 64), which relates to a painting of the same name in the Guggenheim Museum in New York.

I was especially pleased that Iran had acquired Picasso's large late Synthetic-Cubist painting *Open Window on the Rue de Penthièvre in Paris* from Thaw. The composition had been developed in some fifty preparatory studies done prior to the final picture.[20] The prominent Parisian dealer Paul Rosenberg & Co. originally bought the canvas directly from the artist. In 1940, shortly after the occupation of the city, the invading Germans stole it from his gallery along with many other works. The cache was eventually recovered in 1946 from a French dealer who claimed to have obtained the rolled-up bundle of about a dozen canvases from the Germans. The Frenchman was arrested, but won his release by returning the loot to Rosenberg who, ten years later, sold *Open Window* to Norton Simon for $225,000.[21] Besides its stellar provenance, the painting was a large and readable example of Synthetic Cubism and had been reproduced in every major publication on the artist and exhibited frequently in major exhibitions on Cubism in the United States and Europe.

I had been working at MoMA when the first large-scale retrospective of Picasso's sculpture was mounted in the United States. Now that I was working for the Iranian Government, I considered it my good fortune to find an example of Picasso's *Baboon and Young*, an amazing sculptural transformation in which the artist used modeling to supplement and correct assembled materials. This charming and eminently accessible bronze was composed of two toy cars—a Panhard Dyna X and a Renault that art dealer Daniel-Henry Kahnweiler had given to Picasso's son Claude in 1951— for the female baboon's head, broken cup handles for the ears, a rounded

pottery jar for the body, and an automobile spring for its long tail. With sculptures like *Baboon and Young*, Picasso transgressed boundaries and brought a strikingly new approach to the art of metal sculpture and assemblage. The original plaster for the sculpture is at the Musée Picasso in Paris.

Derain's large oil *Composition (L'Age d'or)* from 1904–5, probably painted at Collioure, references historical prototypes in the works of Eugène Delacroix and Jean-Auguste-Dominique Ingres, as well as motifs his contemporary Henri Matisse developed in *Luxe, calme et volupté*. Nevertheless, it most certainly was a prelude to Matisse's *Bonheur de vivre*. Depicting the joy of life rather than the golden age, it is an amalgam of Neo-Impressionist and Fauve technique and thus a significant transitional canvas, which was lent by Her Majesty's Private Secretariat to the seminal 1976 exhibition *Fauvism: Wild Beasts* mounted at the Museum of Modern Art in New York.

Robert Delaunay, *Window
on the City*, 1925
Lithograph, 56 x 43.1 cm

Willem de Kooning,
Light in August, c. 1946
Oil and enamel on canvas,
140 x 105.5 cm

Other major paintings acquired in New York that May were André
de Segonzac's *La Soupière de Moustiers* (1938–39, p. 152) and Willem de
Kooning's *Light in August* (c. 1946), a large abstraction from a group of
paintings in black and white household enamel that in 1978 traveled a
curious odyssey to the Seibu Department Store Museum in Tokyo, to the
Whitney Museum of American Art in New York City and then to the Herbert
F. Johnson Museum in Ithaca, New York. Because of the Islamic Revolution
and concerns that artworks might be destroyed as products of American
imperialism, president Carter considered three paintings, including the
de Kooning and Rothko's *No. 2 (Yellow Center)* (1954, p. 66) on loan to the
Solomon R. Guggenheim Museum, as part of the frozen Iranian assets in
the United States. Finally, in the summer of 1982, *Light in August* was
returned to Iran via Bonn, West Germany when Huntington T. Bloch Fine

Mark Rothko, *No. 2
(Yellow Center)*, 1954
Oil on canvas,
289.5 x 173.5 cm

Helen Frankenthaler,
Persian Garden, 1965–66
Lithograph in three colors,
64.8 x 50.8 cm
Edition of 24

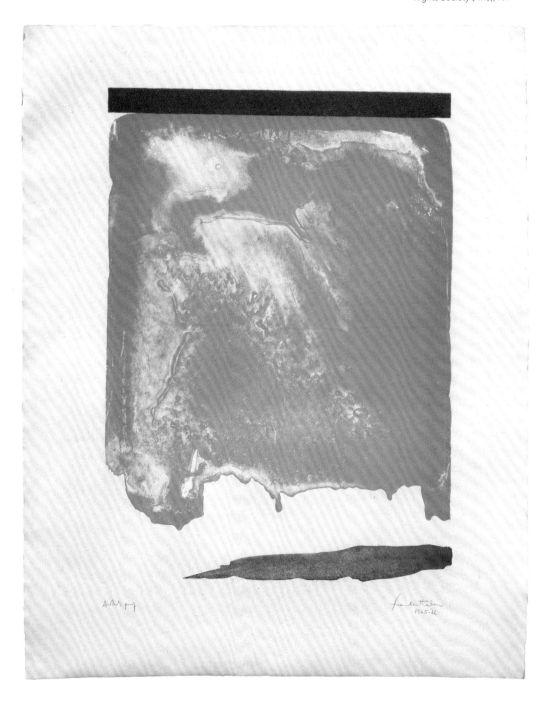

Jasper Johns, *Decoy*, 1971
Lithograph with die-
cutting,104.1 x 73.7 cm
Edition of 55

Published by Universal
Limited Art Editions
© Jasper Johns / Universal
Limited Art Editions /
Licensed by VAGA at Artists
Rights Society (ARS), NY

Jasper Johns,
Pinion, 1963–66
Lithograph in 5 colors,
101.6 x 71.1 cm
Edition of 36

Published by Universal
Limited Art Editions
© Jasper Johns / Universal
Limited Art Editions /
Licensed by VAGA at Artists
Rights Society (ARS), NY

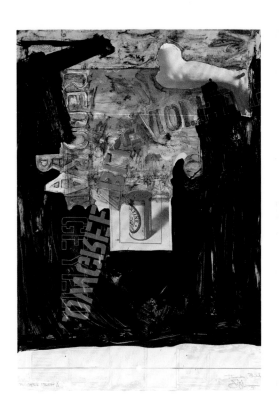

Robert Rauschenberg,
Booster, 1967
5-color lithograph
and screenprint,
182.9 x 90.2 cm
Edition of 38

© 1967 Robert
Rauschenberg and
Gemini G.E.L.

Robert Rauschenberg,
Water Stop, 1968
Lithograph in 5 colors with
embossing, 137 x 81.3 cm
Edition of 28

Published by Universal
Limited Art Editions
© The Robert Rauschenberg
Foundation / Universal
Limited Art Editions /
Licensed by VAGA at Artists
Rights Society (ARS), NY

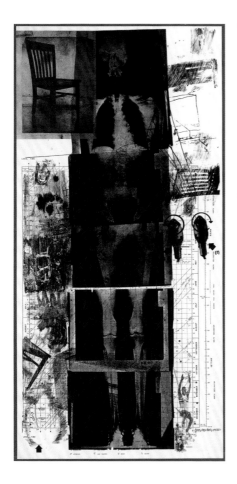

James Rosenquist,
Off the Continental Divide,
1973–74
Lithograph, 106.7 x 198 cm
Edition of 43

Published by Universal
Limited Art Editions
© Estate of James
Rosenquist / Universal
Limited Art Editions /
Licensed by VAGA at Artists
Rights Society (ARS), NY

James Rosenquist,
Expo 67 Mural–Firepole
33' x 17', 1965–66
Lithograph in six colors,
86.4 x 47 cm
Edition of 41

Published by Universal
Limited Art Editions
© Estate of James
Rosenquist / Universal
Limited Art Editions /
Licensed by VAGA at Artists
Rights Society (ARS), NY

Art & Musical Instrument Insurance agreed to insure the transfer. The Rothko was returned at a later time.

Following my April visit to Universal Limited Art Editions in Bayshore, Long Island, the Private Secretariat agreed to purchase two unique and rare print portfolios by Jasper Johns for $33,300, including a special museum discount of 10%: 10 lithographs and overprints in *0–9* (1960–63) and seven etchings, six photo engravings, and one relief print in *1st Etchings* (1967). Later in May, ULAE made available nineteen additional collector's items and some editions at a net price of $42,040, which included a special 20% discount. This order comprised the work of Sam Francis (a trial proof of *Five Stone Untitled*); Helen Frankenthaler (artist's proofs of *Persian Garden*, p. 67, and *Connected by Joy*); Jasper Johns (artist's proofs of *Painting with Two Ball II, Passage I, Decoy*, p. 68, as well as available additions *Hand* and *Pinion*, p. 68); Robert Motherwell (*Gauloises Bleues*, a unique edition in which the artist tore each Gauloises package by hand, and an artist's proof of his remarkable illustrated book, *A la Pintura*); Robert Rauschenberg (artist's proofs of *License, Water Stop*, p. 69, *Landmark*, and from the edition *Kitty Hawk*); Larry Rivers (artist's proof of *Stravinsky III* and *Bike Girl* from the edition); James Rosenquist (available editions of *Campaign* and *Off the Continental Divide*, p. 70); and Saul Steinberg (*The Museum* from the available edition). I have always considered the production quality of ULAE as distinctive and exceptional, and admired Grosman's subtle and artful relationship with her artists, who were among the most famous in the United States. Having seen the first print of every edition she had produced since 1957 during the years I worked in the Prints and Illustrated Books Department at the Museum of Modern Art, I was confident these purchases were significant and would continue to retain their value artistically and monetarily.

When I worked at MoMA, Sylvan Cole (1918–2005), the longtime director of Associated American Artists (AAA) established in 1934, became a friend and mentor. I sought his advice and help in acquiring important graphics for the Iranian National Collection. Among the works purchased from AAA were two etchings by James McNeil Whistler from the portfolio *Sixteen Etchings of Scenes on the Thames and Other Subjects* (1859) (*Black Lion Wharf* and *The Lime Burner*); Pierre Bonnard's second lithograph *Scène de Famille*; Mary Cassatt's *Peasant Mother and Child* (1895, p. 74), an exquisite drypoint and aquatint that virtually reverses a pastel from 1894; *L'Album de la Revue Blanche* issued in Paris by *L'Estampe originale* for the artistic and literary journal *La Revue Blanche* in 1895. Containing eleven lithographs and one wood engraving, the portfolio offers a rich overview of the most important Nabis and Symbolist artists at the end of the nineteenth century including Pierre Bonnard, Charles Cottet, Maurice De-

nis, Henri-Gabriel Ibels, Paul Ranson, Odilon Redon, József Rippl-Ronai, Théodore Roussel, Paul Serusier, Henri de Toulouse-Lautrec, Félix Vallotton, and Édouard Vuillard with an additional lithograph on the cover by Bonnard. Other purchases included Maurice Prendergast's color monotype *Telegraph Hill*; Henri Matisse's *Persian Woman (Return from Tahiti)* (1929, p. 76); John Marin's *Brooklyn Bridge No. 6, Swaying* (1913, p. 76), which was originally published by Alfred Stieglitz's Gallery 291 showing the influence of Cubist and Futurist theories and visual effects on the American artist; Lyonel Feininger's *Villa on the Shore, 4*, a special proof on tan paper from the collection of the artist and his wife of a woodcut published in the *Neue Europaeische Graphik, Erste Mappe, Meister des Staatlichen Bauhauses*, Weimar, 1921; Edward Hopper's *East Side Interior*; David Alfaro Siqueiros' *Peace*; three lithographs by Stuart Davis (*Hotel de France, Sixth Avenue El*, p. 77, and *Study for Drawing*), and Grant Wood's autobiographical lithograph *Honorary Degree*, which sold for $5 when it was published in 1939.

Although I knew the asking prices for all the works we considered in New York,[22] I never witnessed the financial negotiations, and to this day I do not know what the final purchase prices were for any of the items I had reserved except for those at the Witkin Gallery, the first commercially suc-

Mary Cassatt, *Peasant
Mother and Child*, 1895
Color drypoint and aquatint,
30 x 24.2 cm

Pierre Bonnard, *Femme au parapluie* from *L'Album de la Revue Blanche*, 1895
Color lithograph, 22 x 14 cm

Henri de Toulouse-Lautrec, *Carnaval* from *L'Album de la Revue Blanche*, 1895
Color lithograph, 38 x 28 cm

Henri Matisse, *Persian
Woman (Return from
Tahiti)*, 1929
Lithograph, 44.5 x 29 cm

John Marin, *Brooklyn Bridge
No. 6, Swaying*, 1913
Etching, 27.4 x 22.3 cm

Stuart Davis, *Sixth Avenue El*, 1931
Lithograph, 30.2 x 45.5 cm

cessful photography gallery in New York City that promoted renewed public interest in the medium beginning in 1969. I was reminded of how small the art world was when, after I moved to Iran, I heard from my long-time friend, photographer Judy Dater, that she had recently met photographer Les Krims and his girlfriend who recounted in great detail what happened at the Witkin Gallery.[23]

For three hours we pored over photographs by David Octavius Hill and Robert Adamson (*Miss Munro*), William Henry Jackson (*Mount of the Holy Cross, Colorado*), Frederick Evans (*French Cornfields*), Alfred Stieglitz (*The Steerage*), Edward Steichen (*Pastoral, Moonlight* and *Auguste Rodin*), Arnold Genthe (*The San Francisco Earthquake*), Lewis W. Hine (*Heart of the Turbine* and *Worker in Shrine*), Eugène Atget (*51 Rue de Montmouracy* and *Quai de Grands Augustines*), August Sander (*Jockey*), Edward Weston (*Sunshine and Flowers* and *California Coastal Landscape*), and Margaret Bourke-White (*RCA Plant*), among others. I explained my choices and their places in the history of photography and art. Dr. Bahadori, ever the guardian of the purse strings, was predisposed toward photography. However, he was influenced by and relied on the advice of the none-too-well-informed Iranian Ambassador, whose paucity of knowledge about photography was equal to his startling lack of manners. I presented the best available work by Edward Weston at the time. When Witkin showed Weston's portrait of the Italian photographer, actress, and political activist Tina Modotti, the Ambassador sneered, "Why would we want to glorify communism?" While the Ambassador was certainly entitled to his political opinions, Witkin and I were shocked by his rudeness, which, looking back, may have testified to the depth of his feelings about the menace the Tudeh Party represented to the monarchy. I naively thought that diplomats exercised diplomacy, but didn't realize that his behavior was part of the art of the deal. While I had based all my decisions on art-historical criteria, I learned from this episode that I had to be more sensitive to the content and better anticipate how the Iranians might react to certain images.

Finally, after the Iranians had selected a number of photographs, the bargaining began. When Witkin offered his standard museum discount and explained that unlike other dealers he maintained a very low margin for mark-up, they demanded a greater percentage off and threatened to walk out. I had worked hard to obtain generous museum discounts for everything I proposed, and was surprised and embarrassed to observe the crude negotiating style of my colleagues. Exhausted from the emotional strain of the afternoon, Witkin finally disingenuously responded with great restraint, "I have never done business this way, but because of what Donna is trying to do for photography in your country, I will agree to your terms." The next day he told me that he would never deal with anyone that way again and to my knowledge he was a man of his word.

Lest you think otherwise, not everything I considered exceptional was purchased. Among the recommended treasures rejected at the Witkin Gallery was *Patriotic Boy with Straw Hat, Buttons and Flag, Waiting to March in a Pro-War Parade* (1967) by Diane Arbus (1923–1971). *Patriotic Boy* is one of her most famous images and a handwritten letter by artist Jim Dine (who previously owned the photograph) describing its provenance accompanied the print. I had met Arbus when I worked at the Museum of Modern Art and admired her oeuvre, which, with rare exceptions, focused on people. Her portraits were mysterious and psychological and captured private realities. Unfortunately, the delegation was not fully familiar with the history of photography and thus not inclined to acquire contemporary photographers for fear that they might not meet the test of time. Perhaps Arbus's image of a flag waver was too all-American for their tastes, or maybe they correctly interpreted the image as critical of the United States. Clearly, price was not the problem, as this unique version of *Patriotic Boy* with Dine's letter was available for a mere $1,800.

We did purchase some historical images of the Middle East from the book dealer Howard C. Daitz: Pascal Sébah's *Palmier Forêt*; Félix Bonfils' *General view* and *Interior of the Mosque of Omar, Damascus* and James Robertson and Felice A. Beato's *Constantinople, Door to Seraglio* (1850–54, p. 82), Harry Lunn (1933–1998) brought some choice photographic prints from Graphics International in Washington, DC. We acquired Hill and Adamson's *Edward W. Lane as a Persian* (1845, p. 81); Man Ray's unique rayograph *Egg Beater and Abstract Interior* (1947, p. 87); Bellmer's *Poupée dans l'escalier* (1934–36, p. 86); and Henry Peach Robinson's composite photograph *Landing the Catch* (1890, p. 82).

I had assumed Middle Eastern subjects would be of particular interest in Iran and looked for excellent examples in all media. The most significant case in point in the photography collection was the early calotype by the Scottish photographers Hill and Adamson. During their partnership in the years 1843–47, they photographed *Edward W. Lane as a Persian*. Lane was an eminent British Orientalist, translator, and lexicographer, known for his version of *The Thousand and One Nights*, the celebrated collection of folk tales compiled during the Islamic Golden Age from Arab, Persian, Turkish, Greek, and Indian sources.[24]

I was also able to find some important photographs at the Robert Schoelkopf Gallery. Among the works acquired were photographs by Alphonse Mucha (*Study for a Painting of the Artist's Wife and Child*, 1901, p. 83); Gertrude Kasebier (*Joe Black – Fox with Face Paint*); two additional works by social reformer and child labor activist Lewis W. Hines: *Barker Cotton Mills* and *Young Girl with Baby*; a magnificent platinum exhibition print by Edward Curtis (*Geronimo*, 1905, p. 84); the rare László Moholy-Nagy

William Henry Fox Talbot,
Single Fern, 1836–37
Photogenic drawing,
16.9 x 15 cm

David Octavius Hill
and Robert Adamson,
*Edward W. Lane as
a Persian*, 1845
Calotype, 14 x 20.7 cm

James Robertson and Felice
A. Beato, *Constantinople,
Door to Seraglio*, 1850–54
Calotype, 30.9 x 25.8 cm

Henry Peach Robinson,
Landing the Catch, 1890
Albumen photomontage,
47 x 38.2 cm

Alphonse Mucha, *Study
for a Painting of the Artist's
Wife and Child*, 1901
Gold chloride toned print,
16.5 x 11.5 cm

Edward Curtis,
Geronimo, 1905
Platinum print,
40.7 x 30.5 cm

Alfred Stieglitz, *Portrait
of John Marin Hand Tinting
his Issue of "291,"* 1915
Platinum print, 11 x 9 cm

Man Ray, *Gertrude Stein
and Alice Toklas in their
Drawing Room, Paris*, 1922
Gelatin silver print,
16.5 x 22.9 cm

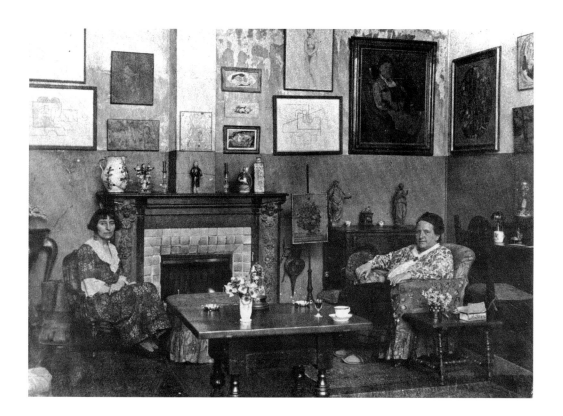

László Moholy-Nagy, *Lyon Stadium*, 1930
Gelatin silver print, 36.3 x 27.3 cm

Hans Bellmer, *Poupée dans l'escalier*, 1934–36
Gelatin silver print, 24.2 x 24.2 cm

Man Ray, *Egg Beater and Abstract Interior*, 1947
Rayograph, 35.3 x 27.7 cm

gelatin silver print *Lyon Stadium* (1930, p. 86); an iconic gelatin silver print by Man Ray (*Gertrude Stein and Alice Toklas in their Drawing Room, Paris, 1922*, p. 85); Walker Evans (*Negro Barber Shop Interior, Atlanta, Georgia* and *Kitchen, Truro, Massachusetts*); Margaret Bourke-White (*The George Washington Bridge, New York, Rolling Optical Glass*, and *Locket, Georgia*), and Roger André (*Pierre Bonnard in his Studio*).

Photographs by prominent artists like the Czech illustrator and poster designer Alphonse Mucha, who acquired a camera in the early 1890s, were also of interest. Artists used camera vision and images as replacements for sketching from nature for authentic detail. Portraits of artists, such as Steichen's photograph of *Auguste Rodin* and Roger André's *Pierre Bonnard*, became an important grouping in the collection. They made visible artists from another era to the viewing public and contextualized paintings, sculptures, tapestries, drawings, and graphics. Man Ray's silver gelatin print of Gertrude Stein and Alice B. Toklas depicts two of the earliest and most important collectors of avant-garde art in the twentieth century. Taken in 1922, the year after Man Ray arrived in Paris, the photograph confirms that the versatile interdisciplinary American artist had already been welcomed into the inner circle of the Parisian art world.[25]

My overarching intention in forming a collection illustrating the history of photography for Iran endorsed the importance of both indigenous and international photography as an irreplaceable cultural resource with which to study the ideas and conditions of modernity. Because photographers view subject matter through the camera lens, they create with light, reframing expectations, bearing witness by preserving the fleeting and capturing the unexpected. The history of photography collection in Iran was meant to be a catalyst for further scholarship, to compare with the intensity of contemporary work, helping young photographers develop their own statements as well as promoting new relationships among photographers, critics, and their growing Iranian audiences.[26] While working in Tehran, I was fascinated to discover that a passion for photography had begun in Iran in the early 1840s soon after the medium's announcement in 1839, and I found a number of stunning early indigenous examples that further validated the pioneering collecting approach that I had recommended to Her Majesty.

Because few institutions or private collections around the world collected and exhibited photographs in 1975, Iran's serious commitment to the art of photography required imagination and the willingness to accept some intellectual risks. By creating a historical survey of the medium, the Secretariat seized the opportunity to take a leading role in an under-collected and burgeoning art form. As Kamran Diba acknowledged in his preface to *Creative Photography: An Historical Survey* (1977), the

catalogue documenting the first exhibition of its kind in Iran that I curated for the opening of the Tehran Museum of Contemporary Art, "this collection will establish the importance of photography as an art form and will inspire young Persian photographers to an even higher level of artistic achievement."[27]

After the Islamic Revolution, despite an anti-American political climate, occasional exhibitions have focused on international photography holdings from the United States, England, Scotland, France, Germany, Czechoslovakia, and Hungary in such exhibitions as *Inner Eye in Iranian Photography* (2008) and *World Photography* (2010).

One mild spring evening Dr. Bahadori and Ambassador Vakil invited Feri and me to dine. In Dr. Bahadori's eyes my acceptance of his invitation probably suggested that I was interested in more than a working arrangement. When he proposed that the evening shouldn't end with dinner and dancing, I laughingly declined the next waltz, but little did I know that this very uncomfortable episode foretold some of the difficulties with chauvinistic sexual politics I would be facing every day in Iran.

[1] These three men guided me in my initial contacts with galleries and private dealers. Walter Hopps (1932–2005), an American museum director and curator of modern and contemporary art, hired me for my first museum job at the Pasadena Art Museum. He was a maverick in the profession, renowned for his sensitive and inspired installations. William S. Lieberman (1924–2005), a legendary museum figure who held top curatorial posts at the Museum of Modern Art and the Metropolitan Museum of Art. A power in the art world for more than fifty years, he was my first boss at the MoMA. Dr. William Rubin (1927–2006) was an American art scholar, a distinguished curator and critic, collector, art historian, and teacher of modern art. He was director of the MoMA's Department of Painting and Sculpture.

[2] Reproduced in H. H. Arnason's *History of Modern Art: Painting, Sculpture, Architecture, Photography* (New York: Harry N. Abrams Inc., 1968), color plate 113, 271.

[3] Letter from F. Daftari, February 19, 1975.

[4] Letter to F. Daftari, April 16, 1975.

[5] Official letter from F. Daftari, March 5, 1975.

[6] See Documents, Letters from March 26, 1975 and April 16, 1975, 218–22 and 226–27.

[7] Official letter from F. Daftari, March 5, 1975.

[8] Email from Robert Wilson, April 3, 2019.

[9] Letter from F. Daftari, April 7, 1975.

[10] Official letter from F. Daftari, April 8, 1975.

[11] Thomas Hoving, *Making the Mummies Dance: Inside the Metropolitan Museum of Art* (New York: Simon and Schuster, 1993), 348–49.

[12] Report to Aydin Aghdashloo, February 28, 1977.

[13] Hoving, *Making the Mummies Dance*, 350.

[14] Letter to F. Daftari, November 5, 1974.

[15] Business letter from Tatyana Grosman, April 16, 1975

[16] Western Union Telegram dated April 12, 1975; letter from F. Daftari, April 8, 1975.

[17] See Documents, Spreadsheets, for lists of works viewed and acquired in May 1975.

[18] Letter from Darryl E. Isley (Norton Simon's curator) to E. V. Thaw acknowledging payment totaling $1,000,000 for this painting.

[19] The painting is now in the collection of the Tate Gallery, London.

[20] My response to official letter, March 26, 1975.

[21] Gloria Williams Sander graciously made available to me this information about the Norton Simon Collection.

[22] See Documents, Spreadsheets listed by medium.

[23] Letter from J. Dater, August 14, 1975.

[24] Donna Stein, "How a Former Museum of Modern Art Curator Assembled an International History of Photography Collection for Iran in the 1970s," in *The Indigenous Lens? Early Photography in the Near and Middle East* (Boston: Walter de Gruyter GmbH, 2018), 332–33.

[25] Ibid., 340.

[26] Ibid., 327.

[27] Ibid., 329.

6. MOVING TO TEHRAN

My Iran Air flight to Tehran was delayed for five hours in London due to technical problems: with the benefit of hindsight, it was a warning of many more obstacles to come. On June 27, 1975 I entered the furnace-like capital city at four o'clock in the morning. I was disappointed but not surprised that nobody was there to welcome me at that hour, so I checked into a nearby hotel and went to sleep. I learned later that several friends had patiently waited for me in the airport lounge until well after midnight.

While living in Tehran full-time, I discovered what it was like to be a feminist in an all-encompassing Islamic cultural environment. Although I had never expected that a daily existence in the Near East would be simple, life in Iran proved much more difficult than I ever anticipated. In truth, I was utterly unprepared for the shock of the intense heat as well as the emotional complexities that living in the Third World would arouse. Extremes of wealth and poverty were everywhere, the middle class was tiny. This California girl was shocked to see a lot of people living on the streets, where they slept on straw mats, although few looked like outright beggars. My previous visits to Iran had occurred during the winter and the homeless population had not been so visible. Now shopkeepers employed guards, and workers watched over construction sites around-the-clock. New construction was everywhere but it seemed like buildings were never finished, which might have been a blessing in disguise because their no-frills architecture was uncommonly ugly.

By this time, I knew enough Farsi to get around town, but not nearly enough to have a substantial conversation. "Language is a big barrier and worse than I imagined,"[1] I wrote my family and friends who suggested resorting to French, Italian, and German, but that didn't help. I began to learn about the city by studying guidebooks published in multiple languages, but decided to delay exploring its highways and byways until the temperature dropped. Since the high temperatures were so enervating, I designated my early days in Tehran as a vacation, spending my afternoons after work sleeping, reading, swimming, and sunning. This represented an agreeable change of pace from my frantic life in Manhattan; however,

View across plaza
at Saman 2 with
Alborz Mountains in
the distance, 1975
Color slide
© Donna Stein

Tehran felt like a cultural wasteland because concert halls and theaters were closed during the summer months.

Although I had a few acquaintances, being so far from home made me lonely and I felt deeply alienated. "Maybe once I have settled into my own place," I wrote an old friend, "it will be better although I have already met some people from the international community."[2] "Most Iranians are very much caught up with their families," I observed, "and remain closely tied to parents and relatives to the exclusion of outsiders. Embedded into their nature is the idea that they should never trust anybody but their own family. Few foreigners are taken into family circles, partly because

TMoCA with Saman Towers
in the distance, 1977
Gelatin silver print
© Donna Stein

of language difficulties and especially because most Iranian families are already enormous."[3]

Within ten days of my arrival, I signed a lease on a pleasant flat in one of the nicest and most conveniently located apartment complexes in Tehran at the time. The twin Saman Towers, each twenty-two stories high, were the tallest buildings in the city until 1977. They were sited around a large plaza resembling I. M. Pei's Kips Bay complex in Manhattan. I wrote a friend that when the cab drivers dropped me off or picked me up at my snazzy new digs, they often impertinently inquired if I am wealthy.[4]

A nice apartment in Tehran turned out to be much more expensive than I had been led to expect. An unfurnished one-bedroom flat in the Saman complex, for example, cost as much as $1,200 per month. My light-filled studio on the fifth floor was about two-thirds the size of my one-bedroom apartment in New York, but it cost 50% more. Still, I considered myself lucky for several reasons. First off, the windows faced east toward the majestic Alborz Mountains. The apartment also offered central heating, in contrast to the smelly kerosene heaters that were typical of other dwellings. In addition, my studio was air-conditioned. The Saman Towers had many other attractive features. The buildings were clean and well maintained, and a sympathetic and helpful concierge was on duty in the lobby day and night. In addition, there was a shopping mall on the mezzanine and basement levels with essential services—bank, supermarket, laundry and dry cleaning, travel agent, florist, shoe repair, photography store, rug shop, and a record store. For me, the proximity to so many necessities of life was extremely helpful. Phone orders could be delivered to my door, albeit not always promptly.

Commutation around the capital represented a formidable challenge. When I saw the chaotic, traffic-chocked streets, I opted not to buy a car

and used taxis instead. Usually, I took a *dolmush* that was similar to a jitney, which cost forty cents for my ten-minute ride to work. They only drove along one-way streets, so you had to tell the driver where to stop. To hail a *dolmush* you raised your hand and yelled *mostaqim*, which means straight ahead in Farsi. While traffic lanes existed, most drivers drifted toward the center of the road, which allowed for startlingly quick moves in any direction. These orange and blue vehicles were a major cause of traffic tie-ups, because they constantly darted in and out and slowed down any time they heard a potential passenger call out a destination. Meanwhile, motorists in private cars and trucks also sliced across divider lanes with alacrity, drove up onto sidewalks, headed in the opposite direction down one-way streets, and heedlessly barreled through traffic intersections and red lights.[5] I was not surprised to learn that driver's tests were not required. There were speed limits, but nobody respected them. In addition, many drivers didn't turn on their headlights at night for fear of wearing out the car battery. I saw at least three serious accidents daily. When drivers had car trouble they abandoned their vehicle where it stood; before leaving them, people removed their spare tires and anything else of value because thieves broke into cars so often. Some just chained the trunk closed so thieves could look inside, see there was nothing to steal and conclude there was no reason to smash the lock.

I was amused to discover that most taxi interiors were personalized with ingenious homemade decorations that deserved recognition as folk art. Drivers often placed brightly colored synthetic fur or wool fringed with tassels over their dashboard. One hack-driver had a mini-exhibition of postcards from major cities around the world mounted on the control panel. Another glued international coins to his dashboard. Most common were pictures and statues of Ali, the cousin and son-in-law of Muhammad, the Prophet. I often spotted lanterns, mini boots, trolls, and plastic doll heads with long synthetic hair in colors ranging from silver to chartreuse hanging from rearview mirrors. Steering wheels were regularly wrapped with brightly colored shocking pink and yellow tape. Car doors often featured pictures of popular actors, singers, and athletes. There was a distinctly formal quality to the way drivers treated their car interiors that I particularly appreciated as if they were dressing them up to suit their taste. Once I even saw a stuffed hooded falcon perched menacingly on the ledge behind a rear seat.

Like Tehran's taxi drivers, I worked to furnish my new apartment in a style that suited me best. I was fortunate that my landlady provided me with basic furniture: a French provincial couch and four chairs with dark green velvet upholstery. These were not to my taste, but I liked the color and they were comfortable. Feri's family lent me a bed and two chairs as well as a lamp, cooking utensils, and a battered but still serviceable typewriter.

Feri helped me retrieve my trunks from customs and this time the inspectors did not seem impressed by my association with the Private Secretariat. The process took six hours in a staggering 105-degree heat. Twelve different steps were required to regain possession of two small trunks. To begin, a customs official logged me in; then another good fellow took us to a vast storeroom to locate my trunks; then someone else riffled though all the contents and hit me up for an extra import fee claiming my goods were new even though they were for personal use. Then it was on to the cashier. The settling of my accounts required four different uniformed agents—one to stamp my papers, another to affix a wax seal, another to take my money, and yet another to make sure the previous steps had been accomplished properly.

Slowly but surely I was getting used to my new surroundings and settled into my new life. I did lots of cleaning, purchased the essentials, and unpacked my trunks and suitcases. By the time I got home from work on most days everything good was sold out from nearby neighborhood specialty shops for bread, chicken, or vegetables. So I had to go to the supermarket in my building, where food was packaged for families of ten. Imported consumer items were expensive and not always available—e.g. $4.50 for a pound of Chase and Sanborn coffee; $3 for a can of Geisha tuna; $2 for an 8 oz. can of grapefruit juice. Such prices were excessive for most Iranian families, because an average income in 1976 was seventy dollars a month. To bring the cost of living under control, the monarchy began jailing exploitive shopkeepers who inflated their prices.

Much to my disappointment, Feri told me in July that she had decided to return to the United States for graduate studies at Columbia University and would be departing at the end of summer. This knowledge made me anxious, even though I understood that she felt stifled and wanted to refresh her abilities; however, her exodus would leave me without a colla-borator, buffer, translator and interpreter of what was going on, and, more importantly, a confidante. Feri had to request leave from Dr. Bahadori, but he had not responded to her before I left for Europe. If Feri left Iran, it would mean that I would be working on a vast project alone.

In August, I was very happy to take a break from the heat and stress of living in Tehran to travel to Italy, where I saw friends from the States and taught a class on the history of printmaking. On my way back to Tehran I stopped in Jerusalem, a city I love, for a long weekend. I spent three days roaming the Old City and surrounding sites, but had an upsetting experien-ce at Ben-Gurion International Airport before I departed. When my pas-sport was inspected at the check-in counter, Israeli officials mistook nota-tions in Farsi for Arabic writing and an aggressive interrogation soon began. Why was I in Israel for only three days? Why had I stayed at the American

Woman smoking *galyam*
(*hookah*), Pasqualeh, 1975
Gelatin silver print
© Donna Stein

Bridge at Pasqualeh, 1975
Gelatin silver print
© Donna Stein

Colony Hotel in the Arab sector of Jerusalem? The more than a thousand slides in my suitcase that I had used for teaching in Italy apparently seemed suspicious. Virtually every slide was carefully examined. I also had packages of tortellini and Parmesan cheese in anticipation of Tehran dinner parties in addition to wrapped presents for my Iranian friends. Each package was systematically torn apart. After three frustrating and frightening hours, I was finally permitted to repack and take my leave of the Holy Land.

Back in Tehran in the cooler September weather, I was informed on my first day back at the office that Feri had left to take up her graduate studies in New York. Stores were open from four to eight, which made it possible to go home for lunch, shop and work on my domestic environment. I started to investigate the city alone, looking for things to make my apartment more comfortable. I installed a full-length mirror from floor to ceiling at the end of a hallway with closets on either side, which extended the dimensions of my living space, bringing the outside in. I bought some attractive houseplants and rented a piano. I also began to meet Iranian artists and art collectors and became especially interested in a scholarly collector of vintage Iranian photography who offered to let me study his material, which was so good it deserved to be published.

When the Jewish New Year came around, I decided to go to one of the synagogues recommended by the American Embassy that was located in a school. Orthodox men and women sat on different sides of the same large classroom that served as the sanctuary. Despite the solemnity of the occasion, everything was very casual and some women were dressed in jeans. A few older women wore chadors. Most worshippers didn't have their heads covered and a few held prayer books, although many participated in the service by reciting from memory. Most of the congregation gave me a warm welcome but some asked uncomfortable questions about my ethnic background.

Unlike many other American expatriates who remained cloistered in walled off compounds, I was a curious and adventurous soul and gained a great deal of knowledge by exploring the far corners of Iran with my

Persian Gulf, Bandar
Abbas, 1976
Color slide

Fishermen with nets,
Bandar Abbas, 1976
Color slide

Death Tribute, Hamadan, 1976
Color slide

Feather seller,
Hamadan, 1976
Color slide

Masjid-i-Jumeh (Friday
Mosque), Yazd, 1976
Color slide

all © Donna Stein

American and Iranian friends. After work and on weekends, I would travel to numerous notable towns and sample life in a few of Iran's more than 61,000 villages. I went from Rasht and Nowshahr on the Caspian Sea to Bandar Abbas and Minab on the Persian Gulf. I visited Hamadan, Sanandaj, Isfahan, Yazd, Kerman, Bam, Shiraz and many small villages in between and around the larger cities, toured historic sites, and learned about the Iranian people and their heritage.

Much of the Iranian landscape resembled the southwestern part of the United States yet it was so different. Within a half hour, one was away from the city, sucking the sweet juice of pomegranates. Life in many villages continued as it had in the pre-industrialized world. Traditions were handed down from father to son. The women seemed preoccupied with food, home,

Lion door handle (for men),
Bazaar, Kerman, 1976
Color slide

Tile detail, Masjid-i-Jumeh
(Friday Mosque), Yazd, 1976
Color slide

Dome, Dowlatabad
Gardens, Yazd, 1976
Color slide

View of the Medieval
citadel, Bam, 1976
Color slide

Preparing the clay,
Lalejin (pottery village
near Hamadan), 1976
Color slide

all © Donna Stein

children and weaving rugs. I found the people outside big cities much more curious, communicative, and friendly than the city-dwellers of Tehran. I wrote a friend, "I've begun to travel around and see the real Iran. The official solar Islamic calendar year is 1354 and that's just about where they are—the fourteenth century."[6] Seeing village life first hand helped me understand the tensions between traditional Persian ways and Westernization.

I learned that in many regions of Iran, people spoke Turkish and not Persian. In fact, a villager is considered well educated if he knows both languages. In these small villages, the homes are all made of *pisé*, mud brick, and are at most two stories high. The entry through double wooden doors is ornamented with decorative metal hinges and doorknockers. One door is for men and the other for women, identifiable by the sound and shape of the knockers (no pun intended). Inside, a passageway leads into an open court, around which the rooms of the house are arranged. The extended family lives together—grandparents, their children, and the grown children's children. Regularly, there is no electricity. Due to a lack of running water, villagers use wells or *qanats*, a gently sloping subterranean system that taps into nearby aquifers, of which there are some 60,000 all over Iran. In Kashan, as elsewhere in the Iranian countryside, city planning, architecture, and lifestyle are based upon the requirements of people living in the desert.[7] There, I saw the first examples in Iran of *yakhchāl* (ice

pits), conical dome-shaped structures with underground storage spaces that function as evaporative coolers and icehouses in the summer, using water channeled from a *qanat*.

Back in Tehran, a stream of art dealers, museum directors, film critics and other writers for Western publications were constantly arriving. Among them was Paul Cornwall-Jones (1937–2018), the founder of Petersburg Press and one of the most important graphic publishers in England and the US. I had done a freelance job for him in 1974, so I knew him fairly well. While he was in Tehran, I introduced him to several galleries and spent a lot of time with him because I wanted the Private Secretariat to acquire a number of his print publications. Maurice Tuchman, the senior curator of Modern Art at the Los Angeles County Museum of Art, who had offered me a curatorial position at LACMA shortly after I accepted my job in Iran, arrived in November and stayed in Tehran for six days. He was on my list of potential advisors for the art museum, and I was happy to arrange a meeting with Dr. Bahadori for him. Harry Lunn, the owner of Graphics International in Washington, DC who specialized in the history of photography, and Aldis Browne, a prints and painting dealer in New York, were in Tehran to pursue sales with the Private Secretariat. Two friends from Time-Life Books also arrived from London and Washington, DC. Most of these encounters were business-related, but many of the people who came were truly old friends, whom I had known for at least ten years. Their visits were a very good way of keeping in touch, since all the news media were censored in Iran and the English language newspapers in Tehran were extremely limited and mostly focused on social events. I never imagined that Tehran would be the crossroads of the world, but in the years I was there I received a constant influx of visitors from the United States and Europe, many of whom were hoping to cash in big on the oil boom.

Everyday life in this fevered "gold rush" period of the mid-1970s included entertaining business associates and friends, attending lunches, and going to dinner parties or dancing late into the night. I soon got tired of eating out and started cooking at home. Although I couldn't find a lot of the ingredients I used in the States, especially proteins, I adapted recipes and made do. For several months I hosted three dinner parties a week at my little apartment.

There was a weeklong international film festival around Thanksgiving. I went every day—they were the first films I had seen since August. Layla Diba joined me for Charlie Chaplin's "The Great Dictator" that proved to be one of the highlights of the festival. Seeing the film in the company of an extravagantly appreciative Iranian audience that was greatly moved by the final speech, in which a humble Jewish tailor advocates for democracy, made me begin to question the stability of the Shah's autocratic regime.

At the beginning of January in 1976, I was invited to my first official function attended by Her Majesty. She nodded at me, even though we had not yet been formally introduced. The occasion was an elegant lunch and exhibition opening for the Seyhoun Gallery at Lautrec, a restaurant named after the French artist. Most of the attendees at these events were from the court retinue. Considered the best eatery in town, Lautrec was designed to feature art exhibitions so that whoever had money and no time to go to galleries could support local artists.

In mid-January, I was walking up wet steps inside the entrance to a post office when I slipped and badly twisted my ankle, fracturing and chipping a bone in my right foot. Luckily, two friends were with me and we had a taxi waiting. After bringing the swelling down with ice at home, we went to the Pars American Hospital next door to my apartment, where an American-trained orthopedist treated me. The care was extremely efficient and good. I had to wear a boot cast to my knee. The first week after my fall I didn't go to work, but every day I had at least ten visitors who helped keep my mind off the pain and discomfort. My cast quickly became covered in amusing drawings, including ones by Iranian artists Ardeshir Mohasses and Ghasem Hajizadeh. When I no longer needed crutches, a member of the office support staff drove me to and from work, since taxis were not always reliable. Prior to the injury, I had had great difficulty with certain personalities at the office, but after the accident, my colleagues felt sorry for me, set aside their jealousy and antagonism, and became very solicitous. I could not have predicted that my mishap would bring me such benefits. By the middle of February, my cast came off and I was allowed to wear proper shoes again, even though it would take another month before the swelling and pain subsided.

Through a mutual friend I met a young Qajar prince (from the dynasty that preceded Pahlavi), who had an apartment in my block of flats and was enormously wealthy. In addition to his Tehran apartment, Hassan also owned a fabulous Hollywood-style playboy mansion in Isfahan that was surrounded by a lovely garden with an Olympic size swimming pool. I was curious to see his establishment, so at the end of February I accepted his invitation and flew down to Isfahan for thirty hours to attend what turned out to be an unexpected exercise in debauchery. The first night we went with a group of his relatives, friends, and other houseguests to the Khourosh Hotel for dinner and dancing to a live band. Afterwards we returned to Hassan's house where music played, and everyone chatted and sat around a brazier with a charcoal fire. Some guests smoked opium or hashish, sniffed cocaine and drank alcohol. The party continued throughout the night.

The next evening there was another much larger dinner party hosted by Hassan's cousin Halaku who owned and bred horses. Halaku's large modern house successfully incorporated the beautifully painted wood windows,

doors and partitions, stained glass and mirror work from a 100-year-old Qajar house. The living room was arranged Persian style with all the furniture lining the walls and pillows on the floor for lounging in one section of the room. There were many candelabras, a display of food on a decorative cloth on the floor in the middle of the pillows, and flowers everywhere. Some men were casually dressed in slacks and jackets, but most of the women wore long, elegant dresses with gaudy jewels. Our host had hired Hayedeh, one of Iran's great singers of Persian classical, folk, and popular music, to entertain. For her performance Hayedeh brought a four-piece Persian "orchestra" (violin, drum, mandolin, and santor) to accompany her as well as a comedian. It was a treat to hear her in such an intimate setting. She had a wonderful bell-like voice and the orchestra was excellent. A buffet dinner on two large tables full of different dishes was extravagant and delicious. There was lots of liquor, lots of merriment, but I had to disappear at 11:30 p.m. in order to take a plane back to Tehran for work on Saturday.

While indisputably a product of American culture in the 1960s, I remained naïve about hallucinogens. In Iran I learned that practically anyone with cash could score any kind of hard or soft drug they wanted cheaply. Since so many older members of society were addicted, many dangerous drugs were legally dispensed. The pharmacists who distributed drugs to addicts were given an additional daily quota that they, in turn, sold mostly to young people. Consequently, drugs were easily accessible to high school and college students, perhaps to insure their passivity. Nevertheless, the disturbing result was that many young adults had serious health problems.

I received clearance from my boss to travel back to the United States for three weeks that spring to visit family and friends in Paris, New York, Los Angeles, and London. It was my first trip home in nearly a year. I was very excited to see everyone and touch base with my old life again. Seeing familiar places and beloved people made me realize just how much I missed everyone and how I had steeled myself to the hardships of being on my own so far away. I gave slide shows for friends and family in New York and Los Angeles. I met with Richard Oldenburg, the director of the Museum of Modern Art, and William Rubin, head of the Department of Paintings and Sculpture at MoMA. I used the opportunity to investigate jobs in Paris, London, and New York. This trip clarified for me that I would not stay in Iran a moment longer than my contract required.

[1] Letter to E. Grand, July 6, 1975.
[2] Ibid.
[3] Letter to parents, July 25, 1975.
[4] Letter to R. Carsch, July 18, 1975.
[5] Andrew Scott Cooper, *The Fall of Hea-* *ven: The Pahlavis and the Final Days of* *Imperial Iran* (New York: Henry Holt and Company, 2016), 274.
[6] Letter to A. Fisher, September 21, 1975.
[7] Letter to D. Andersen, December 9, 1975.

7. INSIDE THE PRIVATE SECRETARIAT OF HER IMPERIAL MAJESTY

As the first foreigner to work at the Private Secretariat of Her Imperial Majesty, the Shahbanou of Iran, I was breaking new ground. I was simultaneously an insider and an outsider, both participant and witness. I quickly learned there was no administrative infrastructure to support my efforts and that I would be held responsible for precisely nothing and everything. The Empress's Special Bureau was located in a drab three-story building and employed a staff of fifty workers to manage every aspect of Her Majesty's daily existence. She received an average of eighty thousand letters per month from her adoring subjects, and many needed a response that was ordinarily very slow in coming.[1] The official workweek was Saturday through Thursday from 8:30 in the morning until 1:30 in the afternoon with a half hour break for morning coffee. Friday was a welcome day of rest.

I began working the day after I arrived, but those earliest weeks were not particularly productive. I wrote a few reports and arranged my desk in a room with one small window containing three desks and dominated by a large photographic portrait of the Shah and his glamorous young wife. I soon learned that my concept of an efficient organization was absent from the vocabulary of my Iranian colleagues. Everything had to be requisitioned, be it a box of Kleenex tissues or a steel file cabinet. I filched a spare gooseneck lamp and plain metal wastebasket from an as yet unoccupied workspace. Two weeks passed and I still didn't have a pencil or pad of paper to my name, to say nothing of a typewriter. His Excellency Dr. Bahadori was virtually always occupied. Everyone else moved in slow motion. With three individuals in the same small room speaking several languages simultaneously, my new office was not conducive to serious study.

I quickly learned that the culture of work in Iran was very different from my experience at the coldly efficient Museum of Modern Art. There were no staff meetings—decision-making was hierarchical and not necessarily well reasoned. There was little information sharing because knowledge is power and one's authority was seldom shared. To my Western eyes many staff members seemed irredeemably lazy. These risk-adverse workers didn't want to make any decisions because they knew they would

be blamed when things went south as they always do. I got impatient and, like the Little Red Hen,[2] I ended up unpacking thirty-seven crates of art books all by myself. Under the best circumstances, Dr. Bahadori was very remote and since I was new to the staff and was a foreign woman who had rejected his advances, he couldn't look me in the eye. The first time we met, Dr. Bahadori asked me why I had agreed to come to Iran. I told him it presented a unique personal and professional challenge and at that point in my life I was eager for a change. I'm sure he assumed that I would exploit any association with Her Majesty and use her to promote my advancement. Maybe that's why he concluded our first meeting on site by coldly informing me that he was the only person authorized to sign letters that were printed on the Secretariat's lavishly embossed cream-colored stationery.

Dr. Bahadori's father passed away shortly after I arrived and he wasn't at the office for a week. In Iran and all Moslem countries, the death of a family member is followed by more than a month of intensive mourning by family, relatives, friends, and colleagues. On the fortieth day, the mourning ceremonies conclude with a final memorial rite.[3] I attended the memorial service at a local mosque with a group from the Secretariat and was very surprised that people smoked and socialized during the service, making it seem more like a party than a funeral. Nevertheless, the Moslem version of an Irish wake seemed to be an excellent way for both family and community to celebrate life.[4]

On my second week in Tehran, Jim Elliott, director of the Wadsworth Atheneum Museum of Art in Hartford, arrived to interview for the position of director of the Tehran museum. Mr. Elliot was of particular interest to the Iranians because of his expertise in modern art and his innovative approach to the science of museology. I had known Jim Elliott when he was a progressive curator at the Los Angeles County Museum of Art. I did not participate in his interviews with Dr. Bahadori, but he later confided that his encounter with His Excellency had been problematic, which made me doubt that he would ever take a job in Tehran.

I saw Dr. Bahadori four times during my first five weeks in Tehran and spoke with him once on the phone. He never acknowledged any of the reports I gave him. Before I left in July, I submitted a twenty-five-page report and a six-month work plan and was anxious to have feedback. The September weather was much more temperate and I began taking Farsi lessons four hours a week, determined to make rapid progress in view of Feri's absence. Contrary to what I was led to believe, few people at work spoke English. Even Dr. Bahadori, who knew English well, sometimes missed the nuances or made assumptions, misinterpreting what I really said. I was also motivated to learn Farsi because I wanted to know what people were

saying about me, especially when they thought I wouldn't understand. By the end of October, I had completed thirty hours of private Farsi classes, but since Dr. Bahadori didn't consider Farsi a prerequisite to my job he refused to pay for my language lessons.

Farsi is an Indo-European language. Verbal communications are overly polite, lack gender distinctions, and provide a means to differentiate power relationships and class distinctions. There are many ways of saying please and thank you, for example, which people often sequence by reciting one phrase after another. Persians make a lot of linguistic jokes that involve changing the sound of one letter in a word, thereby radically changing the meaning. They also make jokes about people from different regions of the country. The jokes about Rasht, for example, are all about the infidelity of the women and the stupidity of the men. For instance: A man doesn't trust his wife and decides to surprise her in the afternoon. When he arrives home no one is in the main living rooms and so he goes into the bedroom, where he finds his wife in bed. He interrogates her and she says she is tired and resting. He doesn't believe her and immediately starts to look around the bedroom for evidence. Finally, he opens the closet door and sees a man standing there naked. "What are you doing here?" asks the husband. "Waiting for the bus," the man says. The husband closes the door. Another ending is: The husband opens the door and sees a soldier standing there and says, "We've had men of higher rank than you hiding in this closet."

When it came to manners, certain Farsi modes of communication suggested play-acting. These elaborate ceremonial compliments or insincere courtesies are known as *ta'arof*. One begins by saying "Hello how are you?" but after a conversation that is all sweetness and civility, a person may say under his or her breath, "I hate him," or "that bitch is crazy" while walking away. Such language represented a social pretense because with some Iranian practitioners you never knew where you stood. These social conventions were strongly upheld. If a woman walked down the street holding a man's hand or they happened to sneak a kiss, it could cause a minor scandal, but when it came to foreigners, any kind of indiscretion could be readily forgiven.

Less tolerant was SAVAK, Iran's notorious security and intelligence service similar to the FBI. Members of SAVAK had a prominent presence in society and the Private Secretariat's director of human resources was rumored to be an agent. Everyone was uncommonly careful about what they said and to whom they spoke. I am a naturally gregarious person and this constraint was a constant weight on my shoulders. Vigilance would quickly turn into fear but everyone joked about it quipping, "Wherever three Iranians gather, one is from SAVAK."[5]

Once established in my Tehran office, I worked directly with Dr. Bahadori on acquisitions of art from the Western world and with Firouz Shirvanloo, regarding contemporary Iranian purchases. Shirvanloo and I often visited galleries and artist studios together and he would encourage me to select works for the National Collection. Dr. Bahadori was not educated in art history, and I considered it my responsibility and challenge to awaken his interest in what I was trying to achieve. Slowly but surely a solid working relationship was established. He would forward to me all the auction catalogues, letters, and materials about works purchased by or offered to the Private Secretariat for the collection, and I would write an assessment evaluating the artwork regarding its conformance with our acquisition policy. We met as often as his schedule permitted to go over each item that was offered. At every meeting we spoke about quality, value, and art history. I carefully explained how each of the artworks I was recommending fit the approach he had approved. In a summary report I submitted in March 1976 entitled "Research and Report on International Works Offered for Sale," I indicated that I had written eighty-five reports in the past six months. Meanwhile, I was also presenting slide shows of graphic works from various publishers in Los Angeles, New York, and London justifying my recommended acquisitions for a growing print collection.

Over time I learned that the museum project had been the Empress's idea. Her concept occurred long before globalization and any notions of cultural dialogue. Her aim was to enliven the local scene while simultaneously placing Iran squarely on the international cultural map.[6] In my 1990 interview, Farah Pahlavi described the origin of the museum project:

> As for the museums of modern art, many Iranian painters [including Iran Darroudi and Kamran Diba][7] came to me and complained that they needed a place to exhibit their work and wanted to see paintings from other countries in order to learn from them. Eventually, we decided to establish a museum of Western art for our people to see contemporary developments outside of Iran. After all, the Metropolitan Museum of Art and so many other institutions do exhibit Near Eastern art. We envisioned the museum as a lively center, a place where people would attend lectures, hear music, and watch films. The museum's placement in a park in Tehran helped to encourage visitors who happened to be walking nearby . . . I don't recall how we decided to create a Museum of Western and Iranian Contemporary Art in Shiraz . . . except that Shiraz was a developing city and becoming industrialized. We chose Alvar Aalto [1898–1976] as the architect, because he was such a famous international figure. We thought his building would be a work of art. He came to Iran and loved Shiraz where he chose

a special site for the museum [a small hill on the Pahlavi University campus overlooking the city], which unfortunately never got past the planning stage.[8]

Like the Empress, I believe the arts are unifying. They bring people together and open minds. The arts can move you, inspire you, inform you, make you think and see things from different points of view. Art can be a tool for social change because of its ability to stimulate conversation. A central question was if a clear and compelling vision could shape a better tomorrow. But the Empress knew that building a national collection required more than money. The mission would take challenging and visionary works of art that were charged with meaning and could be used to point the way toward public enlightenment.

Because of my formative experience at the Museum of Modern Art in New York, I considered it essential to take risks, to be a bold and uncompromising pioneer. I recognized any museum of modern art's primary concern must address current work, which is best understood as the most recent mutation of an organic and continuing tradition. In this light, an outstanding historical collection with a broad international base would become a measuring rod by which Iranians could gauge the artistic achievements of their own day.

I believed that even an unusually well endowed new museum could not compete with institutions that had been acquiring works for many years, maybe centuries. What I tried to do was create a representative history—via all media—of the major artists, art styles, and techniques that could educate people in the broadest possible sense with ideas, theories, and philosophy in order to advance the development of a more contemporary perspective. An emerging nation must be nationalistic so whatever was being presented had to refer to their particular heritage. With Iran, this was easy since their culture was so rich. As *Los Angeles Times* art critic Christopher Knight recently observed, "Art museums have two audiences—one general, who may or may not have a genuine interest; the other a dedicated art audience, who range from passionate enthusiasts to committed professionals . . . the trick is to serve both publics at once."[9] In the collections and exhibitions I organized, I always tried to provide a context from which an under-educated audience could learn about Western art within an international framework.[10]

Shaping such an international collection required delicate diplomacy, because royalty from many countries and every major art dealer in the world were vying to sell their wares to Iran. Among the most important goals was the formation of a well-chosen permanent collection of moderate size that surveyed the history of modern Western art, with important

artists and their masterpieces serving as benchmarks and making explicit the evolution of art and ideas from Impressionism to the present. Great works of art gathered together would thus initiate a conversation that would evolve and unfold over time. The collection was to establish a standard of quality against which important temporary exhibitions would be evaluated and prevailing art movements considered. The collection would contain all manner of works—paintings, sculptures, tapestries, mixed media, drawings, graphics, illustrated books, and photographs—to make the evolution of art and ideas explicit. Whenever possible, singular examples of an artist's style would be selected. Certain artists turned to the graphic media naturally, with as much facility as they did to paintings on canvas, and certain graphic works must surely be ranked aesthetically with the best of their output. Thus, where unique examples of paintings or sculptures of superior quality were not on the market, representation of an iconic artist was first acquired via drawings, original graphics, and photographs.

If rarity and condition establish an object's worth, the criteria for art selection were rooted in my understanding of quality and value. Quality demands connoisseurship and requires discrimination of many factors, including originality and intelligence, inspiration of the artist, compositional resolution and perfection, iconographic intention and technical skill. Value depends upon rarity and condition. In an effort to bring the high standards of art history to a general public, these ideals were meant to help educate the populace and provide a context from which to interpret contemporary Iran's contributions to world culture. As shorthand for distinguishing the most worthy artists and objects to acquire and a way to broadly identify what I was seeking to my superiors, I developed a rating system of artists based upon my personal knowledge, gut instinct, as well as scholarly verification. I created a list of artists beginning with Impressionists and placed them in three categories: marquee names essential to the collection, requiring in-depth coverage across media; artists whose achievements could be summarized by one fine painting or sculpture; and obscure minor artists, who surely did illuminate the art of their time but would be only included in the works on paper collection. I believed then (as I do now) that, whenever possible, it was practical to collect in depth in order to shed light on an artist's vocabulary and range of concerns, especially since some of them do not work in terms of single images. On the other hand, the work of some artists does not justify a comprehensive treatment, but they should still be acquired for their minor achievements to show the full spectrum of art in our time.

Building an important collection was daunting and dependent on the vagaries of the art market. With even reasonably unlimited funds available,

it would undoubtedly prove almost impossible to acquire major paintings by some artists simply due to their rarity; so older works had to be purchased as they became available. In an atmosphere of secrecy and suspicion, I chose artworks that were eventually purchased from local galleries, international auctions, international galleries, graphic workshops, artist's studios and estates. Much later I learned that the monies for art purchases were primarily allotted from the government's oil revenues through the National Iranian Oil Company.[11]

After the initial buying spree in New York City in May 1975, all further acquisitions I proposed were made from the Tehran office. Consequently, I had to rely on what became available on the auction market as well as what was submitted via transparency through galleries, collectors, artist's studios, graphic workshops, etc. Certain dealers were more reliable, offered better and fairer prices, and presented the highest quality material for possible acquisitions. Therefore, they were more consistently frequented. Even though I was in Tehran and could no longer inspect artworks offered from abroad up close, my role as an arbiter of taste discouraged the acquisition of poor-quality material through every imaginable source.

Few understood my role in the Private Secretariat and mean-spirited people around me doubted my integrity and assumed that I was taking bribes, which was standard business practice in Iran. Bribery was not a new problem in the art world, as Russell Lynes reminds us in *The Tastemakers: The Shaping of American Popular Taste*: "When Roger Fry, the British art critic and painter, came to America at J. P. Morgan's bidding to be Curator of European Paintings at the Metropolitan Museum . . . one of his most disagreeable problems was turning aside the constant efforts of dealers to bribe him to buy their masterpieces."[12]

As my role was advisory, I never had the final say or knew the final prices of objects acquired, as I was not involved in the bargaining process that was part of every purchase. For works acquired in New York City during May 1975, I knew the asking prices and had already requested museum discounts, however I did not know what price was finally negotiated, as I was not present, except in the case of the Witkin Gallery.[13] In Iran, I eventually learned the price of items acquired through auctions and in some cases from sources such as artist's studios and print workshops. Otherwise, I was not informed of the final purchase prices. My job was to guide the selection process and establish a high standard of quality.

All of Feri's unfinished work was dumped in my lap and I would have gladly bribed her to return to Iran. We kept in close touch via the mail: "I am afraid I will not be able to help much because my academic schedule is incredibly heavy,"[14] she confessed. Feri couldn't understand why the woman she had recommended to be my assistant had not been hired.[15] It

was time for a showdown with Dr. Bahadori and I hand-delivered an in-temperate memo for his eyes-only that boldly summarized my frustration:

> *Dear Dr. Bahadori,*
>
> *It is now two weeks that I have not had any work of consequence to do (and it is not a new state of affairs). I am forced every day into creating activities for myself. Since I am unable to see you, except on rare occasions, my hands are tied in relation to execution and completion of the more important work I should be doing with regard to the modern art program.*
>
> *As far as I am concerned, I have been little more than an accomplished secretary for the three months that I have been here, writing and typing letters, setting up a filing system and keeping that up-to-date, organizing 37 cartons of books in the library, simply because I can read English.*
>
> *According to the outline I made of my responsibilities in my report of July 30, 1975 I have not accomplished any of the work I had hoped or expected. In addition, the work I have been asked to do bears little relation to what I was originally contracted. I have four more months on my contract and if the pattern continues, these seven months in Tehran will have been an extremely boring, unrewarding period for me. As of today, my salary check is also two weeks in arrears.*
>
> *Sincerely, Donna*[16]

I found it infuriating that I was often paid a week to three weeks late. It's not that I didn't have money to live on—it was the evident disrespect. Among the problems was that the Secretariat had not deducted taxes for the first seven months of my contract. They should have taken out 2,600 *toman* (or $375) per month. Even though it was to my benefit, for five weeks they withheld my salary as they searched the tax codes until they found a legal rationalization for taxing me only $100 monthly. In December, they pulled another bureaucratic stunt and deducted $200 to punish me for being late to work and claiming I didn't fulfill my obligation of one hundred sixty hours per month.

Dr. Bahadori and I patched up our feud and began to confer on a more regular basis. I threw myself into work with renewed energy and things began to go more smoothly. Best of all, His Excellency gave me the opportunity to make decisions about what works to acquire. Apparently, he realized I had a lonely and difficult job. Without Feri, I had no one with whom to exchange ideas. In early November, he gave me permission to recruit the young woman Feri had recommended and I was hopeful that I would soon have a reliable and sympathetic assistant. I also identified a

capable American librarian whose husband worked at the US Embassy who was hired by the Secretariat to catalogue our burgeoning art library. She eventually worked with an Iranian-trained librarian, which accelerated the process, as I had selected thousands of books and exhibition catalogues on the history, theory, and philosophy of art from booksellers and publishers when I was working from the United States that were ultimately purchased.

After gaining Dr. Bahadori's trust, I soon became a liaison between international art dealers, architects, designers, curators, and filmmakers seeking the engagement of the Empress in their creative projects. William Lieberman, my former boss at the Museum of Modern Art, gave my contact information to his friend Wolfgang Fischer of Fischer Fine Art Limited in London who was frustrated by his previous experience navigating the royal bureaucracy. From a group of works he had offered to the Secretariat in 1975, five had been reserved: Klee's *Astrale Automaten*, Picasso's *Bust of a Woman After Cranach* and *Arlequin – Le Fou*; Lindner's *The Street* and Feininger's *Zirchow II*. Dr. Bahadori had not been in touch and he asked for my intervention.[17] I contacted Mr. Fischer explaining that I was aware of the previous correspondence and that Dr. Babadori was often out of the country and unavailable. I told him that I looked forward to meeting him on my next trip to London.[18] He wrote immediately to say my letter was a great help, "as one feels quite at a loss in dealing with Tehran."[19] He also informed me that since the reserve period had expired the Lyonel Feininger masterpiece he had offered had been sent to another client on approval and was no longer available.

In August 1975, Fischer wrote again offering to make the necessary contacts for Her Majesty to visit the studio of Henry Moore, with whom his gallery had a special relationship. He also proposed an exhibition of the artist's extremely rich graphic oeuvre in Tehran.[20] He wrote again the following day proposing several other exhibitions over a period of two years using his good connections with other artists, foundations, and estates: an Emil Nolde exhibition of paintings, watercolors, and graphics; an exhibition of Egon Schiele, Gustav Klimt, and the Art Nouveau with the help of the Austrian government; and a Paul Klee exhibit from the collection of the Klee family who still owned three hundred paintings and watercolors.[21] He sent numerous books and exhibition catalogues as supporting material, but to the best of my knowledge nothing ever came of his enticing proposals, although the Empress's time with Henry Moore proved to be very productive indeed.

Nearly eight months later, just three days into the new administration of British Prime Minister James Callaghan, the Empress and her retinue, including Dr. Bahadori, met Henry Moore, who was one of the other invited guests to a state dinner at no. 10 Downing Street. As a result, the

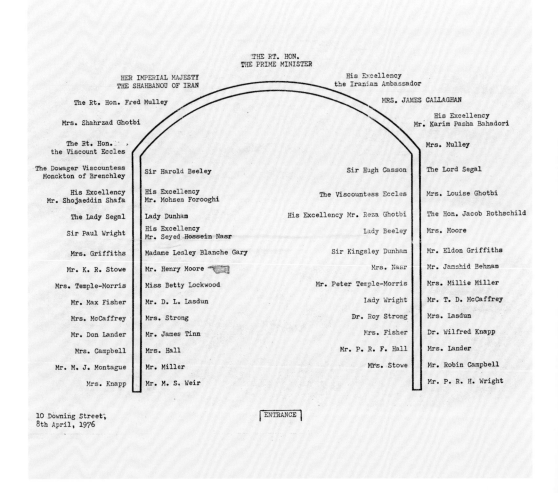

THE RT. HON.
THE PRIME MINISTER

HER IMPERIAL MAJESTY
THE SHAHBANOU OF IRAN

His Excellency
the Iranian Ambassador

The Rt. Hon. Fred Mulley

MRS. JAMES CALLAGHAN

Mrs. Shahrzad Ghotbi

His Excellency
Mr. Karim Pasha Bahadori

The Rt. Hon.
the Viscount Eccles

Mrs. Mulley

The Dowager Viscountess
Monckton of Brenchley

Sir Harold Beeley

Sir Hugh Casson

The Lord Segal

His Excellency
Mr. Shojaeddin Shafa

His Excellency
Mr. Mohsen Forooghi

The Viscountess Eccles

Mrs. Louise Ghotbi

The Lady Segal

Lady Dunham

His Excellency Mr. Reza Ghotbi

The Hon. Jacob Rothschild

Sir Paul Wright

His Excellency
Mr. Seyed Hossein Nasr

Lady Beeley

Mrs. Moore

Mrs. Griffiths

Madame Lesley Blanche Gary

Sir Kingsley Dunham

Mr. Eldon Griffiths

Mr. K. R. Stowe

Mr. Henry Moore

Mrs. Nasr

Mr. Jamshid Behnam

Mrs. Temple-Morris

Miss Betty Lockwood

Mr. Peter Temple-Morris

Mrs. Millie Miller

Mr. Max Fisher

Mr. D. L. Lasdun

Lady Wright

Mr. T. D. McCaffrey

Mrs. McCaffrey

Mrs. Strong

Dr. Roy Strong

Mrs. Lasdun

Mr. Don Lander

Mr. James Tinn

Mrs. Fisher

Dr. Wilfred Knapp

Mrs. Campbell

Mrs. Hall

Mr. P. R. F. Hall

Mrs. Lander

Mr. M. J. Montague

Mr. Miller

Mrs. Stowe

Mr. Robin Campbell

Mrs. Knapp

Mr. M. S. Weir

Mr. P. R. H. Wright

10 Downing Street,
8th April, 1976

ENTRANCE

Seating plan for State
dinner at 10 Downing Street,
London, April 8, 1976
Henry Moore Foundation

Shahbanou was invited to Hoglands, Moore's home, studio, and gardens in rural Perry Green, Hertfordshire, some twenty-five miles out of London. To test the Empress's connoisseurship, Moore showed her a small wood relief and asked if she knew who the artist was. "He was so impressed I knew it was a work by Miró," the Empress told *The Art Newspaper* in 2016.[22] In a phone conversation in 2015, when Her Majesty recounted this delightful anecdote to me, I suggested that she use such stories in her interviews, which she has subsequently done.

A few weeks after her visit to Moore's estate, the Secretariat received a list and photographs of at least ten works that the artist made available for Iran. I was asked to justify my selections from the photographs and accompanying documentation as acquisitions for the National Collection. By the end of the year, four bronze sculptures were acquired: *Two-Piece Reclining Figure: Arched Leg* (1969–70, p. 116)[23] and *Three-Piece Reclining Figure: Draped* (1975, p. 116), which entered the National Collection, as

Interior of Henry Moore's sitting room with Joan Miró's wood relief, published in *Henry Moore Intime*, exh. cat. (Paris: Éditions du Regard/Didier Imbert Fine Arts, 1992)

well as two smaller bronzes, *Two-Piece Reclining Figure: Holes* (1975) and *Reclining Figure Curved: Smooth* (1976), which instead did not become part of it. Although Moore always worked first in small scale, he has commented: "Everything I do is intended to be big, and while I'm working on the models, for me they are life size."[24] The two monumental sculptures of reclining figures were installed in time for the Tehran Museum of Contemporary Art's grand opening and have been on constant view in the garden of the museum for more than forty years, even though a bullet somewhere along the way apparently damaged one. *Working Model for Oval with Points* (1968–69), currently in the National Collection, was purchased in 1973 through the British Council for £13,332 as it had been shown in Iran as part of an overseas exhibition, *Henry Moore: An Exhibition of Sculpture and Drawings 1928–1969* that traveled to Istanbul, Turkey as well as to Isfahan and Shiraz.[25]

By fall 1975 several distinguished works were identified and purchased in 1976 from the Galerie Beyeler in Basel. The National Collection already

LIST OF SCULPTURES AVAILABLE. MAY 1976.

LARGE

1. THREE PIECE RECLINING FIGURE: DRAPED $275,000
2. SHEEP PIECE $300,000
3. RECLINING FIGURE: ARCH LEG $200,000

MEDIUM

1. HELMET HEAD No.6. $55,000
2. TWO PIECE RECLINING FIGURE: ARMLESS $45,000

SMALL

a. RECLINING FIGURE: SINGLE LEG $7,000
2. RECLINING FIGURE: CURVED $7,500

CARVING

1. POINTS (Rosa Aurora) $125,000

IRAN.

included two major sculptures and a typical portrait painting by Giacometti, so when the artist's *Standing Woman I* (1960, p. 165) and *Walking Man I* (1956–60, p. 117) were offered it seemed like an obvious choice to add these two extraordinary bronze sculptures to the collection. *Standing Woman I*,[26] a classic Giacometti pose—erect, frontal orientation staring straight ahead, arms tightly bordering an emaciated body, reduced head—embodies the sacred calm employed by ancient Greek, Egyptian, Oceanic, and African artists.[27] No matter how stylized these tall figures became, they somehow remain strikingly representational. In 2010, I discovered that another cast of *Walking Man I*, a 6-foot-tall bronze, was sold at Sotheby's in London for an astounding $104 million, breaking the world record price for an artwork sold at auction.[28] These two sculptures were created at the high point of Giacometti's mature period and represent the pinnacle of his experimentation with the human form. For more than thirty years, *Standing Woman I* and *Walking Man* were installed outside in the courtyard of the museum.

Recently, because of damage from acid rain, causing corrosion and other adverse affects to the bronze surface, they have been moved inside.[29]

On the same occasion, *The Painter and His Model* (1927, p. 120), one of Picasso's largest and most arresting canvases since *Les Demoiselles d'Avignon*, was also purchased from Beyeler. The painting had a distinguished provenance, including the collection of the artist's original biographer, Christian Zervos. Influenced by the Surrealist language, this composition is essential in a lifelong series devoted to the artist's studio. The interplay of two figures in extreme transformation outlined in black lines on a spot-lit field of abstract forms implies a symbolic representation of the act of creation. Tehran lent this painting to the Kunsthaus Zurich in 2010 for a reconstruction of the first Picasso retrospective held there in 1932, which established this modernist giant as one of the most radical artists of the twentieth century.

During the round of meetings in New York, it was recommended that a preliminary proposal be submitted by the Private Secretariat to indicate some areas in which the Museum of Modern Art and the International Council particularly could assist Iran in the development of its modern art program. In October we finally wrote MoMA requesting valuable assistance in training personnel; help with library expansion and organization as there were few trained art librarians in Iran; and traveling exhibitions that would clarify the past and reveal traditions, contemporary work to illustrate experimental directions, and educational explorations of a medium. We proposed establishing an exchange program to bring experienced museum professionals to Iran on a rotating basis, as well as sending bi-lingual Iranians to New York for training.

In fall 1975, Dr. Bahadori agreed to purchase *Les Maisons de Knokke, Belgique* (1894, p. 119), an oil on canvas by Camille Pissarro in excellent condition offered by Aldis Browne. Among other works we acquired from Browne were four print variants of *The Plough* (1901) by Pissarro: a proof in black ink with a pink-tone plate; an early working color proof from the first of two states bearing printed color annotations; the final editioned lithograph; and a posthumous print. I considered the four images very instructive about the artist and his working method. We also agreed to buy Rouault's *Clown* (1923, p. 121), an oil painting on paper. I had hoped to also add Henri Matisse's only landscape lithograph, *Harbor at Collioure* (1907), which in its condensation suggested a Far Eastern brush and ink drawing, but I couldn't convince Dr. Bahadori of its rarity and importance.

Pissarro is considered the "father of Impressionism." Among his cohort, he was the most technically experimental in his practice and inspired and mentored many younger artists, including Gauguin, Georges Seurat, and Paul Cézanne. From June through September 1894 he visited

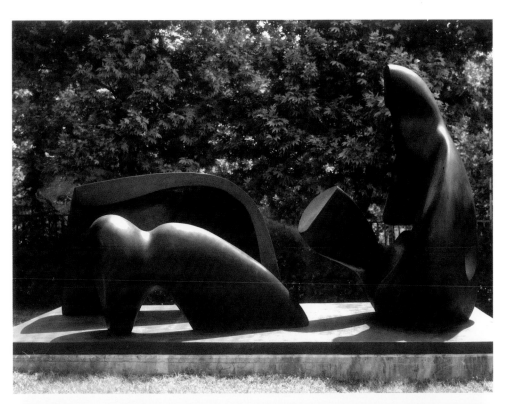

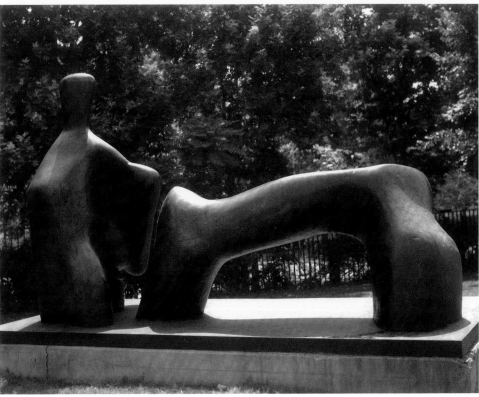

116/ 7. Inside the Private Secretariat of Her Imperial Majesty

Henry Moore, *Three-Piece Reclining Figure: Draped*, 1975
Bronze, 265 cm wide

Henry Moore, *Two-Piece Reclining Figure: Arched Leg*, 1969–70
Bronze, 254 cm wide

Alberto Giacometti, *Walking Man I*, 1956–60
Bronze, 182.5 cm high

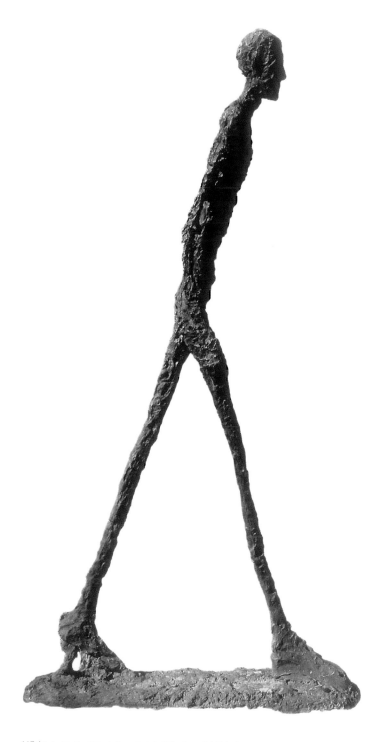

Henri de Toulouse-Lautrec,
The Jockey, 1899
Color lithograph,
51.6 x 36.2 cm

Brussels and Bruges and lived in the northern Belgium coastal town of Knocke-sur-Mer, where he painted fourteen works. Because of Pissarro's own anarchistic beliefs and the political tensions in France following the assassination of the French president, where some of the artist's friends and colleagues were being investigated and imprisoned, Pissarro chose this short period of self-imposed political exile in Belgium. The landscape *Les Maisons de Knocke* exhibits solid drawing and a more subtle and refined color scheme that built on his earlier style, combining the mechanical character of Neo-Impressionism with the freshness and spontaneity of Impressionism.

I corresponded regularly with Robert Light, a prints and drawings dealer I admired. In October, Dr. Bahadori agreed to purchase a pristine Munch *Self-portrait* (1895, p. 123) and Toulouse-Lautrec's *The Jockey* (1899). However, I was very disappointed that he decided against buying Picasso's symbolic intaglio print, *Minotauromachy* (1935), the artist's most ambitious etching to date with motifs that anticipate *Guernica*. In the middle of negotiations Light wrote me, "Occasionally, an important print or drawing turns up that I think you might be interested in, but so far, these items have turned up in a frame of reference that makes it exceedingly

Camille Pissarro,
Les Maisons de Knokke,
Belgique, 1894
Oil on canvas, 65.5 x 81 cm

difficult to adapt such acquisitions, either through purchase or consign-
ment on my part, to the pace at which the Royal Secretariat seems to
consider such potential acquisitions. Perhaps the only thing for you to do
is to let me know from time to time whether the procedure for considering
purchases and coming to decisions is becoming a bit simpler and more
expeditious."[30] In December I learned that Light had acquired a group of
important woodcuts and lithographs by the German Expressionist painter
Ernst Ludwig Kirchner, which interested me very much.[31] Although two of
the Kirchner prints I was enthusiastic about were sold, *Fünf Kokotten* and
Frau im Zimmer, six months later Dr. Bahadori agreed to buy Kirchner's
early lithograph *Erna, Reclining Nude Seen from the Back (Portrait of the
Artist's Wife)* (1911) for $8,000.

Light wrote to let me know he had neither been paid nor received
acknowledgment of the safe receipt of the prints: "According to the terms
of the agreement I received from Mr. B[ahadori], I was to receive payment
upon receipt of the prints, and according to the shipper, they were received
in Tehran in November." He went on to say, "The newspapers are full of
stories recently concerning the fact that the income in Iran is markedly
lower than what had been expected, and curtailments have had to be made

Pablo Picasso, *The Painter and His Model*, 1927
Oil on canvas, 214 x 200 cm

Georges Rouault, *Clown*, 1923
Oil on paper, 37 x 25.5 cm

Edgar Degas, *Coming
from the Dressing
Rooms*, 1880–83
Monotype, 21 x 16 cm

Edvard Munch,
Self-portrait, 1895
Lithograph, 46 x 32.2 cm

EDVARD MUNCH 1895

Marcel Duchamp, *Study for
The Large Glass*, c. 1915
Pen, ink, and crayon
drawing, 13.5 x 21 cm

in all sectors of the economy. I assume this applies to the acquisition of
art, as well as everything else, but I hope it does not affect commitments
already made. I am sure you realize that, though the amount due would
be just a drop in the bucket for a firm such as Wildenstein, it means con-
siderably more to me. Can you suggest any steps I might take at this point
to expedite payment—another letter to B, a telephone call to him, a letter
to someone else instead of Mr. B. Or, is it better to do nothing and simply
wait?"[32] Two days later, he wrote again, "Wouldn't you know it—after be-
ing patient for so long and then writing you two days ago, payment in full
arrived this morning. I'm sorry to have bothered you about this and hope
you haven't gone to any trouble about it."[33] So the wheels turned slowly,
but they did turn.

Despite his frustration, Light also offered a superb Klee watercol-
or of unusually fine quality from the Bürgi family collection, which was
eventually purchased at my suggestion by collector friends in Iran, as well
as an extremely rare and fresh set of Picasso's *Suite Vollard*, one of the
early unsigned sets for which he was asking about $100,000 plus a ten
percent commission. "As I said earlier," he wrote, "I know you have shied
away from buying sets as such, but if you were to go out and try to buy
the most important ten or twelve prints from this set, you would end up
paying almost the same amount of money as you would have to pay for the
entire ninety-six plates, and consequently this is why I say it seems like an
unusually good opportunity."[34] By the time Dr. Bahadori decided that this

offer might be worthwhile, Picasso's famous print series had been sold to Indiana University Art Museum.

In early December, as a follow up to his discussion with Dr. Bahadori in November, Maurice Tuchman proposed a special project entitled *American Art since 1945* that he wanted to curate. Tuchman envisioned an exhibition of approximately one hundred and fifty works of art—one hundred and twenty paintings and thirty sculptures by about forty American artists covering a period of three decades. He projected that it would become the first authoritative account of the major contribution made by American artists to world art history, indicating that no such exhibitions had yet been presented or were being planned. Works would have been secured from private and public collections in New York, Philadelphia, Washington, Baltimore, Chicago, Des Moines, Minneapolis, Dallas/Fort Worth, Houston, San Francisco, and Los Angeles, as well as certain major works borrowed from collections in Milan and Cologne. An important book would accompany this exhibition and be distributed by a prestigious international publisher. Tuchman felt certain that this exhibit would attract scores of international artists, writers, journalists, museum officials, and art collectors to Iran.[35] To the best of my knowledge, this breathtaking proposal by a legendary curator never went anywhere.

Because Marcel Duchamp's *The Bride Stripped Bare by Her Bachelors, Even (The Large Glass)* (1915–23) in the collection of the Philadelphia Museum of Art is a landmark in the history of twentieth-century art, I was very happy we succeeded in buying his *Study for The Large Glass* (c. 1915),[36] which came on the market in December. Executed in Rouen, France, the small colored crayon and pen and ink drawing was originally included in Surrealist artist and publisher Georges Hugnet's deluxe copy of *The Green Box (The Bride Stripped Bare by Her Bachelors, Even)*, published in Paris in 1934.[37] *The Large Glass*, a mixed media work that uses oil paint, lead foil, wire, and dust suspended between two glass panels to depict a visual story of desire and eroticism, was influenced by photography and by chance, and had few if any precedents in art. Duchamp investigated traditional perspective and the idea of a fourth dimension, but prioritized the conceptual over the visual. *The Large Glass* was unquestionably a crucial milestone for modern and contemporary artists."[38]

About the same time we also purchased Henri de Toulouse-Lautrec's *Fille à l'accroche-cœur*,[39] painted on board in 1889. This frontal portrait depicts one of the dancers at the Moulin de la Galette, the famous windmill and adjacent dancehall at the top of Montmartre with a commanding view of Paris. Lautrec made several drawings and paintings of this urban spectacle between 1886 and 1892. Many other writers and artists, including Renoir, Pissarro, and Van Gogh were habitués and also immortalized the

site in their art. The Secretariat had already acquired a pristine impression of one of Lautrec's most important color lithographs, *The Clowness Cha-U-Kao at the Moulin Rouge* (1897, p. 63), and I was determined to show additional facets of the artist's practice and oeuvre.

I decided to bring up the renewal of my contract and start negotiations as my current letter of agreement was ending in mid-February. I knew that Dr. Bahadori wanted me to stay in Tehran, as did colleagues I had been working with at the other museums and at the Secretariat. By the end of the month, I still didn't know what I was going to do so I made a point of saying that I was dissatisfied with significant aspects of my work and asked for a substantial raise. "Unfortunately," I wrote my parents, "I don't think that I will get any more responsibility than I already have, and I also don't think I will be able to travel to do my work. It is frustrating and I don't really know what I want to do about staying. I am waiting to see what their final proposal is financially, because the first offer was a ten percent salary hike, which is definitely not enough."[40] In response to my gambit, the Secretariat's personnel director (who was a member of SAVAK) coldly informed me that if I didn't renew my present contract, I would never work in Iran again. I didn't know if his threat was real, but if I were to leave, why should I care? I felt very confused about what to do and wished there were someone I could talk to about other opportunities in my field—preferably in Europe or America.[41]

[1] Farah Pahlavi, *An Enduring Love: My Life with the Shah, A Memoir* (New York: Miramax Books, 2004), 166.

[2] An American fable collected by Mary Mapes Dodge for *St. Nicholas Magazine* in 1874 that teaches children the importance of hard work and personal initiative.

[3] Sattareh Farman Farmaian with Dona Munker, *Daughter of Persia: A Woman's Journey from her Father's Harem Through the Islamic Revolution* (New York: Bantam Press, 1992), 96.

[4] Letter to R. Carsch, July 18, 1975.

[5] Farman Farmaian with Munker, *Daughter of Persia*, 268–70.

[6] See Interview, 206.

[7] Myrna Ayad, "Farah Diba Pahlavi: An Exile from a Collection," *The Art Newspaper*, April 2016. The Empress attended an exhibition at Daneshjoo Park in Tehran where Iran Darrudi mentioned there should be a place for Iranian artists to show their work, which was the source of the idea.

[8] See Interview, 199–200.

[9] Christopher Knight, "Red Flags wave in preview of LACMA redo," *Los Angeles Times*, March 13, 2019, E6.

[10] Letter to Lanier Graham, September 22, 1976.

[11] Saeed Kamali Dehghan, "Former Queen of Iran on Assembling Tehran's Art Collection," *The Guardian*, August 1, 2012, has published that monies were also budgeted from the government planning office, but the Empress disputed this claim in an email, May 20, 2019.

[12] Letter from R. Lynes, June 27, 1975.

[13] See Chapter 5, 73 and 78.

[14] Letter from F. Daftari, September 13, 1975.

[15] Letter from F. Datari, November 15, 1975.

[16] Letter to Dr. Bahadori, October 27, 1975.

[17] Business letter from Wolfgang Fischer, Fischer Fine Art Limited, London, January 2, 1976.

[18] Letter to Wolfgang Fischer, February 11, 1976.

[19] Business letter from Wolfgang Fischer, February 17, 1976.

[20] Copy of letter from Wolfgang Fischer to Her Majesty, August 8, 1975.

[21] Business letter from Wolfgang Fischer, August 9, 1975.

[22] Ayad, "Farah Diba Pahlavi: An Exile from a Collection."

[23] All prices noted are asking prices.

[24] *Henry Moore Carvings/Bronzes 1961–70* (New York: M. Knoedler Co. and Marlborough Gallery, Inc., 1970), 61.

[25] Emails from Sophie Orpen, Henry Moore Foundation, January 18–29, 2019.

[26] This is the very same work that was damaged: see Chapter 9, 166.

[27] Barry Nemett, "Fixating on Giacometti's Doomed Woman," *Hyperallergic*, September 2, 2018.

[28] http://www.aolnews.com/world/would-you-pay-a-record-1043m-for-this-sculpture/19344056. The edition included six numbered bronzes in the edition plus four artist proofs.

[29] Tirdad Zolghadr," Envy Art Museum, Iran Modern/ism," *The Tehran Museum of Contemporary Art: Shimmering totalities*," no. 6, 2006.

[30] Business letter from Robert Light, October 14, 1975.

[31] Business letter from Robert Light, December 19, 1975.

[32] Business letter from Robert Light, February 23, 1976.

[33] Business letter from Robert Light, February 25, 1976.

[34] Business letter from Robert Light, February 23, 1976.

[35] Copy of letter from Maurice Tuchman to Dr. Bahadori, December 8, 1975.

[36] Sotheby & Co., London, sale no. 841, December 3, 1975, $6,900.

[37] There were twenty deluxe copies in the original edition of *The Green Box*.

[38] Jennifer Mundy, "An Unpublished Drawing by Duchamp: Hell in Philadelphia," *Tate Papers*, no. 10, Autumn 2008, https://www.tate.org.uk/research/publications/tate-papers/10/an-unpublished-drawing-by-duchamp-hell-in-philadelphia (accessed May 2, 2019).

[39] Sotheby & Co., London, sale no. 538, December 3, 1975, £230,000.

[40] Letter to parents, December 29, 1975.

[41] Ibid.

8. TROUBLE IN PARADISE

I finally signed my second contract in January after five weeks of aggravation and indecision. It was still a difficult choice, but somehow seemed like the best alternative. During a conversation, Dr. Bahadori told me that he was very pleased with my work, liked me personally, and enjoyed working with me. I knew such compliments were quite unusual and it was energizing to learn he thought I was making such an important contribution.[1] As I expected people to be uncomplicated and honest, I was too naïve to realize at the time he was probably flattering me. As much as I disliked some aspects of my situation, I couldn't face not knowing what I was going to do next. Nevertheless, I made sure I had an escape clause that permitted me to depart after giving three months notice. I also negotiated a 15% raise. Dr. Bahadori told me the salary was equivalent to his executive assistant's earnings after sixteen years of loyal service.

In early January, John Hightower visited Tehran to interview for the job of the director of the Tehran museum. Our paths hadn't crossed much since I had worked at the Museum of Modern Art in New York during his directorship. Hightower was in town for three days and I spent most of his visit escorting him around town and introducing him to collectors, artists, and galleries. When Mr. Hightower left I wrote to a mutual friend "I think it is highly unlikely that he will take the job."[2]

On the first day of 1976, I supervised the opening of several crates to find *La Soupière de Moustiers* (1938–39, p. 152), a beautiful still life painting from André de Segonzac's mature period that had been purchased in New York the previous year. Dr. Bahadori agreed to lend this canvas to a retrospective exhibition at the Orangerie des Tuileries in Paris,[3] making it the first work from the growing collection of Iran's museum to be exhibited abroad.

The word got out about what I knew and could do, and my willingness to help colleagues turned me into a ubiquitous resident curator around town. Several Iranian artists, gallery dealers, and collectors asked for my help advising, installing their shows, and writing catalogue essays for exhibitions and thereby allowing me to do the work I liked best. I met Ghasem

Hajizadeh in New York and we have remained friends ever since. When I moved to Iran he introduced me to many Iranian artists, galleries, and aspects of life in Tehran. I was happy to design the installation for Hajizadeh's exhibition at the Goethe-Institut as well as write a catalogue introduction for another exhibit hosted by the Iran American Society. It was my pleasure to introduce artists such as Ardeshir Mohasses and Shahrokh Hobbeheydar Rezvani to art world colleagues in the United States. Among other efforts, I also advised on Sonia Balassanian's installation at the Negarkhaneh Saman. Before leaving on a trip, I stopped by the Zand Gallery on my way to the railroad station to see how the hanging of their first show featuring Michalis Macroulakis was going and ended up redoing everything and almost missing my train.

The Saman Gallery, one of several new galleries in Tehran, opened in my apartment complex that March. The gallery owners were among Iran's elite families and their impressive inaugural exhibition featured artists like Claude Monet and Max Ernst. Her Majesty attended a special preview to which I was also invited and she selected *Le Ciel* (1934), a small oil on wood painting by René Magritte.[4] For two or three days in advance of the event, preparations began to secure the gallery and investigate the building staff. The night of the opening I made sure to have my picture ID from the Private Secretariat in my pocket featuring the gold emblem of Her Majesty. The elevator operator asked where I was going all dressed up. When I pulled out my ID card, he exclaimed, "You're going? You work for Her Majesty?" In that moment I realized the building staff was totally unaware of what I was doing in Tehran and only knew me as a foreigner they dubbed "the woman who lives alone." This unfortunate phrase was also used to describe women of questionable virtue, as it was inconceivable that a woman would live by herself, and anyone who lived apart from their families was clearly an outcast. As soon as I walked out of the elevator, the attendant told everyone that I was working for the Empress.

In the meantime, my art collecting activities proceeded apace. Three major paintings were purchased at record prices from the Sotheby Parke-Bernet auction in March from the Estate of Josef Rosensaft:[5] Gauguin's *Still Life with Japanese Print* (1889, p. 132); Rouault's *Trio (Cirque)* (1938, p. 132); and Kees van Dongen's *Trinidad Fernandez* (1910, p. 133).

I was thrilled that we obtained the Gauguin, which I considered among his greatest still-life paintings. Ambroise Vollard, his French dealer, lent the canvas to the New York Armory Show in 1913—an historic exhibition that shocked the world and changed our perception of beauty. This key transitional canvas created between the artist's Brittany and Tahiti periods demonstrated his interest in Japanese *ukiyo-e* woodcuts and primitive art, thereby anticipating the cross-cultural dialogue that shaped the philosophy

of the Tehran Museum of Contemporary Art.[6] In addition, the earthenware jug depicted in the middle of the composition served as an intriguing self-portrait of this pioneering French artist and Van Gogh's best friend.

Georges Rouault's *Trio (Cirque)* is a late work in the Expressionist style. The artist's fascination with circus clowns dates from the turn of the century and was part of his focus on depicting human nature. As one journalist noted, "the robust central figure, with her striking arrangement of Mesopotamian wedge nose and saucer eyes, might have been unearthed at Ur."[7] I successfully argued that *Trinidad Fernandez* by Kees van Dongen was an exemplary painting, which would provide all the important visual clues any viewer might need in order to fully appreciate his work. In the exhibition *All Eyes on Kees van Dongen*, the painting was re-dated from 1907 to 1910, the year that the artist traveled to Spain and Morocco, and is one of a group of lively portraits of women wearing colorful shawls. Purchased from the artist by his gallery the year it was painted, this series was exhibited in Paris at the Galerie Bernheim-Jeune, where Van Dongen had a solo show in 1911.[8] Around the time he traveled in Spain and Morocco, French dealers like Daniel-Henry Kahnweiler and Bernheim-Jeune were aggressively promoting a rage for exoticism and Orientalism. Many artists, including Paul Klee, August Macke, Henri Matisse, Alexei Jawlensky, and Max Pechstein traveled to Spain, Morocco, and Tunisia in the years that followed.

Several weeks after the Persian New Year, I had an exhausting five-hour meeting with Dr. Bahadori. This gave me the time and space to bring up an ongoing issue that continued to bother me, i.e. the topic of bribery, kickbacks, and payments to runners that invariably made me extremely uncomfortable.[9] Dr. Bahadori just shrugged and laughed saying that's the way things worked on his side of the pond and would probably never change.

Mark Rothko's *Sienna, Orange and Black on Dark Brown* (1962, p. 134) was purchased at auction in May at Sotheby Parke-Bernet in New York.[10] About the same time, another exemplary Rothko canvas from a slightly earlier period, *No. 2 (Yellow Center)* (1954, p. 66) was purchased from a private collection in Liechtenstein.[11] I remember vividly paging through a traveling exhibition catalogue looking at a number of paintings that were displayed in Zurich, London, and Paris, selecting this imposing canvas from a group of works that were offered for sale.[12] In these classic meditative paintings from the New York School for which Rothko is best known he forcefully manipulated form and space to expressive ends. Their formality charts the artist's steady course into pure abstraction during the post-World War II period. Incidentally, Rothko's *No. 2* was lent to the Guggenheim and impounded by the American government at the time of the Islamic revolt in 1979.

After studying Francis Bacon's work in a retrospective at the Metropolitan Museum the previous year, I was enthusiastic about acquiring one

Paul Gauguin, *Still Life with Japanese Print*, 1889
Oil on canvas, 73 x 93 cm

Georges Rouault, *Trio (Cirque)*, 1938
Oil on canvas, 75.5 x 106.3 cm

Kees van Dongen,
Trinidad Fernandez, 1910
Oil on canvas, 100 x 81.2 cm

Mark Rothko, *Sienna,*
Orange and Black
on Dark Brown, 1962
Oil on canvas,
193.5 x 176.5 cm

Francis Bacon, *Reclining
Man with Sculpture*, 1960–61
Oil on canvas, 165 x 143 cm

of his exemplary oil on canvas paintings for the National Collection at the same auction sale in New York as the 1962 Rothko.[13] *Reclining Man with Sculpture* (1960–61, p. 135) was first shown in *American and International Art Since 1955*, a group exhibition held at the 1962 Seattle World's Fair.[14] The man depicted in this canvas may be the artist or Peter Lacy, one of his favorite models who had been a fighter pilot in the Battle of Britain. The placement of the sculptured bust on a stool was the forerunner of domestic items Bacon introduced into his compositions to balance their violence, and may also reference bronze busts of the artist produced by William Redgrave in 1959. In 2005, TMoCA lent this painting to the Scottish National Gallery of Modern Art in Edinburgh.

We made our first purchases of fine prints from Petersburg Press in May: Claes Oldenburg's *Ice Cream Desserts* and Jasper Johns's *Corpse and Mirror*. However, I don't believe these works ever made their way into the National Collection but were probably used as Royal gifts.[15]

David Galloway, a professor of American Studies at Ruhr University in Bochum, Germany, wrote to Dr. Bahadori following my suggestion to propose an exhibition of works from the Ludwig Collection, housed in two museum buildings in Aachen and Cologne. He had proposed earlier a similar exhibit for the Iran America Society to coincide with the American Bicentennial, but was unable to make the appropriate arrangements. In his new proposal letter, Dr. Galloway confirmed that Mr. Ludwig was willing to loan the works to Iran and his curators would assist in the preparation of a catalogue. This impressive exhibition was eventually presented in Tehran in 1978, when Dr. Galloway served as the Tehran museum chief curator for less than a year prior to the Iranian revolution.[16]

I was very excited to find a marvelous unique Dada object by Man Ray for sale at auction in Los Angeles in June.[17] We were able to purchase *Last Object*, a rare sculpture in the readymade style that was an early example of Man Ray's iconic metronome sculpture series. Man Ray began this sequence in 1923 with *Object to Be Destroyed* and, according to the artist, he employed the musical timekeeper in his studio as a "silent witness." The Tehran version— signed, titled, and dated 1932–42—had been directly acquired from the artist and references his former lover, photographer, and photojournalist Lee Miller. Man Ray had no compunctions about making replicas and remade this object numerous times in various editions as late as 1974. So, acquiring a unique vintage version was truly a coup.

The Private Cabinet of Her Imperial Majesty in cooperation with the Committee for Modern Iranian Art decided to co-sponsor an exhibit of Iranian artists at the Basel Art Fair. This represented an opportunity for the Iranian government and numerous corporations to support artists; furthermore, it would provide a reality check in relation to where their artworks fit

into the global market. I was part of the organizing committee, which consisted of prominent artists, collectors, and gallery owners. The committee met many times and I offered numerous suggestions about how the exhibit should be organized, although most were disregarded.[18]

That spring I had an absurd confrontation with the promising young woman we had hired to be my assistant: she demanded that I leave her alone claiming, "I don't have to do anything for you. What right does a foreign person have to tell us what we should do in Iran?" Her ill-considered outburst clarified why the atmosphere in the office had become unbearable again. Apparently she resented it when a foreigner gave her direction and what I thought was constructive criticism. She hated to take responsibility for her many mistakes and was afraid to show her ignorance by asking questions. After six days of hardly speaking, a staff interpreter acted as an

Man Ray, *Last Object*,
1932–42
Wood, metal, and paper,
22.2 x 10.5 x 11 cm

intermediary translating into English her Persian, although she spoke my native language beautifully. I wrote a close friend in New York that Persians are proud people, but in some cases it seemed like false pride designed to compensate for feelings of inferiority. I speculated that a lack of humility prevented some from graciously accepting help.[19] A few weeks later, I reviewed the page proofs of the catalogue for the Basel Art Fair that had been handled by my recalcitrant assistant. There were so many embarrassing, sloppy mistakes that I was compelled to redo everything. Even with the help of a translator and typist, the rewrite took me a whole week.

To cap things off, when it came time to go to Basel, Dr. Bahadori refused to let me participate even though it was announced at a committee meeting that I would be invited to join the group of thirty-six artists and their families. Everybody in my department was invited to spend five weeks traveling in Europe except me, even though I wrote the majority of the catalogue, saw to the printing, and helped design the exhibition space. When His Excellency gave me this news I was livid and threw a thick book I was holding across his desk. "Did you just throw the book at me?" he snapped. As I was half way to the door, he invited me to Basel after all. But

I was so angry I neglected to say thank you, reminding him to tell the chief accountant my plane ticket should be purchased immediately. As I walked through the door in a huff he said, "You're getting to be more and more Iranian." I responded, "I hope not." And shut the door.[20]

No sooner had I arrived at the Zurich airport than a man walked up behind me and put his hands over my eyes. It was Aldis Browne. This chance encounter seemed like a good sign and from then on I was constantly meeting old friends and acquaintances, some of whom I had no idea I would be seeing. My Iranian colleagues were surprised and kept telling me, "Donna, you're so famous, the whole world knows you!" and indeed it was very refreshing to be in a more appreciative milieu for a change. I received a lot of feedback from my American and European friends about the Basel Iranian exhibit. They thought the installation was attractive and accomplished with care and taste, but they found the art less than compelling, especially regarding the range and depth of the talent on display. Contrary to my recommendations, the Iranian Basel Art Fair committee had decided to include thirty-six artists with one or two works representing each one. While many of them had shown in Europe and/or the United States, this was the first time their work was displayed in a prestigious international context like the Basel Art Fair. Naturally, the Iranian press was positive, but it was very difficult for Europeans and Americans, who had little exposure to modern art in Iran, to distinguish between the artists and their backgrounds and appreciate the presence of traditional Iranian motifs in contemporary work. The catalogue text was too general and brief, and many observers commented that the selections did not represent an understanding of what was happening outside Iran. Many were impressed that an opportunity had been organized to help Iran's artists evaluate the impact of their isolation for themselves.

In honor of the Bicentennial of the United States, the former director of the CIA and current ambassador Richard Helms and his wife invited me to a gala July 4 cocktail party on the lawn of the American Embassy. There were about a thousand select guests, mostly diplomats and Iranians. As I didn't want to go alone, I invited an American architect of my acquaintance. He wore a red suit, checked blue and white shirt and a blue tie. Servants in livery passed drinks, hamburgers, barbecued chicken, and cups of buttered popcorn. I was talking with my date when prime minister Hoveyda strolled by. I smiled. He stopped in his tracks and we both said, "It's a pleasure to meet you" at the same time in Farsi, and shared a laugh.[21]

That summer, Michael Goedhuis from Colnaghi's wrote me about a very important Claude Monet, *Le Bassin de Londres* (1871), with impeccable provenance—it was originally bought by artist Mary Cassatt from Durand-Ruel who acquired the canvas from Monet a year after he created

it. Goedhuis noted, "Monet only painted five works during the year he spent in London and this canvas is generally considered the finest and subtlest, because of the complexity of his treatment of light . . . Despite its inclusion in Wildenstein's catalogue raisonné (no. 168), the painting had never before been offered for sale and was not widely known."[22] Unfortunately, it was never purchased.

An important painting by Max Ernst entitled *Histoire naturelle* (1923, p. 142) was purchased from Parisian art dealer Pascal Sernet in the summer of 1976. When Ernst left his wife and son and Germany after his first marriage dissolved, he entered France without legal papers and lived in a scandalous *ménage à trois* with the poet Paul Éluard and his wife Gala, who eventually married Salvador Dalí. In 1923, Ernst created at least fifteen wall murals depicting anthropomorphic and vegetative scenes of the natural world for Éluard's house in Eaubonne, a northern suburb of Paris. *Histoire naturelle* was one of two mural panels that once decorated the poet's bedroom. At some point it had been covered by wallpaper only to be rediscovered in 1967. This imposing illusionistic collage-based painting was removed from the wall with the technique developed for the frescoes of Pompeii, affixed to canvas, and then slightly reworked and signed by the artist. In 2002, the Tehran Museum of Contemporary Art lent the painting to the Kunstsammlung Nordrhein-Westfalen in Düsseldorf for *Surrealismus 1919–1944*, one of the largest exhibitions of the Surrealist movement ever organized, where it was reunited with the companion painting from Éluard's bedroom after thirty-five years.

That summer we also had the opportunity to acquire *Capricorn*, Max Ernst's largest freestanding sculpture and most impressive apotheosis. From 1946 to 1953, Ernst lived with his fourth wife, Dorothea Tanning, in Sedona, Arizona in a house they built and named "Capricorn." Inspired by the arrival of water piped to their house in the summer of 1947, Ernst began working with scrap iron, reinforced concrete, and incongruous combinations of found objects. According to Tanning, the result was "a monumental sculpture of regal but benign deities that consecrated our 'garden' and watched over its inhabitants."[23] Collage compositions by Ernst from *Une Semaine de bonté ou Les Sept éléments capitaux* (published in Paris in 1934 in novel form) provided prototypes for this hieratic family portrait that includes Ernst, Tanning, and their two longhaired Tibetan dogs. The composition of *Capricorn* references the tenth astrological sign of the Zodiac, commonly represented by a creature with the upper body of a goat and lower body of a fish. The artist split these attributes between the sexually potent horned monarch on the left, who rules with a scepter constructed from casts of milk bottles set one on top of another, and his mermaid queen wearing a fish headdress on the right. The Surrealist crossbreeding of forms

Max Ernst, *Capricorn*, 1948/63
Plaster, 238.8 x 203.2 x 129.5 cm
The Museum of Contemporary
Art, Los Angeles, Gift of
The Capricorn Trust and Mrs.
Jimmy Ernst

Max Ernst, *Histoire
naturelle*, 1923
Oil on canvas,
232 x 354 cm

James Ensor, *Mariage
des masques*, 1926
Oil on canvas, 50.5 x 61.5 cm

Chuck Close,
Keith, 1972
Mezzotint, 113 x 89 cm
Edition of 10
Published by Parasol
Press Ltd.

Thomas Eakins, *Portrait
of Walt Whitman in his
New Jersey Home*, 1892
Gelatin silver contact print,
11.5 x 9 cm

harnesses the subconscious mind by juxtapositions that confound viewers' expectations. The original sculpture was executed in 1948 and *Capricorn* (p. 141) was featured in a 1952 *Life* magazine photograph by John Kasnetsis of Tanning and Ernst, with Sedona's mountains in the background.[24] Fifteen years later, the artist modified the earlier composition in the preparation of the plaster from which six bronzes were cast at Huismes, France, including the one purchased for the Tehran Museum of Contemporary Art. In 1975, the artist made two additional casts of this popular sculpture. A plaster model, likely made for the 1948–63 bronze version, is in the collection of the Museum of Contemporary Art in Los Angeles.[25]

Another important sculpture entered the collection about this time: René Magritte's *La Thérapeute (The Healer)* (1967). At the suggestion of his dealer, Alexander Iolas, who owned galleries in the United States and Europe and was known for his exclusive representation of major European Surrealists, Magritte mined significant motifs in a wide array of his paintings to create eight bronze sculptures that were cast at a foundry in Verona, Italy. For each sculpture, he carefully created the sketches that would be the basis of the wax casts. Although the artist died before the sculptures were realized in bronze, he signed the wax models and saw the first proofs for each sculpture. The series was first exhibited in 1968 at the Galerie Isy Brachot in Brussels.

After some back and forth with publisher Robert Feldman, we added an important recent print to the collection: *Keith* (1972, p. 144) by Chuck Close, published by Parasol Press Ltd. in an edition of ten. The massive-scale mezzotint, based on a 1970 photograph of the artist's friend Keith Hollingworth, was purchased for $12,000. This was Close's first project at Crown Point Press and was extremely labor-intensive. It was also the first work in which he retained the grid in the composition as evidence of his process—a seminal choice for his subsequent work in all media.

Although I never considered acquiring a painting or drawing by the American master Thomas Eakins, I was thrilled to be offered some of his rare photographs by New York private dealer Janet Lehr. I thought the *Portrait of Walt Whitman in his New Jersey Home* (1892, p. 145), one of America's most influential poets and the father of free verse, would appeal to Iranians because of their profound love of poetry by Rumi, Saadi, Hafez, and others. The experimental aspect of *Boy Jumping over Hurdles* was also appealing because it captured motion and showed the passage of time within the frame.

I was happy when Layla Diba invited me to curate for the Negarestan Museum an exhibit of prints from the Shahbanou's personal collection. "It was the first time I had been inside the Palace gates," I wrote my parents, "but it looks like I'll be going back."[26] Niavaran Palace was far north in the city, surrounded by lovely mountain views. As one entered

the grounds, there was a long drive through beautiful gardens: spring flowers of every color and description were everywhere—pansies, narcissus, tulips, hyacinths, forsythia, flowering trees. As Layla and I walked up the main drive, His Imperial Majesty walked out of the house. We bowed and waited until the Shah passed, before walking on. I visited the Palace several more times on my own to study the works I had selected and supervise the photography for the catalogue, but the Shah and Shahbanou were nowhere in sight.

Over the years, the Empress had acquired original graphics by famous international artists she knew personally like Marc Chagall, or works that just pleased her discerning eye, even if they were not significant. The forthcoming exhibition of her prints represented an opportunity for Iranians to gain insights into the creative processes and the way in which imagination can be expressed through the various graphic media. This survey of forty-one international and Iranian artists would be the first presentation of a condensed view of printmaking and the art of our time. I used available material as a foundation for a didactic exhibition, so I chose the works based on both quality and their ability to further my educational purpose. While the presentation was not comprehensive, it contained enough variety and visual information to enable a discussion of graphic techniques. In my catalogue introduction I asserted, "Prints are no longer just another two-dimensional extension of drawing or an adjunct to painting, but actually provide artists with ideas that can only be articulated through print media. Graphics are finally appreciated as an adaptable and meaningful vehicle for expressing ideas."[27]

Andy Warhol attended the opening accompanied by Factory stalwarts Fred Hughes and Bob Colacello. Warhol had come to Iran to photograph Their Majesties as part of his portrait development process. A couple of days after the opening, Monir and Abolbashar Farmanfarmaian invited me to their home for a festive lunch in their beautiful garden honoring Warhol, who had worked with Monir in the advertising department at Bonwit Teller Department Store in New York and was a long-time friend of hers. As an accompaniment to my print exhibit at the Negarestan Museum, I agreed to give a lecture entitled "Popular Mechanics in Print Making," focusing on the way industrial and commercial techniques had changed our view of originality making an artist like Andy Warhol possible.

One morning, while I waited to see Dr. Bahadori, Shirvanloo came out of Dr. Bahadori's office mumbling something about having my suitcase ready at 7 am the next day as I was invited to accompany Her Imperial Majesty for a junket to the final performances of the Shiraz Arts Festival, where, it turned out, Dr. Bahadori would formally present me to the Empress. An attendant from the Secretariat arrived to collect my suitcase.

Later that morning, I called for a taxi to drive me to the airport. The Royal Pavilion was a small but plush building where tea was served before Her Majesty arrived. Our delegation numbered about a dozen people, including Dr. Bahadori and his wife, and three others from the Secretariat's Department of Arts and Culture. Luckily, Her Majesty's cousins, my friends Layla and Mahmood Diba, were also included and were on hand to help this American innocent abroad understand proper court protocol.

The Empress' private plane, called the Shahbaz or Royal Eagle, was standing by at the airport. The plane's interior was decorated in agreeable red, brown, and orange tones and boasted a bedchamber, two kitchens and what looked like more restrooms than the Tehran Museum of Contemporary Art. Our flight to Shiraz was smooth and took just over an hour. As we deplaned, we were handed a gold embossed envelope containing transportation vouchers, hotel room assignments, and event tickets.

Layla and Her Majesty took lunch together and they apparently discussed when I would be officially presented to the Empress. Her Majesty asked Layla, "Was Donna Stein that slim, attractive, young woman you sat next to on the plane?" When Layla answered in the affirmative, the Empress commented that she expected me to be a frump and was surprised I looked so fashionable.[28] The next day we were due at an exhibition and I debated what I should wear. I considered my white cotton André Courrèges suit but because of the heat, I finally decided on a simple Emmanuelle Khanh mauve cotton dress. When the Empress appeared in the same white cotton Courrèges suit I had contemplated wearing, I was grateful to have avoided the embarrassment of upstaging Her Highness. Late that evening, Dr. Bahadori called me over and introduced me to my royal patron. I was surprised by his timing and blurted, "It's a great honor to know you" instead of "It's a supreme honor to meet you and work on your behalf" as I had planned. The Empress told me that from everything she had heard she expected I would be an older woman with glasses, and we shared a laugh. I was thrilled when she expressed interest in coming to know both me and my work better. As our association developed over the years, I came to consider her among the most graceful, intelligent, caring, and energetic women I have ever encountered.[29]

That fall, *Mariage des masques* (1926, p. 143), an Expressionist and/or Proto-Surrealist oil on canvas featuring five masked figures by the Belgian artist James Ensor, was purchased at auction in New York.[30] The tradition of the Carnival, with roots in the Middle Ages and its more benign Mardi Gras, was one of the major themes of this artist, who held that "reason and nature are the enemy."[31] Ensor employed the mask motif as early as 1883 and two superb hand-colored etchings from 1886 and 1898 that we had already acquired also incorporated this recurring subject. Formerly

in the collection of American collectors Henry and Ruth Bakwin, the work had an excellent provenance and had been exhibited in several important museums and galleries. The painting was signed but not dated. Based on previous exhibition catalogues, it was assumed to be from about 1910; however, in a subsequent catalogue raisonné it was re-dated according to stylistic evidence.[32]

Two extremely rare companion intaglio prints, variations on the theme of Picasso's *Weeping Woman* (p. 58), show the artist rethinking the composition of the limited edition print we had acquired in New York from E. V. Thaw. Purchased at Sotheby's London,[33] these slightly smaller compositions were never printed in an edition and were not included in the artist's catalogues raisonnés. Executed on July 4, 1937, they were among the over sixty artworks on the theme created by Picasso primarily between January and November of that year in various media as emblems of the upheaval in Europe and the consequent turmoil in his personal life.[34]

About the same time, an early Pop Art painting by Roy Lichtenstein, *Roto Broil*, came up for auction.[35] We had already acquired several later prints showing the artist's more mature style and I thought this early canvas was a bold and comprehensible statement, illustrating where he began his study of iconography. In that same period, we also were able to buy Lichtenstein's *Hot Dog*, an enamel on steel multiple in an edition of ten from 1964.

By this time there were two hundred and thirty seven Western works in what was designated as the Iranian National Collection: sixty paintings, twenty drawings, one hundred and forty graphics, eighty photographs, fifteen sculptures, and two tapestries. I was asked to write a memo outlining how to organize a proper storage facility. I wrote a report for Manouchehr Iranpour, the chief architect in Her Majesty's Private Secretariat, inform-

ing him of the extent of the international collections and what space was required for safe and efficient storage.

I felt a sense of profound relief when my uncooperative assistant at the Secretariat resigned and had hopes my day-to-day work life would improve. Three days before I left for Europe on vacation, Dr. Bahadori's executive assistant Nahid Panahi, a poet and my trusted friend at the office who shared my interest in fortune telling, took me to see a psychic who worked in the back of a beauty shop. This seer in hair curlers sat behind a manicure table reading tarot cards as well as Turkish coffee grounds, a typical form of Persian fortune telling then and now. After I drew the Empress card, the psychic asked me what I was doing in Tehran. When I replied that Her Majesty employed me, she emphatically declared, "Your work is finished."

[1] Letter to Klaus Perls, January 25, 1976.

[2] Letter to E. Grand, January 17, 1976.

[3] *Dunoyer de Segonzac*, exh. cat., curated by Hélène Adhémar and Anne Distel, Orangerie des Tuileries, Paris, February 20 – May 3, 1976.

[4] Email from Farah Pahlavi, May 20, 2019. The Empress recalls, "I owned a small Magritte that I had given to a friend. It was returned to me sometime after 1979, and contrary to rumors about the family wealth, I had to sell it."

[5] Sotheby Parke-Bernet, New York, March 17, 1976. The Gauguin sold for $1,400,000; the Rouault for $280,000; the Van Dongen for $160,000.

[6] David Galloway, "Remembering TMoCA," in *The Tehran Museum: A Reader About Art in Iran since 1960* (Berlin: Nationalgalerie, Staatliche Museen zu Berlin, 2017), 45.

[7] "Lifting the Veil: The Finest Modern Art Exhibition in Tehran," *The Guardian*, October 7, 2005.

[8] Anita Hopmans, *All Eyes on Kees van Dongen* (Rotterdam: Museum Boijmans Van Beuningen, 2010).

[9] Letter to parents, April 28, 1976.

[10] Sotheby Parke-Bernet, New York, May 26, 1976.

[11] *Mark Rothko*, exh. cat. Kunsthaus Zürich, March 21 – May 9, 1971, no. 37. In the video "Conversations: 50 Years of Art Basel: the 1970s" (July 16, 2020) collector Ulla Dreyfus-Best mentioned that this Rothko painting was purchased by Iran through Ernst Beyeler's gallery.

[12] Ibid.

[13] Sotheby Parke-Bernet, New York, May 27, 1976, for $160,000.

[14] *Francis Bacon. Catalogue Raisonné*, ed. Martin Harrison (The Estate of Francis Bacon, 2016), 1958–17, III, 628, 61–1.

[15] Business letter by T. Swett, Petersburg Press, to Dr. Bahadori, June 9, 1976. Information confirmed in email from Nahid Evazzadeh, dated December 18, 2019.

[16] Copy of letter from David Galloway to Dr. Bahadori, May 24, 1976.

[17] Sotheby Parke-Bernet, Los Angeles, June 7–10, 1976, lot 1872, for $5,000.

[18] Letter to parents, April 12, 1976.

[19] Letter to E. Grand, April 21, 1976.

[20] Letter to R. Carsch, June 30, 1976.

[21] Letter to parents, July 7, 1976.

[22] Business letter from Michael Goedhuis, P. & D. Colnaghi & Co., July 16, 1976.

[23] See https://www.nga.gov/collection/art-object-page.57105.html

[24] Ilene Dube, "A Pilgrimage to Dorothea Tanning's Arizona Studio," *Hyperallergic*, January 2019.

[25] Donna Stein, *The PepsiCo Sculpture*

Gardens (Purchase, New York: PepsiCo Editions, 1982), 4–5.

[26] Letter to parents, April 28, 1976.

[27] Donna Stein, *Selected Graphics from the Private Collection of Farah Pahlavi, Her Imperial Majesty The Shahbanou of Iran* (Tehran: Negarestan Museum of Eighteenth and Nineteenth Century Iranian Art, 1976), 3.

[28] Letter to parents, August 30, 1976.

[29] Ibid.

[30] Sotheby Parke-Bernet, New York, October 20, 1976, lot 64, for $35,000.

[31] Michael Prodger, "James Ensor: A man of many masks," *RA Magazine*, Autumn 2016.

[32] Xavier Tricot, *James Ensor: Catalogue Raisonné of the Paintings* II (Ostfildern-Ruit: Hatje Cantz, 2009) nos. 549, 521.

[33] Sotheby's Modern Prints Sale, London, October 6, 1976, for £67,100.

[34] Judi Freeman, *Picasso and the Weeping Woman: The Years of Marie-Thérèse Walter & Dora Maar* (New York: Rizzoli, 1994).

[35] Sotheby Parke-Bernet Contemporary Art Sale, New York, October 21, 1976, for $75,000.

9. THE PLOT THICKENS

Autumn in Tehran is deliciously mild and its surrounding mountains are gorgeous and constantly change color with the light. The night I returned from Europe, just when things felt like they were settling down, I received a call from Nahid Panahi, Dr. Bahadori's sympathetic and refined executive assistant, informing me she had resigned because Dr. Bahadori was no longer directing Her Majesty's Private Cabinet. It turned out he had been appointed minister of Information and Tourism in His Majesty's cabinet. The next morning at work his replacement, Dr. Houshang Nahavandi, a former president of Tehran University, was describing his ideas to a wide-eyed Secretariat staff. While undoubtedly brilliant, Dr. Nahavandi knew even less about art history than Dr. Bahadori.

Dr. Nahavandi soon revamped the already confusing and endlessly nuanced chain of command. Dr. Bahadori was an unreconstructed autocrat and kept everything centralized and under his thumb. Dr Nahavandi preferred to only work with Department heads, and certainly not with a lowly American underling like me. My nominal boss was Firouz Shirvanloo, the Arts and Culture Department head. Shirvanloo gave off a peculiar vibe and I am certain he was jealous of me from the moment we first met, because I had Dr. Bahadori's ear and he had his own difficulties with the chief of the Secretariat who didn't trust him. The Shah had pardoned this former Marxist student activist in the United Kingdom after he was implicated in an assassination plot in 1965.[1] Mid-way in my second contract, he stopped talking to me all together unless it was absolutely necessary. My situation became more uncomfortable during November because he began to display even more hostility.

My work on the collection came to a standstill and I began to suffer from crushing headaches. Nevertheless, I continued to field offers of excellent objects, but all purchases came to a stop. I never found working at the Secretariat easy. Dr. Bahadori frustrated me, because he was extremely busy and difficult to reach, but he knew how to act like a decent and reasonable employer when he wanted to. Then too, Dr. Bahadori respected my knowledge, treated me courteously and only with the passing of time

André de Segonzac,
*La Soupière de
Moustiers*, 1938–39
Oil on canvas, 81 x 65 cm

did I realize he was my principal protector. I had hoped to speak with Dr. Bahadori before he left the Secretariat, but he was understandably preoccupied with his new portfolio. Two weeks after he moved to his office at the Information and Tourism Ministry he rang me up and asked me over. He began our reunion by warmly complimenting my work and assured me he would continue to be my friend. I congratulated him on his promotion and confided that I didn't have a clue how I could complete the art projects because of the change in management. I was concerned about the safety of crated art assets that were arriving by air and sea, since there was no effort being made to collect them at Customs. I told him I had written a concise summary report in English to Dr. Nahavandi, describing my work at the Secretariat. Dr. Bahadori surprised me by urging me to contact Her Majesty directly and describe the situation enclosing the report I had prepared for the Secretariat's new management. Despite His Excellency's counsel, I felt I should give my new boss more time to respond before I wrote to the Empress on my own. My suspicion that His Excellency had stolen the credit for my hard work increased over time.[2]

The office environment felt extremely antagonistic. With a wolf in the lead like Shirvanloo, who sported a stylish full beard, it seemed like the entire pack was after me just because they considered me an ugly American. When the American art librarian I hired or I tried to speak Farsi, our Iranian office mates made fun of our accents.[3] This grisly gang also mocked our tiny typist from Bombay. It turned out that the fortune-teller I had visited at the beauty shop was right—everything was finished. I knew I could make it to the end of my contract, but prayed not one minute longer.

Over the course of a few weeks, I supervised the transfer of all the art crates to a new storehouse in Saadabad Palace under the watchful eye of a security officer. National Heritage items, such as a trove of fine carpets, miniatures, and Luristan bronzes acquired by the monarchy were kept there as well. The Iranian official in charge of those acquisitions had been dismissed by the Secretariat for taking kickbacks. Apparently, it was public knowledge in Iran and abroad that he skimmed off 10 to 15% of every transaction, which surely represented a bonanza. Somehow he was able to get away with not telling the Secretariat what he had done and, in the meantime, he remained at his post until he revealed what and where everything was.

Dr. Bahadori told me the administration at the Private Secretariat was astounded when they realized that the Western modern art collection was the only one completely catalogued with all files up-to-date, accessible, and organized. I had indeed documented each work in both the international and Iranian collections in separate artist files with the essential information that applied to each work, including location, provenance,

and exhibition history. I also included photographs and cross-referenced annotated bibliographies.

In December, I met with Dr. Nahavandi to clarify what I was supposed to be doing. Our new fearless leader spoke Farsi and French fluently, but very little English. As both my French and Farsi were not nuanced, I foresaw a formidable communication hurdle. I wrote a concise report in English on collection development, which Dr. Nahavandi could read, and requested a meeting knowing that he scheduled his appointments every fifteen minutes. Although it took a week and a half, I finally got short-listed on his crowded dance card. For half an hour I conducted my briefing in halting Farsi and broken French sentences glued together with a smattering of English. I tried to explain my project, describe its problems in priority order, and give him some inkling of my professional background and qualifications. He patronizingly told me that some decisions would be taken very soon but for the time being I had to be patient. I asked Dr. Nahavandi how he wanted me to operate and if I should keep my cards close to the vest. "Tell Mr. Shirvanloo anything he asks you," he responded in a cavalier manner unsuited to the situation. I mentioned that Kamran Diba had also been requesting confidential information and I asked if I should be talking to the Tehran museum's architect as well. As I did so, Dr. Nahavandi ostentatiously glanced at his wristwatch as a way of telling me my time had expired.

In mid-December, I sent another memo to Dr. Nahavandi briefing him on two pending special exhibition proposals that could help launch the new museum when the building would finally be open to the public. Firstly, there was an important exhibition opportunity proposed by my former boss, the Museum of Modern Art's chief curator William Lieberman, who told me he would gladly organize an exhibition of works from the MoMA drawing collection, unquestionably among the finest in the world. The second enticing possibility from MoMA involved showcasing the Sidney Janis Collection,[4] comprising one hundred and three extraordinary twentieth-century paintings and sculptures.

By the end of December, there were many rumors circulating regarding more leadership changes. A trusted source informed me that Aydin Aghdashloo, a tall and good-looking painter and college professor, was being considered for the post of museum director. One day Shirvanloo walked into my office and curtly introduced Mr. Aghdashloo, whom he identified as my new boss. Later, I asked Shirvanloo about his plans for the future and he sneered, "I'm going home to take a nap." "Whatever comes next at least you'll be well rested," I retorted. Although this disagreeable character didn't know what he was going to do next, he eventually was appointed director of the Niavaran Cultural Center.

I had known Aydin Aghdashloo for a while and had socialized with him and his wife Shoreh, a well-known actress and beauty. The previous June, Aydin and I sat next to each other on a flight from London to Tehran and I spoke to him about my work situation with too much frankness. At a bistro dinner in Paris sometime later, hosted by Monir and Abol Farmanfarmaian, Aydin revealed his true anti-Semitic bias. When I ordered steak tartar, he commented that Jews should eat less raw meat, clearly referencing the blood libel. Abol did his best to smooth things over, but the stench of racism hovered over our table for the remainder of our less than festive meal. Aydin was full of himself, but a known quantity, so I viewed his appointment to the Private Secretariat to be a potential improvement in the quality of my work life.

I kept seeing Kamran Diba at various parties. He let me know that he hoped to complete the building and open the museum by September and he showered me with questions. I told him that Dr. Nahavandi had said that we could talk, so I suggested that he ask him officially and then I would be glad to tell him whatever he wanted to know. One night Kamran came up to me at a party and told me he had an appointment with Her Majesty the very next day and would be sharing a draft organization chart for the museum, which he drew for me on the back of a cocktail napkin to critique. Shortly thereafter, at a going away party for the American Ambassador and Mrs. Richard Helms, I bumped into Kamran again and asked him how his meeting with the Empress went and he responded "very well." "Will Aydin be the director?" I asked. "I'm not sure," he replied, "but I can tell you I am the director of the Board of Trustees." I knew what that meant: I congratulated him and asked to serve on the International Committee. He suggested we drink to that. It was no surprise that when the latest American museum director, Richard Koshalek, and Swiss curator and art historian Harald Szeemann turned down the position, the Empress ordered Kamran to take on the museum directorship himself.[5]

Meanwhile, Aydin assumed his new responsibilities with gusto. He tried to be helpful but I didn't trust him because he was a power-seeker and apparently willing to do whatever he could to get his way. The first thing Aydin talked to me about was my joining the staff of the museum. He told me he heard I was leaving Iran soon and I informed him that my contract ended in mid-February. "We have to see about that," he said mysteriously, "Because we need you here." I told him that I hadn't done any serious work in months and I was even more disgusted with the administration than ever before. He flattered me saying I knew twice as much about art as anyone in the entire country besides being wise, intelligent, and sweet, and he called my productivity legendary. "From the beginning

I've talked to Dr. Nahavandi about you," he alleged, "and told him that you should be working at the museum."

I brought this conversation down to earth by asking for his assistance in getting some art crates out of Customs and into proper storage because wrapping up my work at the Secretariat required that I hand off responsibility for all the art that had been acquired on my watch. As previously described, most of the crates were moved to Saadabad Palace, except for the works in Customs and a few uncrated leftovers that remained at the Secretariat. The last transfer would comprise all of these works, but I refused to supervise their move until the palace storeroom was spotlessly clean.

The next step was to get that crooked expert who had been taking bribes left and right to inventory his own acquisitions. Layla Diba was pregnant and returning to New York to give birth in an American hospital. She too had to complete condition reports on every object and painting that had been purchased for the Negarestan Museum, and that meant my work scope was last in line again. By the beginning of January, it seemed that many people in the know were gossiping about the possibility of my associating with the museum. Kamran called and said he wanted to speak again with me, but Aydin insisted I had to obtain an official letter requesting written permission from Dr. Nahavandi to have that conversation. I diligently drafted a permission letter and gave it to Aydin, who had it translated. Only when I received a signed copy on Secretariat stationery did I set off to confer with Kamran again.

I was impressed when Kamran proudly flashed a letter enhanced by a royal seal granting him a mandate to both open and manage the modern art museum. He told me he wanted me to be his deputy to help him administer the museum and organize its program. His earnestness belied his deviousness. "You must know that I am thinking of leaving Iran when my contract expires," I reminded him. "In order to stay I'd have to have a proper title and job description including to whom I'd report in theory and practice. The devil is in the details," I warned. "I've worked in the bureaucratic soup for twenty-four months and I'm just not sure I can take it any more." He asked me to develop a list of questions for further discussion and additionally prepare various reports: a budget to purchase works up to 1950; a budget for purchases after 1950; ideas for an exhibition program; and my version of a workable table of organization.

We met again the following afternoon and Kamran called in a woman who was working on interior designs for the museum. The three of us reviewed her schematics as well as inspected samples of proposed fabrics and decorative tiles. After she departed, Kamran summoned a fellow American named Judson Chrisney, who was slated to become the museum's first ad-

January 19, 1977

COLLECTION EXPANSION BUDGET ESTIMATES

	BEFORE 1950	AFTER 1950
Paintings	$15,000,000.	$2,000,000.
Sculptures	2,000,000.	1,000,000.
Drawings	500,000.	100,000.
Graphics	250,000.	50,000.
Photographs	100,000.	
	$17,850,000.	$3,150,000.

ministrator, and we reviewed a draft inaugural year exhibition budget (see Documents). At long last the agenda turned to employment arrangements for yours truly.

To prepare for this tricky discussion I had consulted with my friend Iradj Bagherzade,[6] who understood Iran's arcane business practices and had conducted negotiations on behalf of individuals and corporations such as Time-Life. Iradj helped me develop a list of questions designed to cut through the deliberate confusion: Who will Kamran be reporting to? What role will Her Majesty's Private Secretariat have in relation to the museum? Will an advisory committee be formed to pass on all decisions before a project can be expedited? Will the museum be an autonomous organization? What will be the relationship to the Cultural Department of the Secretariat? Who reports to whom? Is there an approved budget with which to open the museum? Where will the money come from? I also had many questions about my role. Will my new contract be as a consultant to the Private Secretariat or as an independent contractor with the museum? What will be my title and job description? Who do I report to? Who will approve my proposals? What am I expected to produce? Will I have a limited contract through the opening of the museum or through the end of December 1977? What staff will report to me? What jurisdiction will I have over who else is hired? What control will I have over the staff's execution of projects? Will staff be utilized from the Private Secretariat? Will I be given the opportunity to finalize aspects of the program through travel? I also

January 19, 1977

MUSEUM JOB TITLES AND DEPARTMENTS

AESTHETIC: (1 Curator/ 1 Assistant)

 International painting, sculpture, tapestry, mixed media

 International works on paper--drawings, graphics, photographs

 Persian painting, sculpture, tapestry, mixed media

 Persian works on paper--drawings, graphics, photographs

 Film

 Architecture

 Industrial Arts

ADMINISTRATION:

 Accounting and purchasing

 Manager of Restaurant

 Manager of Bookstore

 Head of guards (Security officer)

 Building Services--heat, water, cleaning, etc.

 Exhibition preparation--architect/designer
 carpenters
 painters
 framers
 exhibition hangers

CONSERVATION:

REGISTRATION:

 Central cataloguing

 Loans

 Packing, storage and shipping areas

Photography

EDUCATION:

 Librarian

 Education (docents)

 Publications Editor and translator

 Public Relations

miniature shows / a couple of good pic's
drawings, prints, sculptures
+ photo graphic blowups

Matise [Matisse]

Henri Moore [Moore]
works on paper — + maquettes
Nolde —
Schiele + Klimt
Art Nouveau
Klee

German Expressionism

Miro drawings
Sol Lewitt — Wall Drawings
Latin American drawings — Barbara Duncan

Modern Art in India — Lakshmi Sihare
Modern Japanese Art → film / design
Photography / history

Encourage at time of Shiraz festival
So have theatre / film / music / art everything
happening around one place arts culture

Environments / 4 architect/designs create a space

Changing Iran → master architects projects
Retrospective of Ardalan

Early Photos in Iran (before Reza Shah)
Photography now
Tribal arts → Bokhara capes
Tribal Carnegie / Pittsburg
A Persian Garden — pic's →
Contemporary Poster in Iran

Film Clips — Large blowups / w/ various directors
+ film retrospective

one man shows
Retrospectives Parviz Tanavoli
Bahman Mohasses — Hossein Zenderoudi
Kamal - ol - Molk Bijan Saffari
Mansour Qandriz
Marcouch Yektai
Jelil Ziapour
Mahmoud Javadipour
Ahmad Esfandiary

Iranian artists working abroad Modabber
 Nayfar

① one man shows / founding fathers
 dead artists

requested a 20% salary increase, a housing and transportation allowance or a contract completion bonus.

The museum was slated to have five main galleries and several smaller galleries. Kamran Diba and I got together the very next day to thoroughly discuss the exhibition program, which was tricky to confront in the abstract. Special temporary exhibitions had to be staggered. Some would be on display for three months, and others for six weeks with space availability constantly shifting accordingly. Imagining the shape of the first year took a long time and precluded following up on the contract issues that most concerned me. As Kamran headed out the door, I peppered him with questions for which he had no answers. I knew I was being a royal pain in the rear but after all, this was my life we were talking about.

My allies advised me to keep these conversations confidential, because Kamran knew what he wanted, had the ear of Her Majesty, and he could take care of virtually everything. Dr. Bahadori called me at home one afternoon to tell me he had bumped into Kamran the previous week and he had told him I was a jewel and it would be foolish to let me go. Therefore, I thought the situation was going to be a workable one for me. Even though I knew from several sources that Kamran was power hungry and arrogant, I concluded he was easy to talk to and seemed to appreciate what I could do. Several weeks later, he offered me a position he called deputy organizer and I began to wonder if a badge and billy club would come with this ambiguous, inelegant and unprofessional title that would mean nothing to my peers in the museum field.

In retrospect, Diba's scheme and proposed title was an artful deception designed to fool me into thinking that he had actually received permission for me to work at the museum, which was still under the iron-fisted jurisdiction of the Secretariat. Indeed, there was a huge power struggle going on behind the scenes between the architect and the new head of the Cultural Department. Not surprisingly, Aydin soon told me I'd never work at the museum because I was not a Persian and therefore could not understand what was needed for his rapidly developing nation.

When I saw Kamran leaving the Secretariat after his meeting with Dr. Nahavandi, he told me that the new chief of cabinet was very angry at my salary request and, consequently, finalizing a contract might take some time. I told him that time was up because I was getting rid of my apartment and he needed to proffer a serious offer immediately. He said he'd get back to me in a couple of days, but never called. As it turned out, Diba was just using me to get information.[7]

My salary was three weeks overdue again. Virtually every month since my arrival, the Secretariat's accountants had harassed me when it came time to get my pay and I was often asked to justify my hours in writing.

From the beginning, I understood that I would put in many more hours than the regular workday as Dr. Bahadori always made time to see me after lunch, when almost everyone had already left for the day. In addition, I worked many hours outside of the office and Dr. Bahadori had agreed these hours should also be compensated. I was required to keep a log showing my extra hours and always worked more than the required one hundred and sixty hours per month. The Secretariat's bean counters expected me to be in the office by 8:30 am no matter what late night activity my job demanded. I told the Financial Department, "I'm not a day laborer and I don't have to check in like a wage slave." On one notable occasion when I went to collect my pay, which was usually enclosed in a sealed envelop, a Finance Department factotum removed my cash and counted each bill out loudly in a maneuver designed to humiliate me in the eyes of other employees who were also standing in line at the cashiers counter.

I wrote to Aydin demanding an explanation. He informed me that Shirvanloo said he never signed my time sheets and thus Aydin didn't feel it was his responsibility to set things right. I quickly showed him copies of the previous logs signed by Shirvanloo. It began to dawn on me that I was caught in the center of a four-way power struggle between the new head of the Private Secretariat, the old and new directors of the Arts and Culture Department, and the inaugural director of the Tehran museum.

Concurrent with these proceedings, Tamie Swett from Petersburg Press in London was in Tehran trying to finalize the purchase of thirty prints plus portfolios and illustrated books by Jim Dinc, Richard Hamilton, David Hockney, Claes Oldenburg, and James Rosenquist, among others, for which they were owed $63,000. As usual, the guys with the green eyeshades at the Secretariat accounting department were taking their pound of British flesh. Petersburg Press had received a letter signed by Dr. Bahadori agreeing to buy everything at a good discount. The art had arrived in Tehran early in November, but the Press was not notified and by late January, they still had not been paid and couldn't make any headway swimming against the tide. When Aydin told Tamie that they were not going to buy what had been ordered and delivered, that was the last straw as far as I was concerned. After much haggling and Tamie's unwillingness to take no for an answer, the Secretariat relented and agreed to purchase everything.[8] Tamie returned to London a feted heroine, which made me wish someone would say the same about me.

I was so frustrated, depressed, and unhappy that I could no longer choke back my feelings and found myself crying on the telephone with Aydin. While I fancied myself as an intelligent professional who accomplished her ends with logic, I now felt overwhelmed. I decided that I would not consider renewing my contract even if it was the last museum job on

Richard Hamilton,
Interior, 1964–65
Color serigraph,
57 x 79 cm

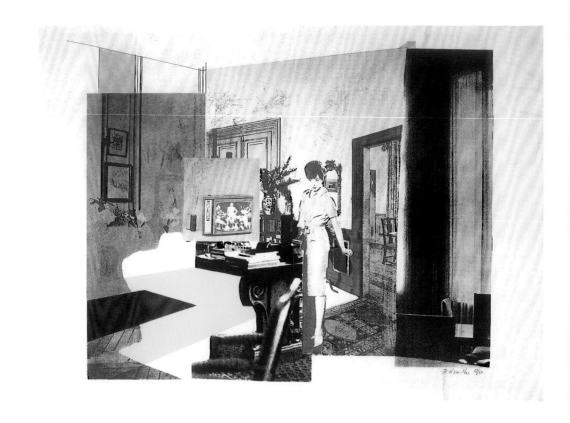

David Hockney,
A Hollywood Collection,
1965: Picture of a Landscape
in an Elaborate Gold Frame;
Picture of a Still Life that
Has an Elaborate Silver
Frame; Picture of a Portrait
in a Silver Frame; Picture
of Melrose Avenue in
an Ornate Gold Frame;
Picture of a Simple
Framed Traditional
Nude Drawing; Picture
of a Pointless Abstraction
Framed Under Glass
Color lithographs,
78 x 57.5 cm each
Edition of 85 each
Published by Gemini G.E.L.
© David Hockney

earth, and wrote a resignation letter. The next morning I delivered my missive to Aydin. He read it as I stood by and after he finished he said, "Oh come on," as if to say, "don't be a fool."

From the very beginning, I understood that the art collection I was forming would be the basis of a permanent collection for a first-rate museum of international modern art. Kamran, however, wanted the collection to be more narrowly focused. "When we started," he recalled in "Iran and the Art of Détente," "my plan was not to have a museum of modern art. I wanted contemporary art."[9] As has been previously described, when no director with international stature was interested in manning the helm, Kamran Diba was on hand to literally and figuratively pick up the pieces. He soon changed the name from the Museum of Modern Art to the Tehran Museum of Contemporary Art (TMoCA) and shifted the collecting emphasis to post-World War II American artists. Diba's choice of direction coincided with the period when New York surpassed Paris and Berlin as the capital of the art world congruent with the vision of scholars and art critics Clement Greenberg and Harold Rosenberg instead of Pontus Hultén, William Rubin, or Martin Friedman.

Aydin's ideas for the museum were in complete opposition to Kamran and he was unable to appreciate the virtues of a dynamic changing exhibition program. Aydin wanted the museum to confine itself to displaying works from the permanent collection, leaving changing exhibitions in the hands of Tehran's commercial art galleries. Then too, Aydin didn't want a foreigner involved in deciding what was best for Iranians, arguing, "They don't know our history and they don't know what we need, but I do." I reiterated to Aydin that I intended to take my leave as soon as possible saying. "I've had it. It's become all too clear to me I can never learn to operate in such a crazy environment. I've tried my dead level best for two years. You have no idea how fragile I've become and this project is not worth getting sick over." Tears streamed down my cheeks and I was mortified when I realized I was becoming a hysterical female stereotype. I was much too candid with Aydin and had recounted my history with the Secretariat holding nothing back nor leaving anything out. At the end of our conversation, Aydin refused to bring my letter of resignation upstairs to Dr. Nahavandi's office and it finally dawned on me that they might be plotting to keep me in Iran without a new contract.

Among the reasons I was determined not to leave before my responsibilities were completed was that I knew Shirvanloo and others were spreading malicious lies that I too had taken bribes. Tellingly, words meaning bribery or corruption are absent from Iran's sense of itself. In general, their economy is based on *parti bazi*, meaning having good connections. Connections refer to many different things—money, position, and family

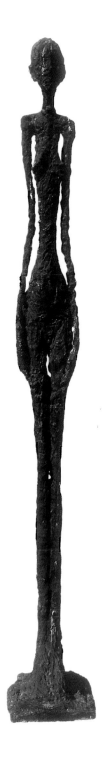

relationships. When I consulted Iradj Bagherzade about my situation, he opined that I was a virtual prisoner bound by red tape and internecine squabbles, because the only way that I could exit the country was to get a travel visa from the government. And the only way I could get an exit visa was if I had tax clearance, which had to come from my office. But the only way I could receive clearance from my office was if they certified I had completed my work, which implied opening all the art crates, and they were clearly in no hurry to do it. The shocking bottom line was my enemies could hold me hostage as long as they liked and I was powerless to do a damn thing about it.

Thus began a period of suspended animation and I began to feel sicker and sicker. Uncrating and checking the conservation status of the contents of more than sixty crates would take several weeks at best. "I guess your daughter is building character," I confessed to my worried parents, "but what a costly learning experience this has been."[10] One day Nahid Panahi encouraged me to consult the I-Ching and after tossing some coins I landed on the hexagram that stands for treading. The ancient Chinese fortune-telling oracle advised me to wait quietly and not take action, in the certainty that change was an inevitable force of nature and after many more travails, redemption would be mine.[11]

In the interim, I spent my time managing my personal affairs. I arranged to send most of my books and work files back to the United States via APO, which was a cheap and fast method available to US government employees. The director of the Iran America Society offered to do me this great favor, mainly because I had done enumerable services for them during my years in Iran without asking for anything in return. I began to sell various items I had lugged over from the USA including a 150-year-old American quilt, clothing that was no longer the latest style, and surplus kitchen equipment. I came to realize the Iranians had no conception of the stress level I was experiencing and never grasped how awkward it was for a foreigner to be left hanging on a fraying rope that was about to break. Without stronger inner resources I'd never survive this emotional roller coaster ride. Clearly my goal-oriented nature was not appreciated nor properly compensated, so growing self-knowledge would have to serve as my reward.

Since the change in administration, I spent my days in the office writing several essays for publication, which I didn't have time to do previously and found very rewarding. I wrote a piece on Ghasem Hajizadeh for an exhibition at the Iran America Society; an introduction on drawings for an exhibition at Litho Gallery (in collaboration with the Galerie Farideh Cadot in Paris) by 14 young American artists including Jack Barth, Tony Robbin, and Michelle Stuart. I completed a book review for *Leonardo* magazine. I interviewed Antony and Mary DeBone, two American artists who were

living and working in Tehran, for an exhibition in January 1977 at the Iran America Society. Marco Grigorian asked me to write an introduction about his earth works for the catalogue of his exhibition at Negarkhaneh Saman in January 1977. I also wrote an introduction for Monir Farmanfarmaian's exhibition brochure at Galerie Denise René in Paris, which opened on March 29, 1977.

Finally, the Secretariat's art committee finished checking all of my art crates. I prepared a detailed condition report for Mr. Aghdashloo the very next day. I was duty bound to inform him that when the crate containing Giacometti's *Standing Woman I* (1960, p. 165) was opened I found a break just below the torso across the thighs. I was worried that this exceptional eight foot, nine inch tall sculpture could not be repaired since it was broken at this masterwork's weakest point. Manoucher Yektai's *Still Life* (1975) that had been purchased in New York was also damaged. This colorful abstraction had a nail puncture in the bottom right quadrant, in an area painted shades of white that would make the hole hard to conceal. Nearly four months after my second contract expired, I finished supervising the opening of sixty-four crates, examining the condition of each item and identifying the works of art purchased by the Secretariat under Dr. Bahadori's administration. As my reward, I was finally given the tax document I requested and my long awaited exit visa soon followed.

In Iran in the late 1970s there was a pressing need to discover what the term "modern Persian" meant, and a passionate desire to bring to an end Europeanization and "Westoxification." Like me, most foreigners were resented and often accused of milking money. Many of the people I worked with were proud and ambitious but they achieved their positions not based on qualifications, but rather on family associations, influence, and bribery. No wonder Iranians didn't value challenges, ethics, professionalism, and the concept of a job well done. This fallow period highlighted the exceptional dichotomy between the professional and social aspects of my life. As an American expatriate, I was lauded and hated—simultaneously appreciated and despised.

Just days before I escaped to Europe, Nahid Panahi took me to another Iranian fortuneteller to help me anticipate the challenges that lay ahead. We entered the shabby kitchen of an old woman's house and sat down at a battered wooden table. After Nahid warmly greeted the seer and explained what we wanted to know, the old crone in black reached for my hand. She looked at my proffered palm intently then closed my hand in a hurry saying that unfortunately she was not in a position to reveal whatever she saw, but Nahid persisted on my behalf. Finally, the old woman relented. "You will soon be near death" she predicted, "but you will survive."[12]

[1] Afshin Matin-Asgari, *Both Eastern and Western: An Intellectual History of Iranian Modernity* (Cambridge University Press, 2018), 197.

[2] Letter to parents, December 11, 1976.

[3] Letter to parents, December 1, 1976.

[4] Sidney Janis was a wealthy clothing manufacturer and discerning art collector who opened an art gallery in New York City in 1948. He was known for exhibiting the works of the emerging leaders of Abstract Expressionism as well as important European artists such as Pierre Bonnard, Paul Klee, Joan Miró, and Piet Mondrian. In 1967, he donated masterworks from his personal collection to the Museum of Modern Art, where he had been active as an advisor from 1934. After his death in 1989, the gallery continued under the direction of his son Carroll and grandson David Janis.

[5] Conversation between Stephanie Barron and Kamran Diba at the Los Angeles County Museum of Art on April 2, 2010.

[6] After the Islamic Revolution, he founded the London-based independent publishing house I. B. Tauris, which was purchased by Bloomsbury Publishing in 2018.

[7] Letter to parents, January 29, 1977.

[8] In a conversation with the author on October 11, 2019, Tamie Swett revealed that Kamran Diba called her and confirmed, "Your bill will be paid but you must leave Tehran tomorrow." She left the next day without a check, but payment was eventually transferred to London.

[9] Arsalan Mohammad, "Iran and the Art of Détente," *Financial Times*, December 4, 2015.

[10] Letter to parents, March 15, 1977.

[11] Ibid.

[12] I became very sick in Tehran during October 1975, which was incorrectly diagnosed as strep throat. I had continuing periods of being unwell during my years in Iran and went to see doctors in London and Los Angeles during my travels. It wasn't until 1978, when I was back in New York, that I found out I had Brill-Symmers disease, a rare form of lymphatic cancer. Fortunately, after a year of treatment, I was pronounced cured.

Installation of Willem
de Kooning's *Woman III*,
1952–53 at opening
of TMoCA, 1977
Color slide
© Donna Stein

10. FREE AT LAST

I finally took refuge in Paris at the end of May 1977; it was sunny and beautiful. I knew I would miss the friends I had made in Iran, but I was sure our paths would cross in the future. Living in Tehran or frankly, working there, had been an enormous strain. I had been under duress for such a long time that I felt as if many of the happy aspects of my personality had been tied in knots. I wanted to relax and become my optimistic self again.

Since the previous summer, I had investigated various job opportunities in Europe and the United States, as well as reapplied to graduate school to complete my PhD. After more than two years in Iran, I wanted to immerse myself in research and scholarship and decided to return to the Institute of Fine Arts at New York University. Henry Russell Hitchcock, the foremost authority on the art and architecture of World's Fairs, some aspect of which I thought might be the subject of my doctoral dissertation, agreed to be my adviser.

After months of being manipulated, I was pleased when Kamran commissioned me to prepare two inaugural exhibitions from the permanent collection of works on paper for the museum's gala grand opening in October. After being forced to jump through so many hoops while building the collection, it was a delicious irony to actually feel needed by the museum after all. It felt good to resurrect my sense of connection to the project and I was similarly gratified when Diba met my terms for participating with no questions asked.[1] In April, I was additionally surprised when he added a third exhibit on Pop Art prints from the collection to my TMoCA guest curator portfolio.

By mid-June, I couriered an exhibition from London to the Iran America Society of top quality nineteenth- and twentieth-century European prints, ranging from William Blake's hand-colored relief etchings to color linocuts by Picasso, which brought me back to Tehran for two weeks. Kamran viewed several prints included in the IAS exhibition that I recommended for TMoCA's permanent collection, but he told me he didn't have any acquisition funds at hand and needed permission from the top to proceed.

Since I did not have much time to research and write scholarly catalogues for *Graphic Art. The Movement Toward Modernism*, and *Creative Photography: An Historical Survey*, I decided to return to New York, where I had easy access to numerous research libraries. Before leaving Tehran, I met with Roxanne Zand, the new curator of exhibitions at TMoCA. Among the things I asked her to facilitate for my exhibitions, I requested that she write to the Museum of Modern Art for permission to reprint and translate into Farsi a chapter in their publication *Modern Art in Prints* entitled "Care and Preservation of Prints," authored by paper conservator Antoinette King. I envisioned the informative chapter in my *Graphic Art* catalogue as an educational guide about the proper handling of works on paper.

I arrived back in New York City at the end of June, nearly two years to the day after I had first departed. Soon thereafter, I attended a charity luncheon at the Pierre Hotel where Her Majesty was the guest of honor. The Appeal of Conscience Foundation, the event's beneficiary, had been founded in 1965 to promote and support religious freedom for all faiths throughout the world. As I walked toward the hotel, I was shocked to see a large gathering of mostly Iranian students at a Fifth Avenue curbside demonstrating against the Shah's regime and protesting the oppression of Iranian women. As I entered the glittering grand dining room, I thought about the precarious situation of Iran's young women at home and abroad and my sadness stifled my appetite for lunch.

David Galloway (1937–2019), a professor of American Studies on leave from Ruhr University Bochum, Germany, had arrived in Tehran three months in advance of the opening to assume the role of chief curator and wrote asking me to send him exact specifications for all the photographs slated for inclusion in both of my inaugural exhibition catalogues. He told me that the staff of Her Majesty's Private Secretariat was moving and everything was in a state of utmost confusion. I wrote back immediately answering his questions and inquired about payment for my curatorial services as well as travel arrangements for my impending return to Tehran. In his next letter, David apologized that the museum was unable to include illustrations of all the art works selected for my two exhibitions.[2] This news disappointed me no end because I had envisioned these scholarly catalogues to be a definitive documentation of the exemplary works on paper collection I had managed to assemble despite formidable bureaucratic obstacles.

Before I left Tehran that June, I was also commissioned to write an essay for a coffee table book about the Behshahr Industrial Group's comprehensive collection of modern Iranian art. Behshahr, Iran's largest conglomerate, moved into new corporate headquarters designed by Nader Ardalan in 1973. The new building, inspired by the Madrasah-Mosque of Agha Bozorg in Kashan, represented a unique opportunity to assemble

Dinner with friends after TMoCA opening. Left to right: Ugo Ferranti, Yvon Lambert, Farideh Cadot, Christian Cadot, Anne Dagbert, Georges Boudaille, Donna Stein, Dennis Oppenheim, October 13, 1977 Polaroid

the first major Iranian corporate art collection. Behshahr purchased and commissioned artworks by established artists living in Iran, such as Massoud Arabshahi and Parviz Tanavoli, as well as expats like Manouchehr Yektai and Charles Hossein Zenderoudi. Guided by the personal taste of Behshahr executives, Ali and Hamid Ladjevardi, this pioneering family effort discovered more than a few emerging artists and by 1977 the Behshahr Industrial Group's impressive corporate collection comprised two hundred and sixty-five paintings and sculptures by seventy-five artists. Although I submitted my text in a timely fashion and each artwork was photographed, the book was never published because the Islamic Revolution intervened.[3] These assets were confiscated in 1979 and are currently locked away in the basement of the Saba Art and Culture Institute (SCAI), which is affiliated with the Iranian Academy of Arts. As in the case of TMoCA, where the international treasures remain locked away in a vault, few have seen the most important collection of modern Iranian art from the second half of the twentieth century since the dark day Behshahr's treasures were similarly impounded by zealous agents of the Islamic Republic.

All summer I heard from various friends that Tehran was extremely hot, dry, and dull, but museum construction proceeded at a frantic pace in the run-up to the grand opening scheduled for October. By late September, there was frenetic activity around the museum. Grass and saplings had been planted, and the sculpture garden was being graded while the two reclining Henry Moores looked on. The museum's signature copper covered skylights were already beginning to tarnish—a harbinger of unpleasant things to come.[4]

I returned to Iran in time to prepare for the grand opening on October 13, 1977 that was scheduled to coincide with the eve of the Empress's 39th birthday. More than thirty VIPs attended from the world of art and diplomacy. Among the notables were Nelson Rockefeller, a former vice president of the United States and long-time governor of New York State; Guggenheim Museum director Thomas Messer; Lisa Taylor, director of the Cooper Hewitt Museum; Waldo Rasmussen, director of the Museum of Modern Art's International Program; Luis Monreal, secretary general of the International Council of Museums; French critic Edward Lucie-Smith; English art dealer Annely Juda, and American artist Dennis Oppenheim, who exhibited commissioned maquettes for five new earthworks.

The Empress visited TMoCA in advance to observe the preparations for the grand opening. I proudly walked her through the two exhibits I had curated and explained why I had chosen each piece. I was additionally honored when Her Majesty encouraged me to walk with His Majesty through the exhibitions at the official opening a few days later. As the Shah and Shahbanou and I gazed at self-portraits by Marie Laurencin and Roger de la Fresnaye (p. 174), Max Beckmann, and Diego Rivera, I pointed out how important it was for contemporary Iranians to have access to masterworks of the past. I explained my choices by illuminating the roles the various selected artists played in the context of cultural history. The Shah's familiarity with Laurencin, a secondary early modernist, made me realize that he was much more informed about modern art than I was ever led to believe. Among my other peak experiences at the grand opening was when the Shah and Shahbanou introduced me to Nelson Rockefeller. I was delighted when

he grinned and said, "It's so wonderful to have one of MoMA's own helping
Iran and the arts in such a big way," thereby acknowledging my role as
a bridge between a pioneering institution that his mother Abby Aldrich
Rockefeller had helped to found and the international art community.

Dignitaries, middle-level government officials and the general popu-
lace mingled during three days of spectacular opening festivities. Under
the direction of Marilyn Wood, American dancers and musicians joined
Iranian folk dancers and traditional musicians for engaging, integrative
performances in the galleries, atrium, and on the roof. I was gratified
that my efforts to make connections for her with the directors of the
Shiraz Arts Festival and TMoCA had resulted in this exciting commission.
Thomas Messer was keynote speaker for a symposium on the "Evolution
of the Modern Art Museum." Dr. David D. Galloway spoke about "Policies

Marie Laurencin,
Self-portrait, 1906
Ink and brush drawing,
22 x 17.3 cm

Roger de la Fresnaye,
Study of Heads, 1923
China ink and brush drawing,
26 x 19.7 cm

Jacques Villon, *The Cards*
(also titled *The Game
of Solitaire*), 1903
Color drypoint, etching, and
aquatint, 34.8 x 44.8 cm

Signed contract for the
organization of three
inaugural year exhibitions

AN AGREEMENT

PARTIES TO THE AGREEMENT: THE MUSEUM OF CONTEMPORARY ART ("The
Museum"), of Tehran, and MISS DONNA STEIN ("Miss Stein"), dated
_February 26, 1977_____, at Tehran, Iran.

MAJOR RESPONSIBILITIES OF MISS STEIN: to organize, install and
write and prepare catalogues for the following three exhibitions
to be held at The Museum according to the schedule of The
Museum:

 1. Survey and history of early photography up to 1930;
 2. Master graphics before World War II and
 3. Pop Art prints.

FEE AND EXPENSES: the fee to Miss Stein would be 550,000 Rials,
plus two round air travel trips from New York to Tehran and
return, plus hotel and other expenses for a minimum three week
total stay in Tehran of 112,500 Rials. The catalogues will
each be designed to conform with the agreed to production cost
of 250,000 Rials per catalogue or a total of 750,000 Rials.

READ AND AGREED TO:

_____ 2535 -12-7
The Museum of Contemporary Art, Tehran Date
Per K. Diba, Chairman, Organizing Committee

_____ _____
Donna Stein Date

and Criteria to Guide the Museum's Exhibitions and Acquisitions," and
Judson Chrisney lectured on "The Museum's Responsibilities to Its Various
Publics." Eminent Iranian artist Parviz Tanavoli addressed "Challenges
Facing the Contemporary Artist in a Rapidly-Industrializing Society." A
day trip to Isfahan for visiting dignitaries was organized to see the glorious
monuments from the reign of Shah Abbas.

TMoCA was greeted with nearly universal enthusiasm. The galler-
ies were packed for the celebrations and subsequent press coverage was
very positive. Many discerning international art critics among the invit-
ed VIPs were surprised by the variety and quality of works on display,
characterizing the program as a significant effort to foster an East–West
cultural dialogue. Significantly, the Tehran Museum of Contemporary Art
debuted more than three decades earlier than any other international
museum in the Near East. Its royal patrons were extremely pleased to see

this groundbreaking cultural institution come to fruition, as it demonstrated an advanced point of view that was destined to inspire Iran's most talented contemporary artists. After the opening celebration, I flew back to America with Marilyn Wood and was happy to return to my old life in New York. Monir Farmanfarmaian's exhibition opened at Denise René's New York gallery in mid-November followed by a lavish dinner at the Iranian Consulate and, for an evening at least, it was like I had never left Tehran.

Meanwhile, Tatyana Grosman asked me to become her archivist at Universal Limited Art Editions. As previously mentioned, I also had signed on to curate a third exhibit for TMoCA during its inaugural year about Pop Art drawn from the more than fifty prints and illustrated books I had assembled by Jim Dine, Richard Hamilton, David Hockney, Jasper Johns, Roy Lichtenstein, Claes Oldenburg, Mel Ramos, Robert Rauschenberg, Larry Rivers, James Rosenquist, Andy Warhol, and Tom Wesselmann. After sending all the materials for a catalogue, the day before Christmas, Galloway wrote me a letter cancelling my contract for the Pop Art show and informing me that the museum had decided to do the exhibition in-house. Late in March, one-sixth of what I should have been paid for my services was transferred to my bank account and that was the last I heard from Dr. Galloway.

The exhibit I curated for the Iran America Society, *Nature 12 Americans*, opened in May 1978 as scheduled, although IAS could not support another return to Iran. I selected twelve contemporary American painters, sculptors, and photographers: Murray Alcosser, Jack Barth, Robert Delford Brown, Judy Dater, David Finkbeiner, Hermine Freed, John Henninger, Terence LaNoue, Tony Robbin, Eve Sonneman, and Michelle Stuart. Two works were purchased by TMoCA: *Bust of a Woman*, a collage and sewn fiber sculpture by John Henninger and Jack Barth's *Untitled* (1977), a work on paper composed of offset woodblock prints.[5] Henninger constructed his portrait by sewing stitches like a draftsman would use a pen, sometimes reinforcing naturalistic contours.[6] Barth's composition expresses the inherent instability between the two-dimensional space we associate with painterly illusion and the physical reality of the three-dimensional objects that are assembled on the horizon point of the painting.[7] I also influenced the acquisition of four works by Robbin and two by Stuart,[8] which were eventually purchased through Farideh Cadot Associés in Paris and became part of the TMoCA collection.

Just when I thought the news from the Near East couldn't get worse, Farabi University, where Feri Daftari was teaching, closed due to rioting by Islamic radicals in September 1978. The Iran America Society, which originally opened in the 1950s, was bombed about the same time and closed for good in November 1979. An American friend wrote me from Tehran

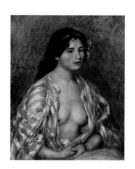

Pierre-Auguste Renoir,
*Gabrielle with an
Open Blouse*, 1907
Oil on canvas,
65.5 x 53.5 cm

in October to say, "People are talking freely and clamoring for change." Echoing the dire situation, my friend's going away party invitation that fall asked guests to attend an event dubbed Cocktails Before Curfew.[9] Like many people inside and outside of Iran, another American friend wrote that she found odd the coalition of extreme conservative Shiites and leftist students who disdained religiosity and superstition an odd one.[10] In reflecting back on the causes of the Islamic Revolution in our 1990 conversation, the Empress reiterated this point: "It started with the intellectuals, who said they were fighting against corruption. The intellectuals thought they could use this religious force, which is very difficult to fight, to assume power and to take over when the Shah left. I think many foreigners also believed in this approach. They expected Khomeini, who some considered a saint, to retreat to the holy city of Qom. Ultimately, many of the people who initially believed in him were disappointed, shot by him or ran away."[11]

Days before the Shah and Shahbanou departed Tehran for good, the Empress, fearing the worst, asked the curators of various museums to rescue precious objects as well as personal possessions from Niavaran Palace that had been given to the couple by various sovereigns and heads of state.[12] Aydin Aghdashloo verified that a part of the TMoCA collection had originally been displayed in Niavaran Palace.[13] Pierre-Auguste Renoir's *Gabrielle with an Open Blouse* (1907), for example, hung above a narrow bed in the King's private quarters. The Shah's French oncologist, professor Georges Flandrin, who prior to the Shah's departure would visit on a regular basis to supervise his care, confirmed this.[14] Ironically, Gabrielle was Jean Renoir's nursemaid; she was a cousin of Renoir's wife and lived with the painter and his family from 1894 to 1914. During those years, Renoir enthusiastically painted scores of portraits of this beautiful young woman.[15] The painting was never purchased for the National Collection, but was one of the objects transferred to TMoCA by the Empress and, because of Islamic modesty, has been banned from view ever since.[16]

Meanwhile, I received a letter from Feri noting that the general situation was deteriorating daily. "I sit shivering in my house where there is no heat. I can't leave my house because my car is out of gas, and the electricity goes off at night . . . this is a revolution and not a joke, so I suppose everyone has to pay a price." She sent me regards from Dr. Bahadori, who was still working at the court ministry. She didn't know what would happen to him and other colleagues, but she tried to put a positive spin on the uprising by pointing out that "People have lost contact with their own history and feel totally alienated . . . now there is a feeling of participation, a greater sense of mutuality, and less megalomania."[17]

With forty years of hindsight, the momentous departure of the Shah and Shahbanou from Iran on January 16, 1979 was a turning point in world

history.[18] Their exile changed the future of the region and brought about the arrival of Political Islam. I was working in Europe that January and assiduously following the global response to these events. Even though I wasn't shocked by the rise of fundamentalism, my family and friends, Iranian and otherwise, talked of nothing else. I feared for my friends and colleagues left behind in Iran and sympathized with others who were forced to make a new life as displaced persons in Europe and America. With each nasty development, I kept thinking of other missteps the American government had made in South America and Southeast Asia by misreading the situation and backing authoritarian regimes, and I wondered why the State Department and the CIA apparently failed to understand the threat to international stability that Iran's theocratic revolutionaries clearly represented.

The Islamic Revolution closed down the museum. Soon thereafter, the international collection I helped assemble became a hostage of circumstance. The art works began to gather dust in the Tehran Museum of Contemporary Art's subterranean vault because Iran's revolutionary leader Ayatollah Ruhollah Khomeini railed against "Westoxification," denouncing Western depravity, which he claimed had infected the Islamic world.[19] The artworks remained unseen until the first signs of post-revolutionary openness occurred in 1999, ten years after the death of Khomeini under the reformist regime of Mohammad Khatami. Nearly four decades later, the hostile attitude toward the Pahlavi Dynasty engendered by Khomeini's public relations machine has lost its legitimacy. Nevertheless, the Western works in the National Collection illustrate the complexity of the Islamic Republic of Iran's relationship not just with the West but also with its own pre-revolutionary past.

The Islamic government reopened TMoCA in October 1979, nine months after assuming power. A new radical exhibition program became an anti-Western instrument of political transformation. With occasional forays into the open air, TMoCA's Western art masterpieces remain sequestered in a locked basement storeroom. *Woman III*, a well-regarded New York School painting of 1952–53 (p. 168) from a series of six by Willem de Kooning, purchased from Galerie Beyeler in Basel, is a notable exception.[20] This masterpiece was on loan to the National Gallery of Art in Washington, DC and among the artworks seized by the US government after the revolution.[21] *Woman III* was eventually returned to Iran, but fifteen years later, in 1994, was quietly deaccessioned by a vote of the Parliament and exchanged for the rare and beautiful *Shahnameh of Shah Tahmasp* by Ferdowsi, one of the most famous illustrated manuscripts of the national epic poem of Greater Iran detailing the ascension of Shah Tahmasp to the Persian throne.[22] The illuminated manuscript originally

held two hundred and fifty-eight hand-painted miniatures and had been offered to Iran in the early 1970s for $28 million, well before the Iranian government art purchase program had gained access to an unlimited acquisition budget underwritten by petrodollars.

By the time Ferdowsi's "Book of Kings" was exchanged for the de Kooning painting, its previous owner, American industrialist and art collector Arthur A. Houghton Jr. had already given to the Metropolitan Museum of Art seventy-six text folios including seventy-eight miniatures in December 1970. He subsequently sold some of the *Shahnameh*'s most important miniature pages at a Christie's London auction in November 1976, some of which were purchased by well-known Iranian collectors. Nevertheless, the remaining one hundred and twenty miniatures were priceless to the Iranians, and the Islamic government decided to get rid of a "lewd and grotesque" de Kooning they would never have been permitted to exhibit in the interests of reclaiming some of their lost cultural patrimony.

Manhattan art dealer Larry Gagosian brokered the sale of *Woman III* to Los Angeles entertainment mogul and collector David Geffen, who paid $20 million for a work that originally was purchased for less than $1 million by Iran.[23] When the Empress learned the collection had been raided, she called the museum to protest, pretending to be an art student.[24] Geffen subsequently resold the picture through Gagosian to New York hedge fund billionaire Steven A. Cohen for $137.5 million in 2006. *Woman III* remains the only painting from de Kooning's seminal *Woman Series* in private hands.

Otherwise, the National Collection has remained intact except for two artworks that were vandalized by rioters at the beginning of the revolution. A public sculpture by Bahman Mohasses, who was known to be homosexual and therefore despised by the Islamic Republic, was destroyed. In addition, Andy Warhol's *Portrait of the Shahbanou* (1976), which once hung proudly at the main entrance of the museum, was slashed and burned. It's not clear how many duplicates Warhol made of his portrait of the Empress,[25] which was typical of his practice. Fortunately, at least a second example survived and was included in the recent Whitney Museum of American Art's 2018 retrospective *Andy Warhol: From A to B and Back Again*.

One subject that has been little discussed or acknowledged is that the Islamic Republic confiscated private property from the followers of the Shah who fled the country. Painter and former director of TMoCA Habibollah Sadeghi told journalist Kim Murphy that "one-third of the TMoCA collection had been added since the revolution." He confessed that "Some of these paintings were in the hands of private collectors, and in the fallout of the revolution, we feared they might go missing, so we painstakingly have assembled them here."[26]

Recently, TMoCA has developed new aspirations to collect international artists as evidenced by recent acquisitions donated by Günther Uecker, Bertrand Lavier, and Tony Cragg. The only modern artworks on permanent display are the sculptures in the atrium by Alexander Calder (*The Orange Fish*, 1946, pp. 60–61) and Noriyuki Haraguchi (*Matter and Mind*, 1977), bronzes by Max Ernst, Alberto Giacometti, René Magritte, Marino Marini, Henry Moore, and Karl Schlamminger as well as other outdoor sculptures by Max Bill, Alexander Calder, and Eduardo Chillida.

Beginning in 2001, there have been several attempts to privatize the Tehran Museum of Contemporary Art. The most recent endeavor to transfer control from the public sector to private ownership occurred in 2016, when rumors circulated that the museum would soon be relocated from the Iranian Ministry of Culture's Department for Art Affairs to the Roudaki Foundation, a non-governmental entity established under supervision of the ministry. Artists, activists, and other members of the cultural elite stopped this sly maneuver by launching protests because they believed the move would increase corruption.

Because the current president Hassan Rouhani is considered well versed in the value of cultural bridge building, several proposals from Germany, Italy, the US and other countries were submitted to host a touring exhibition vetted by the Iranian authorities. When progressive Iranian minister of Culture Ali Jannati stepped down in October 2016, this endeavor fizzled. Apparently president Rouhani canceled the tour because of financial concerns and in response to influential voices inside Iran who warned that there might be pending legal claims and consequentially there was a substantial risk that alleged creditors might seize the art.[27] Jila Dejam, the only photographer who had an official license to take photographs at the opening of TMoCA, posits that Iranians feared that "the art might not be returned, and that the wealth they have held on to so tenaciously might inadvertently be lost."[28] However, Farah Pahlavi, in a well-publicized interview, denied having any plans to reclaim the artworks.[29] She was happy that finally the Iranian people have realized that the collection is a priceless national asset.

This book would not be complete without accounting for the fate of other personalities that were so instrumental in accumulating such an extraordinary cultural treasure. After the revolution, Karim Pasha Bahadori worked for Sotheby's in Monaco,[30] where he now lives a quiet life with his family. Fereshteh Daftari completed her doctorate at Columbia University and served for more than twenty years on the curatorial staff of the Museum of Modern Art in New York. Beginning in 1993 with her numerous curatorial projects, she introduced an alternate Middle Eastern perspective through global artists in dialogue with the Western cultural bias. As an

independent scholar since 2009, she continues to curate exhibitions and write from a post-colonial viewpoint. Daftari's latest book entitled *Persia Reframed: Iranian Visions of Modern and Contemporary Art*[31] was recently published. Layla Diba returned to New York and completed her PhD at the Institute of Fine Arts, New York University. Currently, she is an independent Islamic scholar specializing in eighteenth- and nineteenth-century and contemporary Persian art. For ten years she was the Hagop Kevorkian curator of Islamic Art at the Brooklyn Museum of Art, where she curated the exhibition and edited its path-breaking publication *Royal Persian Paintings: The Qajar Epoch, 1785–1925.*[32] Kamran Diba lives and works between Paris and Costa del Sol, Spain. He continues his architectural practice and also makes art. In 2010, he published *A Garden Between Two Streets: 4001 Days of the Life of Kamran Diba* in conversation with Reza Daneshvar, but unfortunately it is only available in Farsi. Painter and art critic Aydin Aghdashloo remained in Iran after the revolution. He continues to take an active role in publicizing the contemporary art scene in Iran through teaching and curatorial projects that have traveled to China and Japan.

As I reflect back on the 1970s, I realize more than ever what an extraordinary opportunity I had to live and work in Iran during those heady years. Not only did I lay the groundwork for an exemplary collection for the museum, but also clarified my own scholarly interests, which served me well in the succeeding years. For twenty-five years I organized exhibitions for museums around the world and published accompanying catalogues, essays, and books about my curatorial interests. I worked for the California Institute of the Arts and the University of Southern California and eventually became the deputy director of the Wende Museum of the Cold War in Los Angeles, where I had a second opportunity to help build a new museum and a pioneering collection.

I never imagined I would become a confidante of the Empress because I was openly discouraged from having substantive contact with her during my tumultuous twenty-four months living within a short distance of Niavaran Palace. However, we began to communicate more after 1990, when she honored me by granting a wide-ranging and empathetic on-the-record audience at the home of a mutual friend in New York City. This auspicious occasion arguably represented the first time the Empress broke her silence in exile. Her willingness to trust me and speak her mind astonished me. I brought along the feminist portrait photographer Judy Dater to help me capture her grace and beauty. Our mutual appreciation increased when the Empress told me how much she enjoyed reading the portion of our conversation that pertained to museums and the arts when it was finally published in 2013. The text of the full interview appears here for the first time accompanied by some of Dater's photographs.

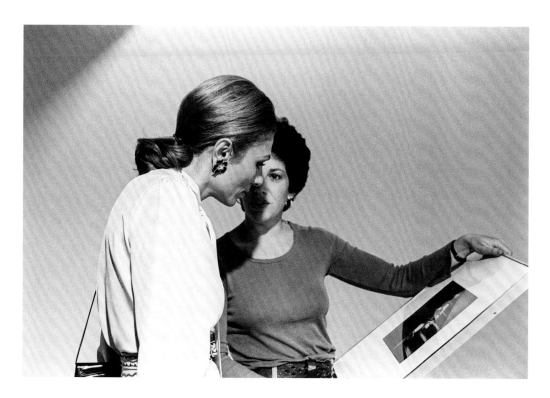

*The Shahbanou and Donna
Stein Discussing Bellmer
Photograph During
Installation*, 1977.
Gelatin silver print
© Jila Dejam

The Empress and I continue to speak from time to time as issues of interest to both of us arise. Her warmth and intelligence never fails to enhance my gratitude that fate connected two women of very different backgrounds who have both had their fair share of ups and downs. Despite formidable obstacles, we have managed to nourish many with transformative results from the lofty aspirations that originally brought us together.

[1] Letter to parents, February 21, 1977.

[2] Letter from David Galloway, Tehran Museum of Contemporary Art, August 27, 1977: "The problem is multiple. First, we sent you a cable on July 24 asking for your photographic requirements, and never received a reply. We were trying to set everything up for the photographer who was coming in from London. When the deadline had become urgent, I asked Roxanne to telephone you, and she gave me a list of the photographs you required, which turned out to be a supposed list of the photograph work not required—as we learned too late. This threw us into a mighty crisis here, and we began ransacking the files for photographs you thought were here. Many are not here; most of the rest have had paperclips put onto them, so that they are unusable for reproductions. (NB: the files arrived here with photographs thus defaced.) We therefore got in a photographer to fill in the gaps for your catalogues, but (the final crunch) many of the works for your shows are miss-

ing from the collection. We will find them in time for the opening, but we cannot possibly organize them for the photographer in time to meet the production deadlines. The excessive detail is intended, simply, to let you know we have made every effort in your behalf, but that an entire galaxy of circumstances seems to have conspired against us. Approximately half the works in both shows will, however, be illustrated."

3 Email from Hamid Ladjevardi, February 24, 2019.

4 Letter from N. Hart, September 24, 1977.

5 Email from Nahid Evazzadeh, TMoCA, May 1, 2019.

6 Oliver Andrews, *Limited Materials: A Sculptor's Handbook* (Berkeley and Los Angeles: University of California Press, 1983), 312.

7 Email from Jack Barth, June 5, 2019.

8 An email from Nahid Evazzadeh, TMoCA, May 29, 2019 listed the following works by Tony Robbin: *Untitled*, acrylic on canvas, 1976; *Untitled*, acrylic drawing on Arches paper, 1974; *Untitled*, acrylic drawing on Arches paper, 1974; *Untitled*, acrylic drawing on Arches paper, 1974; Michelle Stuart, *Canyon de Chelly, Arizona*, 25 color photographs, 1977; and *Untitled*, graphite drawing on paper, 1976.

9 Letter from N. Hart, October 21, 1978.

10 Letter from J. Taboroff, November 11, 1978.

11 See Interview, 198–99.

12 Farah Pahlavi, *An Enduring Love: My Life with the Shah, A Memoir* (New York: Miramax Books, 2004), 4.

13 Leonardo Bordin, *Storia del Museo d'Arte Contemporanea di Tehran*, degree dissertation, Università Ca' Foscari, Venice, Department of Philosophy and Cultural Assets, academic year 2015–16, 25.

14 Pahlavi, *An Enduring Love*, May 1, 1974 medical report, 245.

15 Barbara Ehrlich White, *Renoir, His Life, Art and Letters* (New York: Harry N. Abrams, Inc., 1988), 200.

16 Confirmed in a telephone conversation with Farah Pahlavi on May 18, 2019.

17 Letter from F. Daftari, January 18, 1979.

18 In a letter dated May 8, 1977 Dr. John Mack, a Pulitzer Prize winning Harvard professor of Psychiatry and my uncle through marriage, presciently commented on the situation in Iran: "I think that a society, which looks upon dreams, as the article you sent suggests, must have other problems in regard to its view of reality. The bit at the end about the sovereign who imprisoned the soothsayer who didn't tell him what he wanted to hear and rewarded the one who did, is especially revealing. It suggests (and I assume some of this still goes on) that once you are in power you can declare reality, or get others to declare it, to be anything you wish. Life becomes then merely the manipulation of dreams and fantasies and wishes by the powerful at the expense of the weak."

19 *Arab Weekly*, November 11, 2015.

20 Information confirmed by Lenore Greenberg, May 25, 2019.

21 Jeff Gerth, "Iran Says U.S. Museums Hold Its Art," *The New York Times*, December 12, 1979, C28.

22 This long poem was written between c. 977 and 1010 CE.

23 St. Louis art dealer Nancy Singer wrote me on November 1, 1976, saying "Had dinner at Lee Eastman's with Bob Motherwell and new wife and Bill Lieberman . . . Heard Iran bought a DeKooning $800,000???"

24 Myrna Ayad, "The Queen of Culture: Her Majesty Farah Pahlavi," *Canvas*, 6 I (2010): 38–49.

25 *PRI's The World*, produced by Shirin Jaafari, November 4, 2013. According to Bob Colacello, at the time of this program there were copies at a restaurant in New York.

26 Kim Murphy, "Picasso is Hiding in Iran," *Los Angeles Times*, September 19, 2007.

27 The artworks chosen for the exhibition in Berlin and Rome were ultimately shown in Tehran beginning in March 2017. A handsome catalogue was published: *Selected Works of Tehran Museum of Contemporary Art, Berlin–Rome Travelers*.

[28] Werner Bloch, "Wild nights at the museum: Long-hidden pictures reveal Tehran in the late 70s," *DW*, February 17, 2017, https://www.dw.com/en/wild-nights-at-the-museum-long-hidden-pictures-reveal-tehran-in-the-late-70s/a-37599194

[29] Mohammad Salemy and Stefan Heidenreich, "Vultures over TMoCA? What's behind the cancellation of the Berlin Exhibition from the Collection of the Tehran Museum of Contemporary Art," e-flux conversations, November 5, 2016, https://conversations.e-flux.com/t/vultures-over-tmoca-what-s-behind-the-cancellation-of-the-berlin-exhibition-from-the-collection-of-tehran-museum-of-contemporary-art/5438

[30] According to David Nash, May 23, 1982. Thanks to Dr. Zahra Faridany-Akhavan for confirming Dr. Bahadori's place of residence.

[31] Published by I. B. Tauris & Co. Ltd, London, 2019.

[32] Edited with Maryam Ekhtiar, containing essays by B. W. Robinson, Abbas Amanat, Layla S. Diba, Maryam Ekhtiar, Adel T. Adamova, Afsaneh Najmabadi, and Peter Chelkowski, Brooklyn Museum of Art in association with I. B. Tauris Publishers, 1998.

František Kupka,
Mechanistic Series,
1923–26
Gouache and pencil
drawing, 28 x 28.2 cm

George Grosz,
Unexpected Guest
(also titled *The Man Who
Ate Himself to Death*), 1925
Watercolor, gouache, pen,
and ink drawing, 46 x 60 cm

Jean Dubuffet,
Inhabitant of the Oasis,
March 1947
Watercolor, pen, and ink
drawing, 17.5 x 26.5 cm

A SEED PLANTED WITH LOVE
NEVER DIES

Farah Pahlavi was the first female patron of the arts in Iranian history. She retains a deep affection for her country and with each passing year, her legend and legacy grow. Her Imperial Majesty Shahbanou Farah Pahlavi has lived in exile since January 16, 1979. Her departure followed eighteen months of increasingly violent demonstrations against her husband's rule. To this day, Farah Pahlavi remains a beacon of hope for many Iranian artists who still work under difficult circumstances. "I buy work that I can afford by contemporary Iranian artists from their galleries in London, New York, and Paris," she acknowledges. "It's important to me to be surrounded by the art of Iranian artists; It makes me feel like I am living among friends and that gives me energy."[1] "I do not live in the past," she has said, "I live in the present, always hoping for a brighter future. This is my message to my countrymen."[2] Her personal wish is that Iran will eventually become a democratic society that respects women's rights, thereby becoming the glorious country it surely deserves to be. Farah Pahlavi remains devoted to her family and divides her time between Paris and Potomac, Maryland. Through her challenges as Empress, she discovered what she was capable of and set a good example for modern Iranian women and men. Her leadership ensured that the 1970s will be remembered as a golden age in the arts for the Iranian avant-garde as well as for traditional Persian artistic expression. She is a leader of Iran's long march toward its rightful place and an inspiration for the international community.

On October 18, 1990, eleven years after the revolution, I had an extended on-the-record conversation with Shahbanou Farah Pahlavi. The discussion that follows is a transcript of the first comprehensive interview she granted after going into exile. A portion of the interview that relates to the arts was published as a chapter in *Performing the Iranian State: Visual Culture and Representations of Iranian Identity* in 2013.[3] More spirited discussions between us have continued up to the present, underlining our shared conviction that seeds planted with love continue to sprout.

Donna Stein: *The last time we met was a very grand occasion—the opening of the Tehran Museum of Contemporary Art in October 1977. I had the great pleasure of showing you around the exhibitions I curated of works on paper (prints, drawings, and photographs). The Shah was there and you kept pushing me forward to speak to him and explain everything. What were your goals and aspirations as a patron of the arts in Iran?*

Farah Pahlavi: I had such high hopes for the preservation of my country's heritage and Iran's emergence as a contemporary cultural force. I have loved art since my childhood and considered beauty life's principal pleasure. As a student, as a queen, and especially now, it adds a special dimension to my life. I really believe the old saying: "A thing of beauty is a joy forever." As a developing country, Iran had many economic and social problems. For a long period, there was little attention paid to our artistic heritage. I have an enormous respect, love, pride, and belief in our thousands of years of history and civilization. I believe we have to learn from it. Although many programs started before I became Shahbanou, I hoped to make our legacy better-known for all our people to be proud. Of course, there were many who cherished our past and culture, but to love it, you have to know it; to know it, you have to see it, to read and learn about it in books, to have museums and examine objects. Like other developing countries, we had an inferiority complex about the advanced world, and everything outside Iran was admired and considered more beautiful. But in the last years of the monarchy, we had passed through this period of emulation, and our identity was secure.

DS: *Did the Iranian people need a point of comparison?*

FP: Not really, because Iran is an ancient country, one of the cradles of civilization. Although we had been invaded by many cultures, like the Hellenes, the Arabs, the Mongols, and had political relationships with the Chinese and Indians, we never lost our own identity and authenticity. We learned from other cultures, and they learned from us. We have an unending treasury of beauty and inspiration—in poetry, science, philosophy, architecture, ceramic work, textiles, handicrafts, jewelry, metalwork, painting, miniatures, and architectural brickwork that we had to preserve and, at the same time, make known to our people.

DS: *Did you think it was important to distinguish what was unique about Iran?*

FP: Absolutely. The style of architecture in our country, for example, is very special, because it was built for the region, climate, and people. Even the material that was used, *pisé*, was made from the earth, not to distract from a unity of form and color with the landscape. And simple unedu-

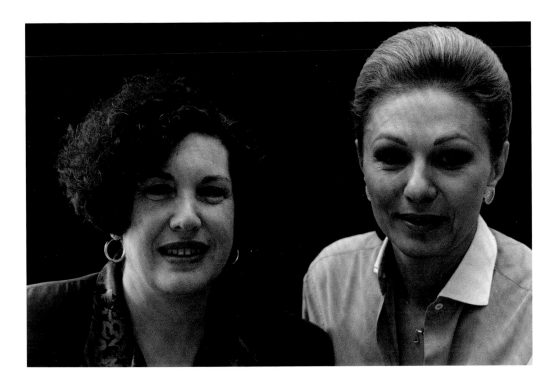

cated people built these structures. They were artisans. They didn't have diplomas. Of course, our houses should have had better hygiene and more modern standards of living, but we had to make our builders understand and believe that what they did was truly beautiful and should not be destroyed by development, even though it was made of mud.

DS: *Is the* badgir *(wind tower, wind catcher) a good example?*
FP: Yes. When there was no air-conditioning, as we know it today, desert cities, like Yazd and Kashan for example, where it is very hot for most of the year, had a *badgir* to create natural ventilation in buildings, which made living in such an inhospitable climate tolerable. The design of *badgir*, while efficient and economical, was also pleasing to the eye. In cities like Bandar Abbas, where for six months of the year it is extremely hot, this invention was fantastic. Not only were the towers distinctive, they made the basements of houses at least 15 degrees centigrade (59 degrees Fahrenheit) cooler.

DS: *You have great passion for architecture.*
FP: I really do. In preserving our old ways, we could not forget we are living in modern times. Henri Corbin, a French scholar who wrote about mysticism in Iran, was a great lover of our culture. He said, and I have to paraphrase him, "Tradition is good as long as it is creative. If there is no

creativity, tradition remains only a funerary cortege." We had to learn from our past, but at the same time, allow contemporary-inspired ideas to flourish. We wanted to encourage our creative people. We could not always copy what we have had for thousands of years. From a national perspective, aesthetic considerations have a powerful impact on progress, invention, renewal of self-determination, social integration, and quality of life. We had to improve our educational and cultural values, because physical and material developments proceed much faster than cultural advancement. Like so many other Third World societies, we had to break loose from the tyranny of resistance to change and the inertia of underdevelopment. My husband and I sincerely believed change required cultural transformation. We were inspired and helped by many Iranians who had deep knowledge of our culture and believed in social change. It is not an accident that those, like some mullahs, who were anti-development, were also virulently anti-art, anti-beauty and anti-happiness. Here again a comment by Avicenna [c. 980–1037], the great physician and philosopher who lived in Persia during the eleventh century, seems appropriate: "The ultimate of life is love, love of beauty. And beauty is an ideal seekingness." We had to respect this fact and learn from it, not become depersonalized and lose our individuality in the course of rapid development. We could have succeeded because we had national wealth and human riches. What we had to instill was the desire and understanding, which, from my point of view, occurs with the growth of art and culture.

DS: *Are you a collector by nature?*
FP: Not really. Of course, when I was in Iran, I collected a few things, especially Persian art. I had some pre-Islamic objects and Safavid and Qajar lacquered papier-mâché *qalamdans* (pencil boxes) and Qur'ans and some enamel work. I bought some modern art, not many paintings and sculptures, but lithographs by artists like Miró, Chagall, Calder, César, Arman, George Segal, Arnaldo Pomodoro, and Rouault, just for the sheer pleasure of looking at them.[4] I wanted to have beautiful objects around me. I also bought artworks by contemporary Iranian artists because I liked them and wanted to encourage and support our national artists by exposing their work in the Palace. On the few occasions when government officials wanted to give us presents, I asked them to offer significant miniature paintings instead of a pretty box or object, so our national patrimony would remain in the country. At first, most Iranians didn't have the money to collect, and later, those who had the money and the interest started some very beautiful and serious collections of Persian art. I also received various presents, such as pre-Columbian sculptures from Latin America and masks from Africa. Eventually, what I tried to collect were old books about Iran by

travelers, published in previous centuries. So many of these books contain magnificent engravings of historic personages and monuments, many of which no longer exist. I wanted to study them. Of course, this collection remained in Tehran.

DS: *Do you collect now?*
FP: No. When I left Iran, times were so difficult, and I was so upset mentally, thinking of all the efforts lost. It made me sick to go to an art gallery or museum. It took time to rehabilitate myself to a normal life. Unless one has been in exile, there is no way to comprehend that feeling. When I first came to America in 1982, I vowed I would never collect again. But life takes over. I needed to furnish a house—empty walls are very depressing. So I bought some modern Persian paintings because of their emotional and not just artistic value. I also have a few Persian objects people gave me or I acquired. Not many, just some symbols for my children to remember their heritage. If you have a carpet somewhere in the house, a Qajar period painted lacquer object, you begin to relate to your personal history and country. Now I am trying to find books about Iran, not just the old ones, but recent publications too, because so many of them are already out-of-print.

DS: *Who were your cultural advisors?*
FP: There were many, especially for Persian art history. Many Iranian scholars and artists would discuss their ideas, teach, or advise me. In the field of modern art, I really didn't have an advisor. I visited galleries, cultural foundations, museums, and artist studios when I traveled abroad and inside Iran. I didn't formally study art, but I love it and was in a position to make some dreams come true.

DS: *Do you have any art advisors now?*
FP: No. Sometimes I visit galleries and museums.

DS: *How do you think your architectural training and French cultural background affected your personal taste and approach to the arts?*
FP: I finished high school in Tehran and then went to Paris where I was a student of Architecture for two years. During that time I visited galleries and museums regularly. I loved what I was doing. In those days, there was only one female architect in Iran (Nectar Papazian Andreef). Later, there were many, and today, there are more still. After I married, I enjoyed meeting with architects, discussing what should be done in Iran. Many Iranian-born architects studied abroad and when they returned home, they copied whatever they had learned in America, England, France, or Italy. Slowly, these architects realized they needed to find an individual

style, not repeat the past or aspects of say, Los Angeles architecture. By using the old and ancient architecture as inspiration, they had to reconsider the lifestyle, climate, and other factors, which was very hard because the country was developing fast. By the time you took care of something, another building was destroyed, and something else was built in its place. We organized a committee to reward those who built beautiful buildings inspired by Iranian architecture. Architects would bring me their ideas about urban design and the development of our new society, and I would convey the information to the proper governmental authorities. Later, we created a High Council for Urban Design to help control the planning and rapid development of cities throughout Iran without destroying their old sections and monuments in a rush for the new. This was not easy.

Architecture is not just one building; it is about the life of a family in society. City planning, urban design, housing for people have so much influence on society and politics. This was not just our experience but also the experience of most of the developing countries throughout the world. You cannot take a villager from his little hamlet and put him in a ten-story apartment house. He would feel miserable and alienated and wouldn't know how to live in those conditions. There were so many social aspects of their lives we had to consider. Also, it was not always easy to implement our ideas, because there were responsible persons who didn't believe in them.

DS: *Did you travel extensively around Iran?*

FP: One of my great joys was traveling many thousands of kilometers to the far corners of Iran by all means of transportation—car, jeep, one propeller, and jet airplanes. I visited nearly every community from north to south, east to west. I planned these visits so members of government and concerned organizations would accompany me to speak with local residents and learn their problems firsthand. Sitting in Tehran, it was hard to appreciate the real needs and priorities of a distant community. People confided in me, and I reported back to my husband. Thank goodness I was young and had a lot of energy. I would go to different places, imagining I would be sad because of the poverty and underdevelopment, but people have such human spirit and integrity that I would return to Tehran every time filled with hope and resolve. I really loved village architecture in the desert. The buildings needed repair and a healthier way of living, but they were beautiful, like sculptures made by hand. On one visit, when I told the people of a village, "Why don't you let us repair your houses?" one of the village elders asked, "Why do you want us to live in these ugly ruins? Build us houses like Tehran." Whatever was in Tehran seemed better and more advanced. We preserved two of our beautiful towns as national monuments: one was Masuleh, the 1,000-year old village near the Caspian Sea

situated on a steep slope where roofs and streets become one; the other was Tabas, which tragically was completely destroyed during an earthquake.

DS: *I'll never forget a story someone told me of trying to get a group of tribal people to stop being nomadic. A new city was built for them in the desert to inhabit, but they never used it because they refused to give up the traditions they knew.*

FP: Some nomads eventually became city dwellers, but many of them wanted to continue traveling in their old patterns. You cannot force them. Many of these tribal people had sons at Harvard and Columbia Universities, but they were still living as nomads. For them we had a wonderful educational program—mobile schools in tents, just like the way they lived.

DS: *So many of the tribal groups spoke different Turkish dialects. At what point was Farsi nationalized?*

FP: In 1935, during Reza Shah's time, Farsi became the official Persian language. Children had to learn Farsi in school—nevertheless, tribal people continued to speak their native dialects in daily life, because they were not written languages.

DS: *I remember visiting a small village near Kermanshah and speaking with a young girl about ten years old. I asked her about her family and what they did. She told me that her parents spoke Turkish and they couldn't communicate in Farsi. Their tribal group didn't speak the official Persian language. That conversation brought home to me what a significant problem it was to try and unify a country.*

FP: During Reza Shah's era the centers of power were scattered. Most of the population was nomadic and some of these travelers were robbers and bandits. We needed a unifying factor for all these ethnic and minority groups, otherwise the country could not move forward. During my husband's reign, we had reached another position. We found that too much centralization had become a problem. Consequently, we were in the process of changing some laws to make the various provinces more autonomous and self-sufficient. We believed that the kingdom was the cement of these religious groups and minorities, which would gather all under one umbrella.

DS: *During your tenure as Empress, was there true freedom of religion? My experience was that it was quite open to all groups.*

FP: Iranian people in general are very tolerant. We have had periods of difficulty because of the instigation of religious clerics. However, I still believe most Iranian people are tolerant if left on their own. We have never been a colony of another country and we never developed a hatred of foreigners.

The biggest religious minorities in Iran included the Christians, the Jews, the Zoroastrians and the Bahá'ís. About 8% of the Islamic population was Sunni and not Shiite. The Sunnis primarily lived in Kurdistan, Baluchestan, among the Turkomans in the North, and along the Persian Gulf. During my husband's reign, these groups all had their representatives in Parliament and the Senate. They were free to have religious schools, religious ceremonies at their houses of worship. Nevertheless, there were some laws in the Constitution that favored the Shiite. At the level of minister, for example, a candidate had to be a member of the Shiite faith. The only problem that existed was with the Bahá'ís, because their faith started after Islam, which is not acceptable to practicing Muslims. Some Bahá'ís were mistreated because of the instigation of the Islamic clerics, not by the government. We had hoped to break this barrier, although it was not easy, because my husband was head of the religion and keeper of the Shiite Moslem faith. I think if we had had more time, this problem might have improved.

DS: *In hindsight, should the Pahlavi administration have been more respectful of traditional Islamic values?*
FP: What happened in Iran is the result of so many factors. My husband possessed the traditional values: whatever changes were made in Iran were with the blessings of our respected religious leaders. But he understood that these people used Islam as a tool to achieve their own authority. Their greed for money and desire for power caused them to be against many of the social changes implemented in the White Revolution of 1963. But you cannot stop development, which demands changes in a society, like women's emancipation, land reform, and so many other programs. We had a different point of view.

DS: *Were these opposing Islamic religious leaders heard and given an opportunity to have some effect?*
FP: Yes, but when they started to undermine all the reforms, it was impossible to accept their judgment, because the country had to move forward. Finally, there was no point of negotiation. We could not change the beliefs of some orthodox religious people. However, I believe the revolution in Iran started as a result of other criticism. Religion came afterwards. The first slogan was democracy, which the religious leaders didn't believe in and they have said so. It started with the intellectuals, who said they were fighting against corruption. The intellectuals thought they would use this religious force, which is very difficult to fight, to assume power and to take over when the Shah left. I think many foreigners also believed in this approach. They expected Khomeini, who some considered a saint, to re-

treat to the holy city of Qom. Ultimately, many of the people who initially believed in him were disappointed, shot by him or ran away.

DS: *It was understandable that Iran wanted to buy back its national patrimony and build museums to represent the finest examples of indigenous art. What did you have in mind when you authorized the acquisition of international modern art and the building of more than one museum to house it?*

FP: We created a number of museums to house our beautiful objects and treasures. We had to collect them from inside of Iran and buy back those collections that had fled the country. The Negarestan Museum housed eighteenth- and nineteenth-century Qajar period paintings, jewelry, and popular paintings of the period. It was unbelievable to me that we didn't have one museum for our carpets. The carpets of Iran are among the products that are most known to the world: there is Persian oil, Persian carpets, and Persian caviar. Over many years we located the valuable carpets in Iran, sometimes in palaces and government offices. After identifying what was in our own country, we purchased some special collections and brought them back to Iran for the Carpet Museum in Tehran. At the Reza Abbasi Cultural Center we housed pre-Islamic and Islamic objects and books that we had to buy and bring back to Iran. The Iran Bastan was in the process of being restored and redecorated, so we exhibited its collections at the Reza Abbasi center as well. The Abgeneh Museum and Cultural Center, in an old Qajar house that we managed to buy and restore, was designated for ceramics and glasswork. The building was restored and vitrines were ready, but I did not have a chance to inaugurate it. I understand the objects were eventually installed, and the museum is open to the public. I was intent that all the museums would not be in Tehran. Some people from Khoramabad, which was the center of Luristan, told me about a fortress-like building called Falaq Ophlak that in the olden days had been used as a prison. The governor of the region made this building available for a museum, which ultimately contained the ancient Luristan bronzes. We collected objects from inside and outside Iran. In Kerman, a family interested in art and culture donated a beautiful old house and garden for another regional museum, which had its own Board of Trustees. The subject of their first exhibition was Persian painting and the design of carpets. We were happy to encourage private individuals to contribute to the nation's cultural profile.

 As for the museums of modern art, many Iranian painters came to me and complained that they needed a place to exhibit their work and wanted to see paintings from other countries in order to learn from them. Eventually, we decided to establish a museum of Western art for our people to see

contemporary developments outside of Iran. After all, the Metropolitan Museum of Art in New York exhibits Near Eastern art. We envisioned the museum as a lively educational center, a place where people would attend lectures, hear music and see films. The museum's placement in a park in the center of Tehran helped to encourage visitors who happened to be walking nearby. I don't recall how we decided to create a museum of Western and Iranian contemporary art in Shiraz, except that Shiraz was a developing city and becoming industrialized and had a big university. We chose Alvar Aalto as the architect, because he was such a famous international figure. We thought his building would be a work of art. He came to Iran and loved Shiraz, where he chose a special site for the museum.

Besides these museums there were some cultural centers in different parts of Tehran, like the one in Niavaran, which has a huge old garden that we saved and preserved. That center had an exhibition hall, boutiques, and a theater with a very active program, including workshops. The Bagh-i-Firdoz in Shemiran had an old Qajar house that had been a high school for girls at the beginning of the twentieth century. The government transformed the site into a public park and cultural center.

We were particularly proud of our libraries for children, which also featured paintings, handicrafts, and music. These centers were free. We were in the midst of building the Center of Intellectual Development of Children and Young Adults. Education was so important in our country, not just academic education, but hands-on training. We had started by taking a box of children's books into downtown Tehran and eventually it grew into a huge organization that built libraries in cities around the country. Children could check out books from these centers and take them home and read them to their illiterate parents in order to teach them to read. We also had mobile libraries that took books to tribal groups by jeep or mule. Because we didn't have enough writers, illustrators, or filmmakers for children's material, we started a whole creative movement. Over a period of ten years we developed a film industry devoted to children's needs and sponsored a fantastic film festival for them. Many of our books and films won international prizes. We also sent young artists abroad to learn about puppetry, animation, and moviemaking.

DS: *What was the purpose of the Iran Cultural Foundation?*
FP: The Iran Cultural Foundation, which promoted the Persian language through the publishing of books and translations, was important to me. This organization published books about Persian history, culture, and literature. We sent teachers abroad to countries like Pakistan and Egypt. There was also the Imperial Academy of Philosophy, which dealt with the relationship between values and beliefs in the East and the West. We had

the Asia Institute, affiliated with Pahlavi University in Shiraz, which was created by Arthur Upham Pope, a renowned American expert on Persian art, who was very well-respected by all Iranians. He published a twenty-four-volume survey of Persian Art, making Persian culture known to Americans and others around the world. He loved Iran so much that he chose to be buried in Isfahan.

DS: *Were the budgets for your cultural programs part of the Five Year Plan?*
FP: Yes. The Five Year Plan provided some funds for cultural activities, especially for the Ministry of Culture and some of the other organizations. The National Iranian Oil Company (NIOC) also provided some funds.

DS: *Did your office apportion the monies for each of the museums and organizations?*
FP: The largest expenses we had were for buying the objects and building homes for them. Iran had a good period of earning a lot of money from our oil. The government was ready and prime minister Amir-Abbas Hoveyda was very understanding and helped support the purchase of our national patrimony as well as other objects for the museums. Each organization negotiated directly with the Ministry to finalize their budget. If the government didn't accept the plans of these organizations, they would often come to me, and like everywhere in the world, I would push or lobby for a cause or a budget.

DS: *How did your Secretariat interface with the Ministry of Culture, which also had some responsibility for these matters?*
FP: They had the biggest responsibility for the cultural life in Iran. I think we helped each other. Some projects were difficult to achieve through the bureaucracy of government and were easier to accomplish through a foundation or my Secretariat. At different times in history, the Ministry of Culture was not as strong as the Ministry of Labor or the Ministry of Economic Development. We helped each other implement cultural ideas at the government level. They would often ask me to defend their viewpoint. I remember once, around the tomb of Imam Reza in Mashad, an argument erupted about a very old Timurid building and ancient wall that the Ministry didn't want destroyed because it was considered a national monument. But the governor in charge at that time wanted to add onto the shrine and insisted on removing the wall. The Shah and I had to accompany the minister of Culture to Mashad and explain in front of everyone that the wall was indeed a landmark. It took hours of work to find and verify the information. I took all the files from the Ministry of Culture to prove our case. In some ways, I was the Ministry of Culture's guardian angel.

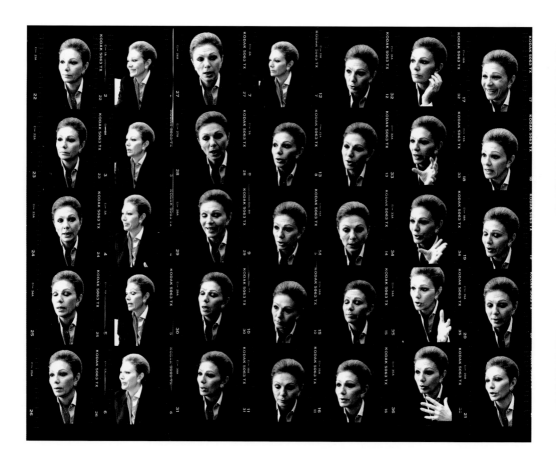

Contact sheet of
Farah Pahlavi, 1990
Gelatin silver print
© Judy Dater

Other times, the Ministry of Culture was not happy because my Secretariat had more freedom to act. One example concerns the Negarestan Museum. I waited for two years for the Amery collection of Qajar paintings to be studied by experts, who had to go to London, assess the value of the artworks, and write a report for the Ministry of Culture. Finally, the collector became so fed up that he decided to auction the collection through Sotheby's. When I heard that, I was so mad, I wanted to cry. I sent my chief of cabinet to London to purchase the collection as a whole. I knew if we had to buy the paintings one by one, it would cost ten times the price we were prepared to pay. I took full responsibility.

For three years, I had someone in my Secretariat working on a book about the brick designs and geometry of tile work in Iran, which I love. The book by historian Yahya Zoka was published after we left; I found it in the United States. We also commissioned a big study on Isfahan's bazaar, which was more than six kilometers long. We wanted to map and preserve the caravanserai, some of which were divided by roads and avenues.

DS: *Do you consider handicraft as part of art?*

FP: I love Iran's handicrafts. All over Iran we had so many beautiful and

different varieties of embroidery, weaving, ceramic work, and metalwork with a high level of craftsmanship. Economically, handicrafts helped the villages. The income from agriculture was not so much. Handicrafts became a cottage industry next to whatever villagers did otherwise. With help from the Ministry of Economic Development we tried to encourage and promote these objects in the cities and outside our country.

DS: *The Finnish architect Alvar Aalto's Shiraz Museum of Western and Iranian Contemporary Art was one project that was never realized. Were there others?*

FP: There was a fortress in Shiraz from the Zand period (1750–94), a huge building that at some point had been a prison. It had been empty for a long time and we wanted to create a museum of handicrafts. The building was architecturally interesting and it had a huge garden. The underground cultural center for the Marble Palace Park, the location of the Negarestan Museum, was never completed. We also had plans for a museum of calligraphy. A science museum was to have been located in a beautiful garden in Shemiran.

DS: *At what point in your life with the Shah did you begin to become involved in Iran's cultural life?*

FP: I was twenty-one years old when I married in 1959. I was young, didn't know my limitations and felt a person in my position could do so much. I met a lot of people in different branches of government, not only culture and art, and men and women from around the country would come to me and explain their needs and what they thought could be done. Slowly, I traveled throughout Iran to investigate their issues. Nevertheless, it took me years to learn some of the problems of our country and also years to know where and how I could be of help.

DS: *When I first visited Iran in 1973, and later when I began to work in Iran in 1975, there were many women working in the government, which I thought was very enlightened, particularly for an Islamic country. When you were learning about your country in an official capacity, were many women active in government or did you have a role in introducing educated women into the administration?*

FP: When I married the Shah there were some women working in different, restricted areas of government. They were active in women's affairs, work, and emancipation, but couldn't do much before 1963, when my husband made what we called our White Revolution, a referendum that put into practice some of his ideas and was accepted by the majority of the people. Among the important elements was land reform; Iran had a feudal system,

and in most other countries, reform only occurred through revolutions and bloodshed. The emancipation of women was one of the most important aspects of the referendum. Previously women, like the military and the mentally handicapped, had not been allowed to vote or be elected. Another important part was the participation of workers in the benefits of the factory. Illiteracy was a huge problem—75% of our people were illiterate. The referendum also established three vital groups: the literary corp, the development corp, and the medical corp. These organizations were made up of young men and women who instead of going into military service went into the villages, eventually gaining the trust of the people. Because we didn't have enough doctors and teachers, they became pivotal persons in the villages. Also, there was the nationalization of the forests and our waters. Iran is a big country, but it's a dry land, except one area near the Caspian Sea. There were many forests that had been destroyed through the centuries, so there was a very active program for reforestation. There were regulations against inappropriate use of water wells and reservoirs. All these points were the foundation of change required to have a more just and equitable society. You always wonder what you can do in a country to make the present and the life in the future better. These fundamental changes gave all of us hope to build on.

My husband tried a third way between capitalism and communism. Most of our natural resources were nationalized, for example the oil industry, coal, and copper mines, and at the same time workers were getting direct benefit from the profits of their jobs in factories.

As time went on, there were many changes related to women in our society and they were made with the blessings of our religious people, including divorce, the problem of polygamy, the issue of who keeps the children after a divorce, family planning, and hygiene. We had different women's organizations that eventually became one huge organization for women's affairs with a woman as the department head. Later, as doors opened for women, there was not one area that women were not allowed to enter and participate. In my position, it was my duty and I could help.

DS: *Do you think it was inevitable that women were relegated to a position of second-class citizens? Is that supported by the Islamic religion?*
FP: I am not an expert in theology, but many other Islamic countries believe that the covering of the woman's face is not in Islam.

DS: *Well, Reza Shah didn't believe it was either.*
FP: He was the first to emancipate women (in February 1934). It was very hard for him to ask his wife and two daughters to appear in public without a chador and instead wear a hat. He was a traditional man, but he knew

he had to set women free in order for them to participate in the life of the country. In all religions the prophets have said, "God preserve people from the merchants of religion." I cannot say that any other religion would accept what has happened in Iran to men, women, and children since the revolution. I don't believe Christianity accepted the Inquisition of centuries ago in Spain and Italy.

DS: *Do you think that women will be able to make a counterrevolution in Iran?*

FP: I believe very much in women. It is not easy in these times and they are the ones that are more miserable than anybody else. Young hoodlums insult them, torture them, throw acid at their faces in the name of religion. Women have been violated, raped before being hanged, because they believe a virgin girl can't be hanged. Then, they bring the body of the girl with 100 tomans or a piece of sugar as a dowry to the family and make the family pay for the burial. There are so many women in Iran who have lost their husbands, brothers, and sons. The war with Iraq (1980–88) was started because of the animosity between two Muslim countries. What was the result beside the destruction of both countries physically, humanly and spiritually? And what did it bring both of them? Nothing.

DS: *What about Iranian women outside of Iran?*

FP: Many men have lost hope, because they have lost their country, their social position. Those who were professionals were not able to integrate themselves, which is a question of retraining. Some men have found a path to retraining. The women have been very strong and helpful to their families in exile. They may have been architects, lawyers, doctors, nurses, etc., but have a sense of survival and have found all sorts of jobs, for example in publishing, design and manufacturing, and cooking, to keep the spiritual and material life of their family together. That proves again that we are not the weaker sex.

DS: *What kind of programs did you support for young children?*

FP: The organizations under my patronage did a lot of work to modernize society and grew rapidly. They were funded by three sources: the government, private funds, and National Iranian Oil Company revenues. One of the programs I was really proud of was related to the health of children. Every single Iranian child was given a vaccination booklet and inoculated against all the endemic diseases existing in our country. Depending on where they were living, every child was also provided with some free nourishment in school—milk, dates, and biscuits. We had some 7,000 orphaned children, from newborns up to the age of eighteen, in centers

all over Iran where they were kept, fed, and educated. When these children reached a certain age, we gave them apartments and helped them until they could stand on their own feet. We also had a good organization for mentally handicapped children. It was not just caring for these children, but also trying to educate them and studying the genetic source of their problems. We passed laws that changed the practice of putting children and young adults into the same prisons.

DS: *Did you have socialized medicine for people who needed medical care and didn't have the resources to pay for it?*

FP: Yes. There were free clinics and government-run hospitals. People slowly started to get medical insurance. Of course, like everywhere in the world, we didn't have enough hospitals, doctors, and nurses. It takes time to build a hospital, to educate a surgeon. In some areas of the country we tried to improve the local medical care: for instance, if there were midwives, we taught them to perform their duties in a more hygienic way. We had a very advanced and important hospital dedicated to burn victims, with Persian doctors and international specialists. That hospital did a lot during that terrible war with Iraq. We also had organizations to help the deaf, dumb, and blind.

Under the Imperial Organization of Social Welfare, there were several technical schools for young people as well as day care centers that fought against illiteracy. The Woman's Organization also incorporated day care centers and taught young mothers how to become self-sufficient with skills like crocheting, sewing, whatever, so they could help support their families. I actively supported the Cancer Society and organizations to fight against tuberculosis and leprosy, which, unfortunately, were still common in Iran.

I must admit that the first time I went to the leper villages was very hard. Deep inside of me I was scared that I might get the disease. They had such horrible places to live. For nights I dreamt about my experience, because it was so unbelievably sad and miserable and I knew I had to do something to help them. First of all, we tried to cure the lepers and secondly, we tried to integrate them into society, which was very difficult. We followed the recommendations of the World Health Organization in Geneva. My husband donated a lot of land in the province of Khorasan, and with the help of some international groups—the French, some Swiss and Germans—we started a village with agriculture, cattle and sheep breeding, and some cottage industries for the lepers who were cured. The village was so successful that people from the outside began to live there. Amazing individuals tried to help these people who had been ostracized from society. Surgeons came from Switzerland, worked for free to operate and perform plastic surgery

on these patients. You cannot imagine the joy of these poor people, who couldn't look at themselves in the mirror, but after treatment married and had children. There were many Catholic priests and nuns who worked very hard in these centers, but not one of our Islamic religious people. Only when we would pay our clerics or invite them for a ceremony, mourning tribute, or religious festivities would they come.

DS: *How involved was the Shah in your projects? Was he interested in art?*
FP: He was very interested in everything that was happening in Iran and was very proud each time we opened a new museum. He was promoting and encouraging many scientific, educational, and cultural enterprises besides the government's official activities. He helped a lot with the preservation of monuments. His blessings and material support from the government made it possible for me to realize many projects and activities in organizations for which I was a patron. Personally, he was more involved with Iranian art and preferred classical art and music to modern forms, but he knew about significant contemporary international artists.

DS: *Whose idea was it to sponsor the International Art Fair that was held in Tehran in December 1974? It was under your patronage as well as the Minister of Culture of Iran. Did you recognize the fair was an opportunity to purchase artworks for Iran's modern museums? I happened to be there at that time and made my first recommendations for the Western collection at your instigation.*
FP: I don't remember exactly, but I think it was a French gentleman, perhaps Aimé Maeght, who was involved in cultural affairs. He thought that if we had an international fair every once in a while, bringing art for our countrymen to see and buy, it would open a market and attract people from all over the world. Iran could then become a cultural center for art like so many other countries and our artists could sell their work and be known outside of Iran.

DS: *Were there plans to do another art fair after 1974?*
FP: Yes, I think so. If it were successful and useful, we would have continued. There was also an exhibition of design.

DS: *In June 1976, through your Secretariat, we organized a large exhibition of Iranian art for the Basel Art Fair. The artists were invited and given the experience of traveling and communicating with other artists. It was intriguing to try and define how these artists should be represented and to see what they learned and appreciated from the experience.*
FP: We also sent some artists to FIAC in Paris and the Salon d'Automne.

DS: *In what ways, besides being a patron, were you involved with the Shiraz Festival, which lasted for more than a decade? I had the good fortune of going once with you in the summer of 1976. I was astounded by the Tazieh (indigenous passion plays), for example.*

FP: Through my discussions with people who were involved in the arts and believed in them, we thought we were in a period where we could sponsor an art festival. We chose Shiraz as the site because of its setting and the logistics of the surroundings there. We wanted it to be different from other festivals—to get the East and West closer through meeting, knowing, and learning from each other. Every morning from 10 am to 1 pm, for instance, the artists would gather at the University and discuss and exchange their ideas. There was a bulletin in French and English about the programs.

We wanted to present our own art, culture, and performing arts and for other countries, especially the Third World countries in Africa, Latin America, and Asia to be able to show their cultural heritage alongside Western programs. The aim of the Shiraz Festival was mainly the traditional, classical, authentic performing arts, but also significant aspects of contemporary performance and music from developed countries. We didn't want it to be folkloric, touristic, or commercial.

DS: *Farrokh Gaffary was in charge. What was Bizhan Saffari's role?*

FP: He was on the Board of Trustees.

DS: *Was he a scout for the festival?*

FP: Bizhan was very involved with contemporary theater in Iran. However, it was mostly Farrokh Gaffary and some other people that researched who would be good participants in the festival. There were advisors from the East as well as the West. We also wanted to show what was important inside Iran. The National Radio and Television took control of the Iranian section and they had researchers and scholars who would go to the villages and discover the native talents. About 70% of the people who came to the festival were between 18 and 25 years old. As you know, the entrance ticket was very cheap, just a few dollars for the whole program, and the students would stay in University dormitories and also have access to the canteen. There were hundreds of programs. Some of the programs people would not understand, but would like them. I even found that some of the very avant-garde theater and music was not pleasurable, but it was a way of education, a way of knowing what was happening in the world. Not everyone can like everything, but young people responded positively.

Most of the artists who came to Iran for the festival did not perform in traditional theaters. They toured the region and chose their own sites. Peter Brook, for instance, performed at Persepolis and Naqshi-Rostam.

Bob Wilson's 168-hour continuous performance took place in the hills around Shiraz. Maurice Béjart choreographed "Golestan," which used Persian music and philosophy as a counterpoint to the dance, for his special programs at Persepolis. The avant-garde music of Iannis Xenakis also was performed at Persepolis. The Bread and Puppet Theater of Peter Schumann performed a political play near an old prison. The Noh Theatre of Japan, a group that had never before played outside their country, chose a very old house and garden. American theater director Andre Gregory chose a site in the Bazaar to present his "Alice in Wonderland."

On the Persian side there was a lot of theater, music, dance, and film. The *Tazieh* programs were very popular. One of the villagers who performed in the *Tazieh* told me, "All my life my parents had looked down on me because I performed in the *Tazieh*, but now that you have come to see me perform, I have the results of all my years of work." His statement touched me deeply. Traditional Persian music at the tomb of Hafez was very well attended. The garden there was a beautiful romantic setting with oil lamps. I remember one fabulous program the year that Percussion was the theme of the festival that paired the American jazz artist Max Roach with a famous Iranian drummer. They performed together in a village outside of Shiraz, surrounded by a large audience. It was an unbelievable happening. It was as if their drums were speaking to each other. Among the classical musicians, we had Arthur Rubinstein, Yehudi Menuhin as well as Karlheinz Stockhausen. Of course, I don't believe that everyone liked everything, but the people were very interested and there were programs on television for the larger public to see and enjoy.

Another benefit of the Shiraz Festival was that artists and architects helped identify beautiful old Qajar buildings to be saved that the government was able to buy and restore.

One thing about Shiraz was marvelous from my point of view. Everyone was participating and helping—the government, the army, the University, everyone was at the service of a cultural enterprise. Everyone who worked for the festival did so with passion and love. They wanted to make it a success.

DS: *Were there conflicts between religious sentiments and cultural programs?*

FP: I never sensed anything during the time I was Shahbanou, because nothing was shocking, immoral, indecent, or improper. In retrospect, the first signs of the subsequent Islamic Revolution occurred in 1977. During the eleven years of the Shiraz Festival, there had been hundreds of programs, mostly traditional, but some avant-garde. Artists were free to express themselves. There was only one questionable incident.

DS: *Why was the festival curtailed in 1977?*

FP: Orthodox religious figures and some revolutionaries made a lot of fuss about one program by a Hungarian group that is now based in the United States. They performed in a shop on a street, and in one part of their play, they pretended to make love. I asked several people who had seen the play if it was objectionable and they said these groups were exaggerating.

DS: *How did people react to the cultural advancement you proposed? Did you sense any dissatisfaction or lack of understanding?*

FP: Not really. Iranian citizens respected their heritage and knew of my interest in saving historical monuments. I received numerous letters from private citizens, telling me where there was a tomb of a poet or identifying interesting buildings for the government to protect, preserve, and restore throughout Iran. What could people say against museums with the treasures of their country exhibited there? They were, on the contrary, very happy. For the modern art acquisitions, some people asked, "Why buy these paintings?" Even if everyone didn't consider them art, I was certain it was a good investment and would never be lost. Frankly, when the revolution occurred, I was afraid the Islamic fundamentalists might, out of anger and revolutionary frenzy, destroy the modern collections. But now they know the paintings and sculptures we purchased are worth ten or twenty times more than their original cost. Even if some Iranians don't like modern art, they know it's valuable. That's why it is still there.

DS: *Because of your position, were people forthright? Would they really tell you what they thought?*

FP: I think so, because I would hear all the complaints. No one would come to me and say everything is beautiful and OK. I would have welcomed some positive feedback for all my energy and hard work. Our intentions were noble and I think that what we did and what we were hoping was that the direction was right. I know we made mistakes. There is no new program, no person, and no country that is perfect. I believe that we had the foundation of a true, equitable, good society and we needed time to correct the problems and make it work.

DS: *I wonder if you could elaborate for my understanding about how the Shahbanou Farah Foundation worked.*

FP: I always wanted to create a cultural foundation of my own, using it as an umbrella outside of my regular office activities. I wanted to separate the social welfare, educational, and charitable projects in my office from the cultural programs. So I created this foundation in 1976 with my personal donation. It had a separate Board of Trustees. In the Five Year Plan and

budget, there was an allowance for the museums and cultural activities. Also, the National Iranian Oil Company and Ministry of Culture helped with funds. The foundation provided a way for private donations of money, objects, and investments to help support the arts. Unfortunately, it really didn't have an opportunity to do much.

DS: *Did the Board of the foundation differ from the Boards for the different museums?*

FP: Yes. The foundation would also have had other activities beyond the museums. Besides the Shiraz Festival, there were two other important festivals: one dedicated to the Traditional Epic in Tus, where our great poet Ferdowsi is buried. It was near Mashad in Khorasan. In the late 1970s, we also started a Festival of Popular Art in Isfahan. Farabi University opened in 1975 as a multi-disciplinary university. We had hoped that, because its educational standards were high, students would receive degrees that would be accepted internationally. The curriculum included general knowledge about man, society and nature, Persian culture and other cultures. The main campus was in Karadj, a city near Tehran, but it also had divisions in Isfahan, in a very old neighborhood, where the students were in touch with real life. The curriculum was not just academic art history and plastic arts, but focused on society. There were four hundred students in the period from 1977–79 and thirty-five assistant professors and professors from all over the world. There were also some students on scholarship from abroad. Artists should be in touch with everything, all aspects of life. Not only to paint, to sculpt, or to make a movie, but to know about other cultures, societies, and the environment. In Hamadan, Avicenna University, dedicated to the sciences, was supposed to start as a medical school, but again in a different way, more integrated into real life. The medical students would have had opportunities to go into the villages and learn firsthand about the needs of the people.

DS: *This method is also a way to keep trained professionals in touch with the community that they serve. So often when people go abroad to study, they no longer want to return home. One of the problems I had working within your Secretariat was that there were very few people trained in art history, even in your own cultural heritage. I realize that Farabi University was targeted to educate that segment of society, who would then work in the cultural sector. How were people placed in positions, like the heads of cultural centers and museums, given the lack of trained personnel in these areas?*

FP: We had some trained people, but we needed a lot more. There were many Iranians being educated abroad and we hoped they would return

home and take over some of these important positions. We had some foreigners working in Iran as well. We had to make due with what we had.

DS: *Did you sponsor the education of students abroad?*
FP: Most of the educational scholarships in all fields were awarded through the Pahlavi Foundation. My Secretariat provided scholarships for some artists to live and work in Paris at the Cité des Arts. Through my office, we also awarded scholarships for specific purposes, like the International Organization for Intellectual Development. We also provided scholarships to study in Czechoslovakia, where they had great animation and puppetry programs. Each organization would send people abroad to learn more about their fields.

DS: *What did you imagine was going to be the role of contemporary Iran when His Majesty was in power vis-à-vis your position in Asia and the Gulf?*
FP: I really thought that we could became an example of development and progress for many countries throughout the Third World because of the programs we were doing in Iran. We had friendly relations with most countries, both East and West. We had treaties with the West but we had political, economic and cultural relations with all the communist countries as well. Of course, there was a lot to be done, but, if things were stable in the fields of education, environment, hygiene, medicine, industrialization as well as politics, and had more participation by the people, Iran would have been a decent nation among others.

DS: *What do you miss most about being an Empress?*
FP: I don't miss being an Empress. My life wasn't easy. I was there to serve. The privileges people saw from outside were so much a part of my life, I didn't consider them extraordinary. In retrospect, I appreciate some of the special opportunities I had. I hope the integrity of my country will stay intact. The economy is in great trouble and the regime admits that they have accomplished very little in twelve years—in actual fact, they have regressed. For example, in the health field, endemic diseases, which had been eradicated, have reappeared. Undernourishment and malnutrition are rampant. The education system is in shambles. The judiciary system is corrupt and ineffective. There is a great threat of uncontrolled population growth. The natural environment in Iran, which has always been very fragile, has suffered greatly during the last twelve years. Tehran is now one of the most polluted cities in the world. Our land, water, and forests are not protected or managed properly. More than half the population of Iran is women and they have virtually been barred from participating in the life of the nation. The government's record of human rights, according to

international organizations, is abysmal and even now there are summary executions and arbitrary imprisonment. I especially miss my country—its nature, people, air, and beauty. I would rather be back in Iran, if I could, as a simple citizen.

DS: *How would you like to be remembered?*

FP: I would like people to remember me as a caring individual, close to the Iranian people, not removed from them, trying to do my duty in the best way I knew.

[1] Myrna Ayad, "Farah Diba Pahlavi: An Exile from a Collection," *The Art Newspaper*, April 2016.

[2] "Interview: Farah Pahlavi Recalls 30 Years in Exile," Radio Free Europe, Radio Liberty, July 27, 2010.

[3] Donna Stein, "For the Love of Her People: An Interview with Farah Diba about the Pahlavi Programs for the Arts in Iran," ed. Staci Scheiweller (London: Anthem Press, 2013), 75–82, 232.

[4] See Donna Stein, *Selected Graphics From the Private Collection of Farah Pahlavi, Her Imperial Majesty The Shahbanou of Iran*, Negarestan Museum of Eighteenth and Nineteenth Century Iranian Art, Tehran, July 1976.

DOCUMENTS

دفترمخصوص علیاحضرت شهبانوی ایران

September 4, 1972

Dear Donna,

I was very happy to find out that your project is becoming
realized. I would be very happy to see you in Teheran. My
brother and his family will probably be still with us by january.
So if you do not mind a noisy house you are welcome to stay with
us.

Regarding Shiraz and Isfahan I can make no definite plans
at this time, for it will all depend on my job . Let's see what
happens.

Yesterday, I called Doreen. She sounds very sweet. I would
love to meet her especially that I get along much better with
foreigners, than with Persians. I will contact her next week as
soon as I come back from Shiraz Art Festival. The only problem
will be that we live very far from each other. Teheran has
spread like Los Angeles. It might take me about 45 mn. to get
to her place!

Donna I would like to bug you with one question now.
Were your print mats standard in the size of the window borders?
I will draw what I mean

If ~~you don't~~ not how do you decide about the size of the window opening?

At the end I would like to thank you for your assistance in
New York and I hope that I can be of some help to you when you
visit Teheran.

Lots of luck,
Feri Daftari

Fereshteh Daftari

P.S. Give my regards to everyone in the
office.

دفتر مخصوص علیا حضرت شهبانوی ایران

Miss Donna Stein
41 West 72 Street
New York, N.Y. 10023

March 5, 1975

Dear Donna,

Having spoken to His Excellency Dr. Bahadori I was asked
to answer your letters dated January 15 and February 20.

As I wrote to you privately, it is agreed that you take
your one month vacation in the month of August. Within a few days,
the salary of your first month amounting to 1/12th of $25.000
shall be sent to you through BANK MELLI IRAN.

Regarding the purchasing of prints the procedure will be
as follows:

- you will select the prints
- you will contact the gallery or whatever source , and inform
 them about your interest in purchasing the selected prints
 for a museum in Iran
- you should ask them to send an official letter to the office
 (xxxxxxfxxx) (to me). In the letter the following informations
 should be stated:
 - name of the gallery
 - complete information on the selected prints
 - market or usual price
 - special price for our museum
 (this does not mean that the gallery can offer a
 high price, as the market price, so that the special
 price would actually equal the usual price, since
 prices can be checked)
 - for payment the office will contact the firm directly.

 As for the purchasing of facilities (matting, special glue,
glassine paper, etc....) is concerned a similar procedure will be
followed:
 - you should make a list of all the needed facilities
 and have it approved by the office
 - make an estimate of the amount of supply the museum needs
 - ask the firms to send us their special price for the
 amount of material you suggest
 - for payment the office will contact the firms directly.

The books you have suggested will be ordered by the office.

Can you use your visitor's visa to come to Teheran? I should think you can since the visa is good for one year. Once you are in Teheran, the office will take care of your working permit.

I spoke to His Excellency about Isamu Noguchi. Iwas asked to write a note about it and I did. Is Teheran on Noguchi's way? How long will he be staying in Japan? Could he come to Teheran before going to Japan or after? Since there is a possibility that this idea may not be approved, please do not emphasize it when you speak to the artist.

There are a few other matters which need to be researched or you may have the answers right away. They are:
- what does a room for the conservation of painting & sculpture need in terms of facilities that we should ask Niloufar Diba to order.
- specifications of solander boxes
- specifications of cabinet files (brochure of the makers, size of the cabinets in the main registrar at MOMA, etc.)
- name of special glass window(used around MOMA's sculpture garden) which filters noxious rays.
- statutes of museum personnel (?)
- permanent collection and exhibition policies at MOMA, Whitney, and Guggenheim. Do these policies exist in written form? if not can you find out what they are?
- purchasing procedure in New York museums (Ex. committees...)
- do the museums in N.Y. have anything called constitution? If yes would you please find out about it. *charter*
- we also need to have the names of the <u>most prominent</u> (Rubin's caliber) curators in modern painting and sculpture in the States and in Europe. Curators or anyone who could eventually act as advisor. This is confidential.

I apologize if I have not been able to be clear. Please xxkxme write to me if you have any questions.
Thank you
Sincerely,

Feres teh Daftari

P.S. Leyla would like to know if you could send her any information or brochures you may have on th International Photo. Center, Patronized(?) by Jackie Kennedy.

March 26, 1975

Dear Feri:

I have been working madly for the past 5½ weeks and I am
not sure where to start with my report and answers and questions.
First of all, I received my salary check yesterday. Also,
please let me know when I am expected in Tehran and if I am
to make any stops in Europe on the way? Will Dr. Bahadori be
in New York City before I leave and will he want to view the
art I have selected, as well as various museum study facilities.

I have been ordering lots of books for the reference library
and establishing contact with important book dealers in the
United States. Enclosed are several lists from which I would
like you to order all the ones (entries) I checked and any
others that you think are needed. John Weber Gallery handles
the works of conceptual and minimal artists primarily, and
these catalogues are important documents and examples of the
various artist's work. Denise Rene handles the works of
artists involved with geometry and optical effects. Pace
editions has sole representation for many of the artists
listed, such as Nevelson. I've also included information from
the Museum of Modern Art to see if we have all their available
books in print; if not, they should be ordered also. Jaap
Rietman Art Books, is one of the good art book dealers in
New York, located in Soho; I have gone through his catalogues
carefully and checked those books pertaining to my interests
as well as many others. Both you and Layla should look through
them carefully and see what else could be ordered. We will
be on his mailing list and he is a very good source for recent
artists books and catalogues from various museums and galleries
worldwide, especially in Europe.

While in Los Angeles, I went to the most reknown bookseller--
Zeitlin and Ver Bruge. Not only are they good for purchasing
ou-of-print books, but they run an excellent search service
and will try and find anything the library will need in the
future. They offer a 10% discount to libraries. They sent you
an invoice directly. I have since written to them canceling the
4 Zervos albums from the order since I have found a complete
set of them (26 volumes, many of which are out-of-print) at
Strand Bookstore.

In New York I have been to Strand Bookstore, which does the
biggest volume of business in remainder books, out-of-print and
used books. Their books are heavily discounted, usually as much
as 50% and thus they do not giave an additional discount. I
have ordered a large quantity of books from them at very good

prices and an invoice has been sent to you directly. Also, I
am sending their catalogue on art books; I have checked
additional books, which I think should be ordered for the
library and have not been covered in my other order. I am
planning to go back once more to look through a private library
of art books which they just bought and want me to select from.
~~before~~ ~~sending~~

I also went directly to Abrams Art Book publishers because I
know the president personally. I was sure not to select any
Abrams books from the other dealers to avoid duplication.
I have ordered all of the volumes from Abrams which I feel
apply to a museum beginning with the Impressionists. An invoice
will be sent to you directly. I am not exactly sure of the
discount. It will vary depending on whether or not the books
are out-of-print or easily available. It will be as much as
20%. p

Unfortunately, Isamu Noguchi is now in Japan. He will return
to NYC by May 5, for he has an exhibition opening at the Pace
Gallery about May 10 or 12. He told me he would be glad to
come to Tehran to consult on the garden, but it would be better
for his schedule if he were invited in early June. If you
want to contact him directly, his address in Japan is:
 Isamu Noguchi
c/o Isamu-ya
 Mure-cho
 Kitagun
 Kagawa-Ken
 Japan

 (0878) 451757

Please be sure with all the book orders that I have not
duplicated any books. After looking at so many books and
lists, it is very confusing. I still plan to contact two or
three other book sellers in NYC in the next couple of weeks--
Wittenborn, Weyhe, and Hacker, all of whom specialize in
art books.

I have contacted two library specialists: ms. Ruth Carsch,
San Francisco and Mrs. Jane P. Franck, NYC. They have made
many helpful suggestions and I have written to several companies
for their catalogues of library supplies and equipment. Mrs.
Franck also suggested that you contact at the University of
Tehran, the chairwoman of the Department of Library Sciences
Mrs. Nouchafarine Ansari, who is apparently very well known
internationally and would be an ideal person to advise on
Iranian projects. Perhaps Niloufar Diba could speak with her?
In Los Angeles, I spoke with a representative of Hiebert Library

Designers. I have their catalogue of standard furnishings which I will bring with me, for it is bulky and heavy to send through the mails.

Also, when I was in Los Angeles, I visited one of the largest framers and art shippers in the United States--Art Services Inc. I spent several hours at their factury and showroom and have photographed their facilities.

As far as the Kandinsky's are concerned, I am still not sure what to recommend. The Knoedler "Dorfstrasse" does not seem to be particularly important from the group of works that were done in Murnau in 1908. But I have not seen the painting. It formally was in the collection of Mr. and Mrs. William H. Weintraub, New York and A.J. Eddy, Chicago (according to Grohmann). There is some discrepancy in the measurements of the "Fruhe Stunde". I want to check with Benedek before commenting further on this work. I am going to see it out of the frame and inspect with a conservater.

I have been visiting several graphic publishers. In Los Angeles, I contacted Gemini G.E.L. and Cirrus Editions. Here in NYC I will visit Tatyana Grossman at Universal Limited Art Editions, perhaps the most reknown and also most respected of the graphic publishers in the United States. Also, I will go to Petersburg Press, a London and New York based firm. I have been collecting their catalogues and slides, when possible, to bring with me to Iran. Of course, graphic publishers are concerned with contemporary art and artists.

All the dealers I have spoken with have been concerned about the time period between selection and decision, payment and procedures and methods of shipping. Will payment come after recipt of goods or upon invoicing? Prompt payment is desireable, for dealers will be more willing to offer choice objects and save works, which they think may interest us. Also, holding in reserve selected material (especially works under $500., i.e prints and photographs) is not exactly fair to a businessman, especially if the material is sent to Iran, out-of-stock for several months, and then possibly returned. As far as shipping is concerned, works of art shuld be sent via normal carriers, such as registered air mail packages (which are restricted depending upon size) or air freight or else via diplomatic pouch, inwhich case art works could be delivered or mailed to the Iranian Embassy in Washington or given over to an authorized currier in New York City. A diplomatic pouch is probably the most trusted means of transportation.

I have also been investigating various traveling exhibition programs which originate in the United States, for future planning purposes.

For the moment, I have based all my proposals of art works on
aesthetic decisions, keeping in mind what fair market value is
and also what the needs of a developing collection are. It
would be very helpful to me if I could have some indication
of budget in order to properly evaluate the program.

I checked on the Soutine with the Klaus Perls Gallery. They
had two very similar "Women in Red" paintings. Unfortunately,
both were sold. At the present time they do not have any
Soutine portraits available. In the meantime, I have selected
a group of 19 paintings and sculptures from the gallery, which
I think are of fine quality and condition. Enclosed is a
catalogue from their forthcoming show, illustrating a few of
the works. They have sent you an invoice with transparencies
and photographs of the works I selected. The Archipenko
"Repos" was sent to the U.S. to be exhibited at the Armory
Show in 1913. Of the Calder's--Chick-lett is a fantastic early
stabile. It is not possible to find works of this quality and
early date on the market. The Orange Fish is really the more
beautiful of the two mobiles and considerably earlier than the
other one, which is huge. I think the Braque is quite beautiful.
I have since seen another Dali (E.V. Thaw, who is also sending
you some transparencies, etc.) which is think is better and
somewhat cheaper. It is about 1/3 the size of the Perls Dali,
but exactly the same year, the same series about Millet, and
also has many more typical aspects of his iconography and
visual vocabulary. The Modigliani is very special and not
easy to find. The Rouault is incredibly beautiful. The colors
are glowing. The Leger, from his cubist period, was formally
in the Guggenheim collection.
The Van Dongen is a very fine, strong and important painting
from his best period. The woman was apparently his mistress.
The Vlaminck is in the tradition of Titian,Goya, VanGogh, Manet
and "Olympia! It is from his best period and quite fabulous.

I have also gone to Lucien Goldschmidt. I selected a wonderfully,
luminescent (black and white) monotype. They are difficult to
find of any quality on the market. He will be invoiceing the
works and sending photographs and information on to you soon.
Yesterday, I also visited with E.V. Thaw and Co. I selected
five works there, among which is perhaps the most important
Picasso painting to come on the market in a long time. It is
a superb example of a synthetic cubist work done in 1920. It
is a fabulous, large painting, for which there were about 50
studies dones prior to the finalpicture. I am also excited
about one print he has reserved--it is one of a few copies,
never editioned, given to friends, closely connected with the
Guernica, a large fabulous etching of a weeping woman from 1937.
It will be a jewel in the collection. Mr. Thaw will be sending
the transparencies and photographs directly to you also, with
supporting literature.

The following is a list of people I feel are particularly
knowledgeable about Modern Art, who are prominent scholars
in their respective fields. These are not necessarily the
people who keep reappearing on committees, which I think would
be an asset. I feel they are people with taste and a wide
range of interests. I have also. tried to recommend people
whose work would not present a conflict of interest.

James Demetrion,Director, De Moines Art Center, Iowa
 specialist in German and Austrian expressionism
Martin Friedman, Director, Walker Art Center, Minneapolis,
 Minnesota
Dr. Leo Steinberg, Professor of Art History, Hunter College,
 New York; specialist in Picasso, Johns, Rauschenberg, and
 one of the most brilliant art historians.
Ms. Anne D'Harnoncourt, Curator of 20th Century Art,
 Philadelphia Art Museum, Pa.; just organized the Duchamp
 exhibition
Dr. Anne Hanson, Professor of Art History, Yale University,
 New Haven, Connecticut; written important works on Manet
 and other impressionists
Mrs. Barbara Duncan, New York;Latin American Art specialist
Peter Bunnell, Professor of the History of Photography and
 Modern Art, Princeton University, New Jersey; world
 authority on Stieglitz and one of first photography
 historians inthe U.S.
Dr. Richard Field, Professor of Art History and Director of
 Gallery, Wesleyan University, Connecticut; Print specialist,
 important writings on Gauguin.
Robert Motherwell, Greenwich, Connecticut; famous abstract
 expressionist artists, but also art historian of considerable
 importance.
Alan Bowness, Courtault Institute, London (son of Barbara
 Hepworth)
Harold Joachim, Art Institute, Chicago; Curator of Prints
 and one of most reknown in field
Dr. Joshua Taylor, National Director, National Collection
 of Fine Arts, Smithsonian Institution; former professor
 of art history and specialist on the futurists
Weston Naef, Curator of Photography at the Metropolitan
 Museum
Jean Boggs, Director, Art Museum, Toronto, Canada; superb
 reputation
Jim Plaut, New York (Crafts specialists
Thomas Hess, New York, Critic and former editor of Art News;
 written many important works on Abstract Expressionists
 Art Historian
Maurice Tuchman, Los Angeles County Museum of Art, California
 Curator of 20th Century Art
Dr. Lois Mendelson, Yale Univ ersity, New Haven,Connecticut
 PHDsin Art History and Cinematography

Bhupendra Kharia, Asst. Director, International Center
 for Photography

Also, I understand that the Director of the Stedlijke Museum in
Amsterdam is first rate, but I don't know him and I haven't had
a chance to look up his name. Walter?

So Feri, I do hope you can understand everything in this letter.
Let me know if you have any questions. Please answer my
questions as soon as possible.

Sincerely,

Donna M. Stein

دفتر مخصوص علیاحضرت شهبانوی ایران

امور فرهنگی

April 8, 1975

Dear Donna,

I just spoke to His Excellency and he says that you should stay in New York until the end of May. He will be there in the month of May. In this case I don't know what you are going to decide about your apt. in Tehran. I wrote to you about it in a separate letter. This afternoon I will go and see it.

As for the books, His Excellency agreed that we purchase them from the sources you have indicated. I have already written to Strand. I send you a copy of my letter, under separate cover. Please remind them to include the 26 Zervos volumes in the new invoice.

I received the Zeitlin & ver Brugge invoice. I will have to ask His Excellency about the payment.Please try to get as ; little as possible German books.

I received the Goldschmidt material and should showed them to His Excellency, who thinks the prices are very high. In any case he said that he would come to N.Y. and if the works are still available he will see them. From Goldschmidt he agreed that 3 out of the 4 books be purchased. The one he did not agree to buy is the $1.000.000 Der Blaue Reiter. I shall write to them myself.

As for the Print collection budget you should submit a range of estimates to His Excellency so that he can make a decision.

As for the time lapse between selection and decision I am afraid it will be rather long at the beginning, until a committee of art advisers is appointed to meet regularly. This is my personal opinion ant it's confidential. I don't think any payment will be made until the works are seen. But I don't k know what kind of arrangements will be made to view the objects

As for the list of art experts maybe they afe too widely spread in the States. It would be difficult to have them all meet in one place. Do you think that it would be dangerous

to include Rubin, Geldzahler, and othersof the same standing?
They probably would not act to our best interest, especially if
they are interested in the same works as we are.

Please try to find books on Bonnard. We constantly get offers
on this artist and I have no material in the art library.

Layla's Museum will open in 2 weeks. She is very busy and
may not find the time to thank you for the material you sent her.
She was very happy with it.

April 9

I saw your studio. It's rather small but quite sufficient for one
person. I have explained everything to the letter I gave Yahya
to mail. Unfortunately, he will not be coming to New York.
If you decide to take the studio you will also have to accept the
risk of paying for it without using it. In any case I am waiting
for your cable.

I hope that the letter is clear. Thank you for everything.
Best wishes,

Fereshteh Daftari

Fereshteh Daftari

April 16, 1975

Dear Feri:

I wanted to bring you up-to-date on my activities in New
York.

I have had several interviews with people in the museum
world and have luckily gathered the information you requested
about museum charters, personnel policy, acquisition policy,
etc. from several sources--The Museum of Modern Art, the
Metropolitan Museum, and the Guggenheim Museum. I should also
be able to get some details from the Whitney Museum. Everyone
has been most kind and helpful. I spoke with the man who is
director of the Conservation school aththe Institute of Fine
Arts, New York University. He was very helpful, has given me
a good bibliography and made several useful suggestions. In
fact, he will be in Turkey during the month of July and would
be available for consultation should that seem appropriate.
His name is Lawrence Majewski and an international expert.

Unless I hear otherwise from you, I plan to bring with me all
the information I have collected. It is so expensive to send
small packages through the mails that I think it is better to
wait. I have collected a lot of catalogues for library
furnishings and equipment, catalogues and reference materials
for various graphic workshops, auction catalogues, etc. Since
I have my own work files and books to bring, it would be
easier to consolidate the whole thing.

I have seen a lot more art in the interim, as well as ordering
several hundred more books. You should be receiving an invoice
from Harry Abrams Publishers for their publications, which I
ordered. They have given a very good discount. Check to see
that there are no duplications, since the Library Overseas
program may have sent some of the books I ordered. I didn't
have a record of anything other than the prints and drawings
and photograph books. Besides confirming the Strand order,
have you also expedited the Light Impressions order and the
Zeitlin and Ver Brugge orders? I ordered quite a lot of
books yesterday from a firm specializing in out-of-print
art books and catalogue raisonnes--F.A. Bernett. They will be
sending you an invoice and their recent catalogue, from which
I have made many selections. I luckily found some crucial

catalogue raisonnes, i.e. Van Gogh, Pissarro.

I have also ordered a lot of books from Howard Daitz, a
specialist in photographic materials. I also found some
terrific early photographs, one of a mosque in Persia.
He will be sending you an invoice directly. Also, I
ordered many early photographs and a quantity of books
from the Witkin Gallery, which also specializes in photography.
(Probably the best dealer in New York) They will be invoicing
you directly also. One of the fabulous things I reserved was
a photograph by Diane Arbus (probably her most famous and made
by her, which is very difficult now that she is dead). The
photograph is accompanied by a letter in the hand of Jim Dine,
who previously owned the photographydescribing how he got the
photograph. Last week I also visited Universal Limited Art
EDitions, the most important graphic workshop for the past
twenty years. Mrs. Grossman, the owner and director, was most
wonderful and generous. I reserved two extraordinary portfolios
by Jasper Johns (unique examples) for the collection. She is
also writing directly to you. In the future, I know she will
be glad to work with use in finding and acquiring key works
that were published by her workshop. She has consistently
published the best work of Rauschenberg, Johns, Mxxxkx Motherwell,
Frankenthaler, Marisol, Rivers, Francis, Glarner, etc.

The Metropolitan Museum has on now a very good exhibition of
Francis Bacon's work. For years I have never felt particularly
strongly about his work, but I loved it. The exhibition focuses
on the period since 1969 and there are some exquisite paintings,
many of which seem to be in the artist's own collection, which
may mean they are for xix sale. There is one triptych, which
seems to tell the story of Bacon's life.

Is there any one else in New York working on projects for
the Secretariat? and Her Imperial Majesty? It would be
helpful to contact such a person.

Have any decisions been made about the works I have recommended
so far? The reason I ask, is that I find that several dealers
are unwilling and also unable to reserve works of art of
superb quality without a definite confirmation, since those works
are in demand by other museums. If Dr. Bahadori is waiting until
a trip to New York to make those decisions, I understand, but also
think that some of the special works will not longer be available.
Do let me know what you think about this matter.

I looked at the Kandinsky--Fruhe Stunde--out of the frame. It is
relined on new canvas, which is not particularly unusual, and
appears not to be cut down as I feared because of a discrepancy
in the measurements from the Grohman and other early catalogues.
However, it seems that a mistake was perpetuated unknowingly.
The work is a bit fragile on the upper right part of the canvas,
but otherwise in fine condition. It is quite luminous and
beautiful.I think it is rare to find a work from this early
russian period on the market and this is a big imposing canvas.
Mr. Benedek bought the work from Wolfgang Fischer, Fischer
Fine Art, London last year.

I would also like to recommend one other person who I think
is one of the most knowledgeable men in the field with regard
to new techniques in museum design and exhibition display.
His name is Karl Katz and he is presently Director of Loans
and Exhibitions at the Metropolitan Museum in New York. I
inadvertantly left his name off my first list.

I want to get this letter into the mail this afternoon so
will sign off for now. Also find enclosed a few other catalogues
for books.

Awaiting your reply to all my questions.

All the best,

Donna M. Stein

April 30, 1975

Dear Feri:

I am writing to bring you up-to-date on my activities.

I am most anxious to know when Dr. Bahadori will be in New
York City. I understand from newspaper reports and various
people in Washington D.C. that the Shah and Shahbanou will be
in the capitol on May 14. Will Dr. Bahadori want me to arrange
some appointments at the Museum of Modern Art and the
Metropolitan Museums? Also, will he want to see the art I
have set aside? There are a couple of out-of-town dealers
(R.M. Light in Boston and Harry Lunn, Washington D.C.) who
would have to make a special trip to NYC to show their work
and it would be good if I could notify them a few days in
advance.

As far as the books are concerned, I spoke with several people
at the Museum of Modern Art regarding the Library Overseas
program arrangement that had been set up with Iran. I looked
at the lists of books which were sent. The Barr Matisse book
which you requested from Strand should have been in the last
shipment. Also, you should be receiving a copy of the Grohman
Kandinsky book from the International Council of the Museum of
Modern Art. Their president, Mrs. Joanne Stern, was very
distressed to learn of the mix-ups, duplication of books, etc.
As far as books in German, there are many references which are
essential and only come in that language; also, they may
provide essential visual information on an artist. In any case,
whenever there is a choice I have selected books in English or
French. By now you should have received a rather long invoice
from Abrams publishers. They are continuing to look for
examples of out-of-print books and will send further invoices
for any other books that they come up with. The Blue Rider
books is not an ordinary reference book. It is the definitive
work published by that group and an important record of their
ideas, art and theories. It is more an art document and thus
an original work than a simple book. It is an essential
reference to anyone working in the area of German 20th Century
art. This particular example is in very good condition and
even has the boxing, which is rare to find.

Regarding the question of advisers, I think it would be a
poor idea to seek the advice of experts who may have a conflict
of interest in terms of their other positions. I do feel a

committee of as few as three people could judge appropriately.
The art world is very small and I think it is important to
select advisers who are not constantly in that same position
with other institutions, private individuals, etc. Also, I
think any person with commercial involvements should not be
part of such a committee of museum advisers.

I feel I have been very fortunate to have seen some very
extraordinary prints and photographs recently, which would be
superb examples to establish a new and major collection of
modern art. The few pieces I selected from Mr. Light are
magnificent aesthetically, qualitatively and without a doubt
key prints in the graphic oeuvre of each of the artists. In
every case, with the dealers I have visited, I have tried
not to settle for anything less than the best examples by
each of the artists. Thus far, I have only concerned myself
with quality and not quantity. I have also not looked at
any contemporary art (aside from some things at Universal
Limited Art Editions) for I know the graphics of this time
very well and feel that they can be selected from catalogue
sources (which I have collected from publishers, etc) except
in terms of condition, which should be checked, in all cases.

Next week there are three days of auction sales in prints at
Sotheby Parke-Bernet. I expect to go and check on prices.
Have you ordered the various auction catalogues from the list
we made-up in December?

About the mail you said is waiting for me. If it seems to be
business mail, please open it and answer that I have not yet
arrived. If it seems to be private mail, just hold it until
I come. I gave the Secretariat address to many people saying
I would be there around May 1.

As far as living accommodations are concern, I am very confused
about what to do. It is so difficult to make decisions with
such a long distance. I got a letter from Doreen today saying
that the apartment she thought would be available probably
will not be, but that their house would be since they are
supposed to go to Italy for June and July on business. Their
house is so far out that I don't know what to do. Any ideas?
Perhaps you could call Doreen and check it out with her?

I have may of the books you specially requested from Strand are
in my own library. If there is something which seems crucial
and unavailable let me know and perhaps I can bring my own
copies.

Have have collected two boxes of information on museum organization,
library furnishings, conservation, papers, etc. which I expect
to bring with me.

I want to get this letter into the mail so will sign off for
now. Do let me know the answers to my questions as woon as
possible. Thanks.

 Sincerely,

January 26, 1977

Dear Mr. Aghdashloo:

 I have decided not to renew my contract with the Daftar for the year 1977-1978.

 As my present contract expires February 14, 1977 (25 Bahman 2535) I would appreciate the following conditions of my contract to be met before that date:

 1) a one-way open air-ticket to New York City
 2) expense of return shipment of personal effects to be paid in accordance with the amount originally sent in June, 1975 (records with accounting department).

 In addition, I expect final payment of all salary due to me before the expiration date.

 I have also requested a letter from Mr. Sharais in English, stating the dates of my two contracts, amount of salaries, and amount of taxes paid to the Iranian government. I need this information for my United States income tax returns.

 As part of my remaining responsibilities at the Daftar, I must supervise the opening of 50 crates now deposited at Saadabad Palace, as well as the removal of uncrated works from the Daftar. Since I do not want to delay my departure, I hope this responsibility can be expedited beginning assoon as possible.

 It is my intention to be as cooperative as I can during these last days and will gladly help and inform you regarding all of my

activities, all of my previous work and any questions or information
you would like regarding the Museum of Modern Art project.
Thank you for helping process these requests.

Sincerely,

Donna Stein

ع/span>دفترمخصوص علیاحضرت شهبانوی ایران

شماره
تاریخ
پیوست

March 1, 1977

Dear Mr. Aghdashloo:

As you know my contract with the Daftar expired
February 14, 1977. I agreed to stay one extra month to
complete the work I was involved with during my period
of employment.

On March 17, 1977 I plan to leave for Europe.
Please submit my letter of January 26, 1977 to the
proper authorities so that my papers can be finalized.

I would appreciate reimbursement of Rials40,260/-
deducted from my salary (Dey, 2355) and one month's rent
(Rials 38,000/-) which was promised to me.

Also I believe I have accrued some additional
leave for which I would appreciate payment.

Thank you for expediting this for me,

D. Stein

Preliminary Organization Plan
and
Budgets for

THE MUSEUM OF CONTEMPORARY ART
Tehran

Pre-Opening Activities

THE MUSEUM OF CONTEMPORARY ART*

Tehran

*Recommended name with Tehran on second line since it is the modern art museum for the entire country and not just Tehran

1. Develop Preliminary Plan & Budget for approval.
2. Hire Primary Staff.
3. Acquire office furniture, equipment & supplies.
4. Contract for Pre-Opening publications, events, etc.
5. Preliminary planning for the Opening:

 a. Programs & publications
 b. Invited participants
 c. Opening exhibitions
 d. Special events
 e. Publicity
 f. Budget

6. Other:

 a. Commence correspondence with art centers throughout the world.
 b. Plan publicity for first year's schedule.
 c. Organize "Patrons of The Museum" for program and financial support.
 d. Examine impact on the immediate neighborhood.

7. Develop job descriptions for Permanent Staff and commence program for circulating the positions and recruiting personnel.
8. Preliminary work on exhibitions which commence with Opening.
9. Registration of the organization with appropriate Government agencies, both national and city.

+ + +

Proposed Organization Of

THE MUSEUM OF CONTEMPORARY ART
Tehran

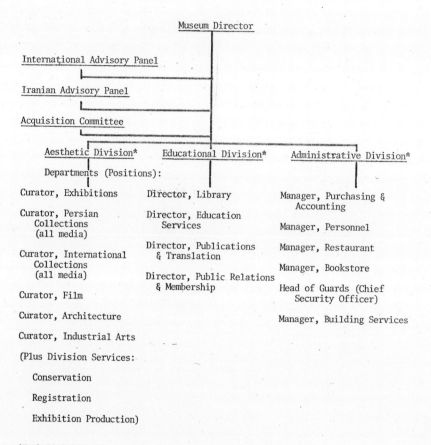

Museum Director

International Advisory Panel

Iranian Advisory Panel

Acquisition Committee

Aesthetic Division* Educational Division* Administrative Division*

Departments (Positions):

Curator, Exhibitions Director, Library Manager, Purchasing &
 Accounting
Curator, Persian Director, Education
 Collections Services Manager, Personnel
 (all media)
 Director, Publications Manager, Restaurant
Curator, International & Translation
 Collections Manager, Bookstore
 (all media) Director, Public Relations
 & Membership Head of Guards (Chief
Curator, Film Security Officer)

Curator, Architecture Manager, Building Services

Curator, Industrial Arts

(Plus Division Services:

 Conservation

 Registration

 Exhibition Production)

*Each Division with rotating chairman, plus clerical staff

First Year Budget

(1 Farvardin - 29 Esfand, 2536)

THE MUSEUM OF CONTEMPORARY ART
Tehran

	Monthly Rate	One Year Total
Permanent Staff (90)		
Museum Director	300,000 Rls.	3,600,000 Rls.
* Curator, International Art	200,000	2,400,000
Curator, Iranian Art	150,000	1,800,000
2 Curatorial Assistants	85,000 (2)	2,040,000
Curator, Film	150,000	1,800,000
Curator, Architecture & Industrial Arts	150,000	1,800,000
2 Librarians (Persian & Foreign)	85,000 (2)	2,040,000
Librarian Helper	25,000	300,000
Director, Education Ser.	100,000	1,200,000
5 Docents (for tours) part-time	50,000 (5)	3,000,000
Director, Publications	100,000	1,200,000
Translator	75,000	900,000
Director, Public Relations & Membership	150,000	1,800,000
Chief Accountant	125,000	1,500,000
** Bookkeeper	50,000	600,000
Restaurant Manager	100,000	1,200,000
*** 2 Restaurant Cooks	75,000 (2)	1,800,000
*** Dishwasher	15,000	180,000
*** 3 Busboys	12,000 (3)	432,000
*** 2 Waiters	40,000 (2)	960,000
*** Cashier	50,000	600,000
Bookstore Manager	75,000	900,000
Bookstore Salesperson	40,000	480,000
Head of Guards	75,000	900,000
30 Guards	15,000 (30)	5,400,000
Building Services Manager	75,000	900,000
5 Building Services Helpers	12,000 (5)	720,000
Registrar	75,000	900,000
2 Cataloguers	30,000 (2)	720,000
2 Art Movers/exh. Helpers	15,000 (2)	360,000
Sub-Totals	3,536,000 Rls.	42,432,000 Rls. (Carried forward)

* May combine this position with that of Exhibition Curator.

** May add Purchasing Agent in following year.

*** May contract out restaurant, omitting these positions but retaining Restaurant Manager.

Preliminary Budget

(1 Bahman - 29 Esfand, 2535)

THE MUSEUM OF CONTEMPORARY ART

Tehran

	Monthly Rate	Two Month Total	
Primary Staff			
Administrative Manager	100,000 Rls.	200,000 Rls.	
Advisor, International Art Collections	200,000	400,000	
Advisor, Iranian Art Collections	150,000	300,000	
Secretary (bi-lingual)	75,000	150,000	
Purchasing Agent (stores)	50,000	100,000	
Bookkeeper	50,000	100,000	
Typist (bi-lingual)	50,000	100,000	
Messenger	12,000	24,000	
Office Helper	10,000	20,000	
	697,000	1,394,000	1,394,000
Staff Overhead	174,250	348,500	348,500
Additional Furniture, Equipment & Supplies	600,000	1,200,000	1,200,000
Pre-Opening Publications			
Educational Posters (research & design)		500,000	
Book on Contemporary Iranian Art (writing & publication)		1,700,000	
Initial library acquisitions (books & films)		2,000,000	
	2,100,000	4,200,000	4,200,000
Building Maintenance & Utilities	600,000	1,200,000	1,200,000
Miscellaneous			
Petty Cash, etc.	1,250,000	2,500,000	2,500,000
Totals:	5,421,250 Rls.		10,842,500 Rls.

Page 2

First Year Budget, Museum of Contemporary Art

	Monthly Rate	One Year Total	
(Balance, carried forward)	3,536,000 Rls.	42,432,000 Rls.	
Photographer	75,000	900,000	
Carpenter	40,000	480,000	
2 Building Painters	20,000 (2)	480,000	
Framer	40,000	480,000	
Exhibition Production Mgr. (Arch.-designer)	75,000	900,000	
4 Secretaries (bi-lingual)	60,000 (4)	2,880,000	
4 Typists (2 Iranian & 2 Bi-Lingual)	40,000 (4)	1,920,000	
Personnel Manager	75,000	900,000	
	4,281,000 Rls.	51,372,000 Rls.	51,372,000
Staff Overhead	1,104,000	13,248,000	13,248,000
Additional Furniture, Equipment & Supplies	1,166,667	20,000,000	20,000,000
Pre-Opening Publications			
Educational Posters (research & design)*		4,000,000	
Card Reproduction*		3,000,000	
Library Acquisitions (books & films)		14,000,000	
	1,750,000	21,000,000	21,000,000
Special Programs for Opening			
Special Events		5,500,000	
Invited Participants (travel & hotel)		5,300,000	
Receptions & dinners*		4,000,000	
Publicity		2,000,000	
	1,400,000	16,800,000	16,800,000
Exhibitions (Seven months)	3,687,500	44,250,000	44,250,000
Building Maintenance & Utilities	583,333	7,000,000	7,000,000
Travel (Staff & Committees)	166,667	2,000,000	2,000,000
Sub-Totals	14,639,167 Rls.		175,670,000 Rls.

*Income producing which will partially offset cost

(Carried forward)

Page 3

First Year Budget, Museum of Contemporary Art

	Monthly Rate	One Year Total	
(Balance, carried forward)	14,639,167 Rls.	175,670,000 Rls.	
Meetings & Conferences	125,000	1,500,000	
Miscellaneous (Petty Cash, etc)	500,000	6,000,000	
Contingency Reserve	763,208	9,158,500	
GRAND TOTALS	16,027,375 Rls.	192,328,500 Rls.	192,328,500 Rls.

+ + +

دفتر مخصوص علیاحضرت شهبانوی ایران

امور فرهنگی

July 30, 1975

REPORT CONCERNING THE COLLECTION OF DRAWINGS, PRINTS AND PHOTOGRAPHS

The first and distinguishing function of a museum is to collect significant works of art that are, in its judgment, particularly fine or instructive in reference to the evolution of art and human ideals. If preserved, these works can be exhibited, reproduced, studied, interpreted, re-evaluated, enjoyed and--perhaps, most importantly--borrowed from by younger artists. By publicizing information on the various arts, a museum will inspire alert criticism and encourage a new relationship between artists (whatever their preference of technique is), critics, and audience.

The museum should be a center for study, where people can see exhibitions, read the literature in a particular field, and meet others who have similar interests. It can help individual artists mature their personal expression as well as inform and clarify to a vast audience the creative possibilities inherent in each medium.

Every medium has both utilitarian and aesthetic functions. The choice of medium depends upon an artist's inclination, training, and the audience he intends to address. Since the 1960s, especially, artists have eroded the traditional boundaries between art media. Today, therefore, it is not the medium but the aesthetic intention that validates a work of art and gives it merit.

To be a MODERN museum means to take risks, to be a bold and un-
compromising pioneer. A Museum of Modern Art's primary concern
must be with contemporary work, however, contemporary work is
best understood as the most recent mutation of an organic, continuing
tradition. Therefore, an historical collection with a broad international
base becomes a measuring rod from which to gauge the artistic achievements
of today.

In the development of a collection of Drawings, Prints, and Photographs
(primarily works on paper), covering the history of modern art since the
Impressionists, about 1870, the collection should not only complement
the painting and sculpture holdings but also represent international artists
whose work is not acquired in other media. The collection should include
the whole spectrum of technical possibilities and also represent the
history of modern art in cases where it is not possible or advisable to
acquire unique paintings and sculptures.

It should be a choice permanent collection of moderate size: a collection
which may serve as a stabilizer or benchmark, a background of quality
against which important temporary exhibitions may be projected and
evaluated. The collection should include unique and irreplaceable works
of art as well as variations of given prints--proofs, maquettes, in other
words, all manner of work to make explicit the evolution of art and ideas.
In addition to the primary collection, a supplementary study collection
should show examples of reproductive processes, early techniques,
unusual interpretations of works of art, exhibition announcements and
posters executed with original graphic techniques, etc.

Generally works on paper are of a less spectacular nature. They are relatively small in scale and format (at least until the mid-1960s). They have an intimate appeal not possessed by oil paintings and are well-adapted to human size and habitation. Often, the techniques are delicate and there is an economical use of color. More importantly, the various techniques demand a spontaneity that shows an artist's purest vision and ability.

That works on paper, in particular graphics and photographs, are made in editions is one of their chief advantages. As a consequence, it is still possible to acquire a fine, representative collection, covering the history of modern art, the important artists, and their masterpieces. Some of the rarest prints and photographs today, may have been issued in relatively large numbers originally, but have gradually disappeared. In the case of other editions, very few sheets were printed from the beginning. With works in editions, it is essential to "shop around", to know the market value of works in order to locate high quality items for the lowest possible price, since works from the same edition may sell for two different prices. This is also true of contemporary and newly published works, although their prices are more standardized than those of older objects.

With few exceptions, original drawings are unique objects done for themselves or as studies or blueprints for works in other media. They can represent the most direct expression of an artist's ideas. They can be quick, immediate depictions of subject matter drawn in pencil, pen, or chalk or resolved, finished masterpieces embellished with watercolor and paint.

Established prerequisites for an original graphic are the creation of the

master image by the artist alone on the plate, stone, woodblock, or other material (recently, this criteria has been more loosely defined); the execution of the print by the artist himself or pursuant to his directions; and approval of the finished work by the artist himself.

Original photographs, often considered a wordless literature, are repositories of facts and personal visions, that essential characteristic which distinguishes all art from non-art. It is an analytic picture-making system, which selects a particular cone of space during a specific time frame. Unlike other mediums of expression, a change in form is a change in content. Recently, many contemporary artists have used photography as a way of documenting their experience of non-pictorial art forms (happenings, conceptual art, earth works, systems art).

In a recent survey by Art in America magazine, photography placed second with 56.4% in "Special areas of art interest." For the follow-up question "In addition to art, which field are you actively interested", photography placed second again with 43.6% after theatre and before film. Nevertheless, one hundred thirty five years after the advent of photography, for an art museum to make a serious committment to the art of photography requires imagination and the willingness to accept some intellectual risks. As yet, few institutions in the world systematically collect and exhibit photography and there are few private collectors in Iran. The new Tehran Museum of Modern Art could take a leading role, as The Museum of Modern Art, New York did in 1929 when Alfred Barr, as part of his founding prospectus for the new museum included photography as a primary medium for acquisition.

For artists who ordinarily create unique objects (paintings and sculptures),

drawings and prints represent a natural extension into another medium of the artist's thinking. This, however, is not true of photography. Few painters and sculptors have employed photography creatively. Therefore, while photographs will and should be included in a "Department of Works on Paper" during the first phase of acquisition and development, it is advisable in terms of a long range plan to separate photography into its own department. Ultimately, this will promote careful study and inquiry into the essential nature of photography and the individuals who have spent their life work exploring the formal and aesthetic considerations intrinsic to this art.

The value of any collection must be assessed first in terms of quality. Quality knows or respects no simple geographic boundary nor should restrictions of national identity be placed on the fundamentally enriching view of collection held by a great institution. Perception of quality demands connoisseurship. Connoisseurship, a matter of education and aesthetic standards, requires discrimination of many factors, including inspiration of artist, compositional resolution and perfection, iconographic intent, technical skill, and printing craft. Secondly, value depends upon rarity and condition.

It is a curators responsibility to visit artists, dealers, exhibitions, bienals, and attend auctions for information and possible acquisition of new materials. Since Iran's laws have limited the importation of foreign art into the country, it is essential for a curator to be able to travel at regular intervals to the important art centers in the world--New York, London, Paris, Milan, Tokyo--in order to keep abreast of recent activities and to carefully judge and select vintage works, which may be appropriate to the collection. It is not enough to write letters for information and view transparencies for the scale, condition, color, and effect of a work of art changes radically in reproduction.

New material should be acquired for the collection regularly through purchase or gift, and unnecessary background material disposed of from time to time according to a careful de-accessioning policy. Works of art that embody surprise, distinctive grace, wit, or original intelligence are made with fair consistency only by artists of exceptional talent who work seriously at their calling. Selection of works should be based on visual and technical originality and intelligence, above clever inventions or large pretensions. Whenever practical to do so, it is best to collect in depth, groups of prints, drawings and photographs, since one or two images are not sufficient to illuminate an artist's vocabulary or the range of his concerns. Furthermore, some artists do not work in terms of single images. The work of artists whose oeuvre would not justify a comprehensive treatment should also be acquired for their minor achievements in order to show the full spectrum of the art of our time. It is possible to systematically select contemporary work from publishers, galleries and artists. However, this is not true of older works, which must be acquired as they become available. With vintage works, it is suggested that a working relationship be established with trusted dealers , who can notify the Secretariat when works come on the market that fulfill our particular needs and interests.

In every museum, the specifics of an acquisition policy and the procedures for executing it are different. Nonetheless, in every case, the responsibility for recommending additions to the collection is delegated to the curator or heads of departments in whose judgment the director and trustees of the museum have placed their confidence. Each curator has a certain amount of budgeted funds for acquisition. Ordinarily, discretionary funds up to a prescribed amount of money are allotted a curator to make immediate

decisions about items which might otherwise be unavailable or inaccessible.
All proposed purchases and gifts are submitted by a department head to an
acquisition committee of experts for final approval. With very few
exceptions, art objects are not purchased by a museum without the
approval of the head of the department concerned.

Besides acquisitions through purchases, works of art may enter a collection
via individual and corporate contributions of money, securities, or works
of art. It is advisable that such ﹛gifts and bequests be of a clear and
unrestricted nature in order to avoid legal and financial complications.
Exhibitions should be planned to try to induce collectors, by showing work
they are interested in, to support the museum program and donate works
to the collection. In any case, only work meeting certain standards of
connoisseurship should be considered for the primary collection.

To create a vital place for a museum in a community of artists and
public, there must be the guiding direction of an exhibition program
defined in conjunction with the acquisition policy. In every case, it is
preferable that the exhibition bear the stamp of an artist's or curator's
personality, insights, and expertise. They should enhance and develop
art appreciation while providing information and critism. A successful
exhibition demonstrates analytic understanding, a perceptive view of
detail coupled with a poetic grasp of the whole. The context of an
exhibition can be enlarged through the publication of an informative
catalogue developing an artistic theme through political and social
history, for example. As Montesquieu said, "The pleasure of thinking
is to discover the similarities between things different and differences
between things similar."

Large and small exhibitions can be roughly classified into five categories:
1) HISTORICAL: to clarify the past and reveal traditions which lend new
perspectives to today's work (i. e. definition of a stylistic phenomenon
within its historical context, location of a specific culture within its
ethnographic confines).
2) CONTEMPORARY: to illustrate, communicate, and express ideas.
3) EDUCATIONAL: to explore and explain the character of a medium.
4) ONE MAN OR GROUP SHOWS: to concentrate on quality, range, and
power of the individual artist's expression (i. e. environments created by
an artist, artist's choosing other artists, private collections).
5) EXPERIMENTAL: informal, to show the new work by known or unknown
artists, technical development s or material of a challenging or enlightening
nature.

Certain operational necessities require implementation immediately for the
program to proceed forward effectively. Besides a staff or trained curators,
we desperately need professional and support people: a LIBRARIAN to
expand and organize an effective research center, provide help for the
curatorial staff and facilitate the acquisition of reference materials needed
in the building and cataloging of a museum collection; bi-lingual ASSISTANTS
FOR CATALOGING AND PREPARATION should be employed as soon as
possible to begin the training and formal procedures necessary for an
effective museum organization; a bi-lingual SECRETARY to relieve the
curatorial staff of excess work to permit fulltime research and organi-
zation for the museum collection and program.

Without proper technical support it is impossible to run a smooth operation.
For instance,the present shortcomings include: no english-language
typewriter in the department (although one has been on order for at least
six weeks);the storage facilities for collection are inadequate, over

crowded, and dangerous to the care and conservation of the art works, and it is impossible to get at the works of art themselves for cataloging purposes. In fact, it is extremely difficult just to get the office supplies required for everyday procedures. These grievances may seem minor in light of the great plan, but no plan will work well if the underlying base is weak and those people filling the various slots along the way are not cognizant of their responsibilities, devoted to the project, and actively working for the benefit of the highest goals possible.

Donna Stein

September 23, 1976

SUGGESTIONS FOR REMOVAL OF WORKS OF ART AND
ORGANIZATION OF NEW STORAGE FACILITY

FOR the new storage facility proper conditions of
temperature and relative humidity should be maintained
and dirt should be prevented from entering the space.
Relative humidity is far more important than tempera@
ture and should be kept between 45-60% (see attached
chart), although the temperature should remain constant
and preferably cool. A fan should be installed in
one or all of the three windows to allow for air-
circulation. At the same time, the doors and windows
should be sealed against dust. If the room receives
direct sunlight, fluctuations in temperature can be
minimized by hanging fibreglass; insulation material
against the window glass.

The storage space should be carefully organized,
uncluttered, and kept clean to insure easy accessi-
bility and avoid accidents. The room should be divided
into areas -- according to size, type of work, or
some other category. Precise master lists of objects
or of sealed containers for each area should be made
as an inventory of the collection and used to identify
and locate works of art.

All personnel authorized to handle crates and works of
art should have read and memorized the brochure on the
physical handling of works of art or other museum objects
(see example of text translated into Farsi).

As more than half of the crates with acquisitions for
the museum (between 50 and 60) have never been opened,
and since the shippers papers do not indicate what
objects are in which crate, it will be necessary to
open all crates thus far received and not carefully
identified. Depending upon how long this new storage
facility is to be used, if it is more than six months,
it is recommended that the works should be removed from
their crates and stored in bins (according to size and
material) to protect them from damage by excessive
humidity, uneven temperature, and the lack of air circula-
tion.

As there is already a complete notebook listing and
filing system for the works, on the international
collection, it is a simple matter to number the pieces.
In museums where accessions are for the most part
single items, a number composed of two parts is generally
given (the year and the number assigned to the object

within the year of its acceptance, for example, 76.1,
76.32, etc. Should it be decided not to leave the
objects uncrated, after opening the crates and number-
ing of each object, the crates can be closed and given
their own number and identification system, which will
correspond to a master list also including their contents.

Crates from all storage facilities, including Lalezar,
should be assembled in one place. Since the storage
area is on the second floor of the building, it is
recommended that none of the crates with sculptures
be removed from their present location.

Projected time required for moving, uncrating organiza-
tion (numbering and listing), is about one month,
using 2 handlers, an accountant, and curatorial
advisor and a competant assistant.

 Donna Stein

December 6, 1976

Your Excellency:

As the person retained by the Private Cabinet of Her
Imperial Majesty, the Shahbanou of Iran to serve as an expert
and confidential advisor, especially for acquisitions and
programs related to the formation of the new Tehran Museum of
Modern Art, may I take this opportunity to inform you of the
developments during my tenure and those areas which remain to
be accomplished. I take this somewhat unusual approach because
I am sure you would want to be aware of the problems and
obstacles which require immediate attention before such a museum
can be operative.

I particularly feel concerned about some of the problems
defined below, because, if overlooked or minimized, they could
jeopardize the quality and high standards thus far maintained
and sought after in this project. More importantly, these
problems may mare what might otherwise be an outstanding
international event with the opening of a new modern collection of
stature, underscoring another area of Iran's leadership in the
world.

Some 337 objects have been acquired for the international
collection, of which two-thirds were selected on my personal
recommendation, and represent a total investment of approximately
20 million dollars:

Drawings:	15	Tapestries:	2
Paintings:	58	Graphics:	168
Sculptures:	16	Photographs:	78

While we have made considerable progress, the collection
is by no means historically comprehensive. Large gaps must be
filled before even a minimum overview will represent the past
100 years in the history of art. Several works of art were

ordered for acquisition prior to the change of administration in
the Daftar, and their disposition must be settled. The more crucial
problem concerns those works which have already been acquired and
because of impooper storage and care may possibly be damaged
before they even have a chance to be installed in the new museum.

In the past, I have had full responsibility for aesthetic
decisions, the negotiations and transactions for financial matters
being expedited by other members of the Daftar. This working method
placed an enormous responsibility on my judgement. I feel I have
shouldered this burden far longer than I ever imagined. If the
Tehran Museum of Modern Art is to have a major international
collection, broader participation is necessary and the procedures
must be objectified. Therefore, I recommend that an acquisition
committee be formed of international experts who could meet on a
quarterly basis in Iran to review all proposed acquisitions and
supervise the continuation of quality and careful buying for the
collection.

We are rapidly approaching the proposed opening for the new
museum. As my contract time of service nears completion, I am
concerned that no rational program has been established for the
direction of the museum. There has been no implementation of
training of staff to handle the precious works of art, no
consideration for installation of the facilities, no preparation
for publication of materials for the opening, no program of major
international loan exhibitions to launch the museum, etc.

In addition, I am being asked to disclose what from the
beginning I understood to be the most sensitive information regarding
the collection. My integrity as a curator in charge of certain
collections makes me feel honor bound not to reveal information
about this project without the specific instructions from you or
Her Imperial Majesty.

I would appreciate the opportunity to meet with you at

3

your earliest convenience to discuss these problems and to
understand how you wish me to proceed with my work in the
future.

Yours respectfully,

Donna Stein

LIST OF PROPOSED PURCHASES
DRAWINGS

	CODE SOURCE		ARTISTS NAME	TITLE OF WORK	DISCOUNTED PRICE($)	DISCOUNT OFFERED
1	G	✓	LAURENCIN	SELF PORTRAIT	2300000	
2	P		MODIGLIANI	CARYATIDE ROSE SUR FOND BLEU	7920000	10%
3	G	✓	VILLON	STUDY FOR HEAD OF BAUDELAIRE	220000	
4	G	✓	LA FRESNAYE	STUDY SHEET WITH 3 HEADS	240000	
5	T		PICASSO	PICADOR	#320000	10%
				TOTAL	12930000	
6	T		MANET	PORT. OF IRMA BRUNNER	6000000	c. 9%

NOTE:

G LUCIEN GOLDSCHMIDT, INC., 1117 MADISON AVENUE, NEW YORK 10028
P PERLS GALLERIES, 1016 MADISON AVENUE, NEW YORK 10021
T E.V. THAW & Co., 726 PARK AVENUE, NEW YORK 10021
* EXTRAORDINARY QUALITY

E OF ORK	TECHNIQUE	MEASUREMENTS	ITEMS FOR FURTHER CONSIDERATION: PRICE
906	BRUSH & INK ON PAPER	8 1/16 × 6 3/4"	
914	GOUACHE ON PAPER	20 1/8 × 14 3/4"	DATES AFTER IMPORTANT PRINTS OF SAME SUBJECT
922	CHARCOAL ON PAPE	7 × 3 3/4"	NICE, BUT NOT EXTRAORDINARY;
923	BRUSH & CHINA INK ON PAPER	10 1/4 × 7 3/4"	
951	BRUSH & CHINA INK ON PAPER	19 3/4 × 25 7/8"	
880	PASTEL		

LIST OF PROPOSED PURCHASES
PAINTINGS AND SCULPTURES (S)
+ TAPESTRIES

	CODE SOURCE	ARTISTS NAME	TITLE OF WORK	DISCOUNTED PRICE ($)	DISCOUNT OFFERED
1	P	VLAMINCK	GRAND NU AU DIVAN	324,000 00	10%
2	P	VAN DONGEN	PORT. d'AGATHE W. GRAVENSTEIN	144000 00	10%*
3	P	ARCHIPENKO	REPOS	28800 00	10%
4	P	"	THE GONDOLIER	37800 00	10%
5	P	LEGER	VARIATION DE FORMES	34200 00	10%
6	P	DUFY	LE PECHEUR NAPOLITAIN	52200 00	10%
7	P	BRAQUE	GUITARE ET PARTITION	324000 00	10%*
8	T ✓	PICASSO	OPEN WINDOW OU THE RUE DE PENTHIEVRE IN PARIS	1630000 00	10%
9	T	"	BABOON AND YOUNG	31500 00	10%
10	P	PASCIN	ANDRE SALMON ET MONTMARTRE	70200 00	10%
11	P	SOUTINE	LES GORGES DU LOUP SUR VENCE	19800 00	10%
12	P	MAILLOL	TÊTE HÉROIQUE (DE PONT VENDRES)	28800 00	10%
13	P	CHAGALL	FLEURS DANS UN VASE BLEU	144000 00	10%
14	T	DALI	GALA AND THE ANGELUS OF MILLET	157500 00	10%
15	P	"	L'ANGÉLUS ARCHITECTONIQUE DE MILLET	432000 00	10%
16	P	CALDER	CHICK-LETT	58000 00	10%
17	P	"	LITTLE LEAVES	48600 00	10%
18	P	"	THE DOT AND I	43200 00	10%*
19	P ✓	"	THE ORANGE FISH	99000 00	10%*
20	P	"	LONDON	171000 00	10%*
21	P	ROUAULT	LA REINE DE SABA	202500 00	10%
			TOTAL	4850600 00	
22	T	BONNARD	INTERIOR WITH FLOWERS	675000 00	10%
23	P	DALI	LE PETIT THEATRE	144000 00	10%
24	P	MODIGLIANI	HEAD	329000 00	10%
25	P ✓	PICASSO	(2 WOMEN) INSPIRATION	76500 00	10%
26	P ✓	Derain	L'Age D'or		

NOTE:

P	PERLS GALLERIES, 1016 MADISON AVENUE, NEW YORK 10021			857000 00
T	E.V. THAW & Co. INC., 726 PARK AVENUE, NEW YORK 10021			1729000 00
*	EXTRA ORDINARY QUALITY			
			TOTAL:	2586700 00

TE OF ORK	TECHNIQUE	MEASUREMENTS	ITEMS FOR FURTHER CONSIDERATION: PRICE
905	OIL PAINTING ON CANVAS	27⅛ x 37¾"	
909	OIL PAINTING ON CANVAS	39⅜ x 31⅞"	
911	BRONZE SCULPTURE S	14" high	
914	BRONZE SCULPTURE S	32½" high	
913	OIL PAINTING ON CANVAS	18⅛ x 24⅛"	
915	OIL PAINTING ON CANVAS	29 x 15¾"	CHARMING; NOT DURING HEIGHT OF FAUVE PERIOD
917-20	OIL PAINTING ON CANVAS	28⅝ x 36¼"	
920	OIL PAINTING ON CANVAS	64½ x 43"	
951	BRONZE SCULPTURE S	21" high	
921	OIL PAINTING ON PAPER	76⅝ x 51⅛"	
923	OIL PAINTING ON CANVAS	24½ x 33¾"	GOOD LANDSCAPE BUT NOT A PORTRAIT
923	BRONZE SCULPTURE S	23" high	CAST AFTER ARTIST'S DEATH
926	OIL PAINTING ON CANVAS	23⅞ x 18"	ONLY HAS HINT OF FIGURATIVE FANTASY, A LITTLE LATE
933	OIL ON PANEL	9⅜ x 7⅜"	SOLD, NATIONAL GALLERY OF CANADA, OTTAWA
933	OIL PAINTING ON CANVAS	28¾ x 23¾"	
934	STEEL STABILE S	88 x 50 x 58"	
941-42	METAL STANDING MOBILES	30½ x 38½ x 72"	
944	STANDING MOBILE; WOOD & WIRE & STEEL	17" high	
946	METAL MOBILE S	75 x 176"	
962	METAL MOBILE S	15 x 30'	HUGE; LATER MOBILE
937	OIL PAINTING ON CANVAS	22 x 15"	
924	OIL PAINTING ON CANVAS		
934	OIL ON GLASS (8 LAYERS IN BOX)	12¾ x 16⅝ x 12¼"	
914	STONE SCULPTURE		
934/35	WOOL + SILK TAPESTRY	76 x 66"	EDITION OF 2 (BARNES FOUNDATION, PHILA, PA.)
904	oil painting on canvas		

5, 1 question)
5, 1 question }

LIST OF PROPOSED PURCHASES
PHOTOGRAPHS

	CODE SOURCE		ARTISTS NAME	TITLE OF WORK	DISCOUNTED PRICE ($)	DISCOUNT OFFERED
1	S		TALBOT	SMALL GIRL IN CHAIR	1200 00	20%
2	L	✓	HILL + ADAMSON	EDWARD J LANE AS A PERSIAN	1440 00	10%
3	W		"	MISS MUNRO	1800 00	10%
4	S	✓	"	BEACH SCENE	2000 00	9%
5	W	✓	MARVILLE	VUE PRISE DU PONT NOTRE DAME	540 00	10%
6	W		CAMERON	CRISTABEL, PORT. OF MAY PRINCEPT	1620 00	10%
7	S		"	ANNIVERSARY	1500 00	NET
8	W	·	SALZMANN	FONTAINE ARABE, JERUSALEM	360 00	10%
9	D	✓	SEBAH	PALMIER FORÊT	27 00	10%
10	D	✓	BONFILS	VUE GENERALE DE LA MOSQUEED'	27 00	10%
11	D	✓	"	INTERIOR " " OMAR	27 00	10%
12	D		ROBERTSON + BEATO	CONSTANTINOPLE, DOOR TO SERAGLIO	27 00	10%
13	S		UNKNOWN	WATER BOTTLES OF GOAT SKIN	180 00	NET
14	W		THOMSON	THE WALLWORKER	360 00	10%
15	W		"	NOVEMBER EFFIGIES	360 00	10%
16	W		"	THE CRAWLERS	360 00	10%
17	W		"	LONDON NOMADES	360 00	10%
18	W		"	STREET ADVERTISING	360 00	10%
19	W	✓	JACKSON	MOUNT OF THE HOLY CROSS	675 00	10%
20	W		NADAR	PORT. OF GEORGE SAND	315 00	10%
21	S	✓	"	PORT OF JOHN GIBSON	2000 00	20%
22	S		MUCHA	STUDY FOR PAINTING, "LEGS"	800 00	20%
23	W	✗	EVANS, F.	ELY CATHEDRAL	450 00	10%
24	W	✓	"	FRENCH CORNFIELDS	675 00	10%
25	W		"	CHOIR AISLE	450 00	10%
26	W	✓	"	APSE, BOURGES CATHEDRAL	1350 00	10%
27	W	✓	"	PORT. OF BARBARA EVANS	675 00	10%
28	W		STIEGLITZ	HUSKING CORN	450 00	10%
29	W		"	FROM BACK WINDOW OF "291"	6300 00	10%
30	W	✓	"	THE STEERAGE	4500 00	10%
31	W		"	TWO TOWERS, NEW YORK	450 00	10%
32	W	✓	STEICHEN	PASTORAL, MOONLIGHT	675 00	10%
33	W		"	AUGUSTE RODIN	405 00	10%
34	W	✓	KASEBIER	LITTLE GIRL HOLDING CUP	450 00	10%
35	S		"	JOE BLACK-FOX WITH FACE PAINT	1250 00	NET
36	W		WHITE	PORT. OF SON	900 00	10%
37	W	✓	GENTHE	THE SAN FRANCISCO EARTHQUAKE	1350 00	10%
38	W		HINE	ITALIAN FAMILY ON BOAT FROM ELLIS ISLAND	270 00	10%
39	W		"	LOWER EAST SIDE, NEW YORK	135 00	10%
40	W		"	HEART OF THE TURBINE, WORKER IN SHRINE	180 00	10%
41	S		"	VENDOR, WASHINGTON, DC.	125 00	NET
42	S	✓	"	BARKER COTTON MILLS	125 00	NET
43	S	✓	"	YOUNG GIRL WITH BABY	175 00	NET
				SUB TOTAL	37 598 00	

DATE OF WORK	TECHNIQUE	MEASUREMENTS	ITEMS FOR FURTHER CONSIDERATION:	PRICE
	PHOTOGLYPH	4½ x 3"		
1845	CALOTYPE	5¾ x 8⅛"		
1840s	CALOTYPE	6 x 8¼"		
1845	CALOTYPE	5¾ x 7¾"		
1855	CALOTYPE	9¼ x 13"		
1870	ALBUMEN PRINT	9½ x 12½"		
	ALBUMEN PRINT	10 x 8"		
1855-56	CALOTYPE	9¼ x 13"		
		8⅛ x 10½"		
		8½ x 11"		
1880		12⅛ x 10⅝"		
		6½ x 8½"		
1877	WOODBURYTYPE	3 x 4½"		
1877	WOODBURYTYPE	4½ x 3¾"		
1877	WOODBURYTYPE	3½ x 4½"		
1877	WOODBURYTYPE	3¼ x 4¼"		
1877	WOODBURYTYPE	3⅜ x 4⅜"		
1880s	ALBUMEN PRINT	13¾ x 21¼"		
1880s		5¾ x 4"	LATE CABINET CARD; NOT ESSENTIAL	
1860s	OVAL PRINT	8¾ x 6¾"		
		6½ x 4½"		
1900	PLATINUM PRINT	3 x 4"		
1900	PLATINUM PRINT	3½ x 7½"		
1900	PLATINUM PRINT	4½ x 6"		
1900	PLATINUM PRINT	7 x 9¾"		
1910	PLATINUM PRINT	4 x 6"		
1923	SILVER PRINT	3½ x 4½"		
1914	PLATINUM PRINT	7 x 9½"		
1907	GRAVURE ON TISSUE	10⅛ x 13"		
1913	GRAVURE	6¼ x 7½"		
1907	GRAVURE, HANDCOLORED	6 x 8"		
1911	GRAVURE	6½ x 9½"		
1900s	GUM PRINT	5¾ x 7¾"		
1898	PLATINUM PRINT	8 x 5¼"		
1912	PLATINUM PRINT	7 x 9½"		
1906	SILVER PRINT	13¼ x 7½"		
1905	SILVER PRINT	4½ x 6½"		
1900s	SILVER PRINT	4½ x 6½"		
1920s	SILVER PRINT	8 x 10"		
1919	SILVER PRINT	4½ x 6½"		
1914	SILVER PRINT	4½ x 6½		
	SILVER PRINT	9 x 6½"		

PHOTOGRAPHS

	CODE SOURCE		ARTISTS NAME	TITLE OF WORK	DISCOUNTED PRICE	DISCOUNT OFFERED
44	W	✓	ATGET	51 RUE DE MONTMOURACY	1080 00	10 %
45	W	✓	"	QUAI DES GRANDS AUGUSTINES	1080 00	10 %
46	S		CURTIS	GERONIMO	2000 00	NET
47	W	✓	SANDER Jockey	PORT OF W: FURTZWANGLER	369 00	10 %
48	S	✓	MOHOLY – NAGY	UNTITLED	5000 00	NET
49	W	✓	BRUGUIERE	GRECIAN HEAD	270 00	10 %
50	L	✓	MAN RAY	EGG BEATER + ABSTRACT INTERIOR	6750 00	10 %
51	S		"	IN DRAWING ROOM GERTRUDE STEIN + ALICE TOKLAS	3000 00	NET
52	L	✓	BELLMER	POUPÉE DANS L'ESCALIER	2250 00	10 %
53	W		WESTON, E.	PORTRAIT OF BRETT	1800 00	10 %
54	W	✓	"	SUNSHINE + FLOWERS	1800 00	10 %
55	D	✓	"	TINA MODOTTI	700 00	NET
56	S	✓	"	CALIFORNIA COASTAL LANDSCAPE	1000 00	9 %
57	S	✓	EVANS, W.	BUILDINGS + STREET LAMP	600 00	NET
58	S	✓	"	NEGRO BARBER SHOP INTERIOR	1000 00	NET
59	S	✓	"	KITCHEN, TRURO, MASSACHUSETTS	750 00	NET
60	S		"	MAIN STREET, SARATOGA SPRINGS N.Y.	800 00	13 %+
61	W	✓	BOURKE-WHITE	RCA PLANT	450 00	10 %
62	S		"	LOCKET, GEORGIA	600 00	NET
63	S	✓	"	THE GEORGE WASHINGTON BRIDGE N.Y.	500 00	NET
64	S	✓	"	ROLLING OPTICAL GLASS	600 00	
65	S		FREUND	PIERRE BONNARD IN HIS STUDIO	600 00	NET
66	S		ANDRÉ	PIERRE BONNARD	450 00	NET
67	W		ARBUS	PRO-WAR PARADE	1800 00	10 %
68	L	✓	ROBINSON	LANDING THE CATCH	1260 00	10 %
				TOTAL	74107 00	

NOTES:

D	HOWARD C. DAITZ, 446 W 20th STREET, NEW YORK 10011
L	GRAPHICS INTERNATIONAL LTD. 3243 P STREET, N.W. WASHINGTON D.C. 20007
S	ROBERT SCHOELKOPF GALLERY, 825 MADISON AVENUE, NEW YORK 10021
W	THE WITKIN GALLERY, INC., 243 EAST 60th STREET, NEW YORK 10022
*	EXTRAORDINARY QUALITY AND ESSENTIAL TO COLLECTION

DATE WORK	TECHNIQUE	MEASUREMENTS	ITEMS FOR FURTHER CONSIDERATION :	PRICE
1910-20		6½ x 8½"		
1910-20		6½ x 8½"		
1905	PLATINUM PRINT	16 x 20"		
1928	SILVERPRINT	6 x 9"		
1920s				
1920s	SILVERPRINT	11¼ x 14¼"	1920s; RARELY APPEAR ON MARKET	
1946	RAYOGRAPH	13 ⅞ x 10 ⅞"	MOST IMPORTANT RAYOGRAPHS IN	
1922	SILVER PRINT	6½ x 9"		
	SILVER PRINT	9½ x 9½"		
1922	PLATINUM PRINT	9 x 7¼"		
1914	PLATINUM PRINT	18¼ x 12¼"		
1924	SILVER PRINT			
1937	SILVER PRINT	7⅜ x 9½"		
1928	SILVERPRINT	2¼ x 1¾"		
1936	SILVER PRINT	8 x 10"		
1931	SILVER PRINT	6 x 6½"		
1931	SILVER PRINT	13 x 10⅜"	LATE PRINTING OF IMPORTANT IMAGE	
1935	SILVER PRINT	17¼ x 13¼"		
1936	SILVERPRINT	13¼ x 10"		
1933	SILVERPRINT	13½ x 9¾"		
	SILVER PRINT	13½ x 9¾"		
	CHARCOAL PRINT (COLOR)	14 x 9½"		
	SILVERPRINT	15 x 11"		
1967	SILVER PRINT	15¾ x 13¼"		
890	COMPOSITE PHOTOGRAPH	18½ x 15"		

Code Source		Artists Name	Title of Work	Discounted Price($)	Discount Offered
1	A ✓	WHISTLER	BLACK LION WHARF	135000	10%
2	A	"	THE LIME BURNER DRESSING-ROOM	171000	10%
3	G ✓	DEGAS	DANCERS COMING FROM THE	2000000	
4	L	RODIN	HENRI BECQUE	500000	10%
5	G	ENSOR	THE COMBAT OF DEMONS	350000	
6	L ✓	"	THE CATHEDRAL - 1st PLATE	1250000	11%+
7	L	"	ENTRANCE OF CHRIST INTO BRUSSELS	1250000	11%+
8	A ✓	BONNARD	SCENE DE FAMILLE	540000	10%
9	A ✓	CASSATT	PEASANT MOTHER+CHILD	1350000	NET
10	A ✓	LA REVUE BLANCHE : BONNARD	FRONTISPIECE	9000 00	NET
11		ALBUM OF 13 PRINTS—BONNARD	FEMME AU PARAPLUIE		
12		5/100 COTTET	BRETONNES		
13		DENIS	LA VISITATION		
14		IBELS	PAYSANNE AVEC PANIER		
15		RANSON	LA LISEUSE COUCHÉE		
16		REDON	CHEVAL AILE		
17		RIPPL-RONAI	LA LISEUSE AVEC LA LAMPE		
18		ROUSSEL	NOLI ME TANGERE		
19		SERUSIER	LA MARCHAND DE CHIFFONS		
20		TOULOUSE-LAUTREC	CARNAVAL		
21		VALLOTTON	LES TROIS BAIGNEUSES		
22		VUILLARD	LA COUTURIERE		
23	G	PUVIS DE CHAVANNES	PAUVRE PECHEUR	49000	
24	L	CARRIERE	PORT. OF PAUL VERLAINE	40000	11%+
25	L ✓	TOULOUSE LAUTREC	LA CLOWNESS AU MOULIN ROUGE	100000 00	10%
26	A ✓	PRENDERGAST	TELEGRAPH HILL	960000	NET
27	A	MATISSE	STUDY OF WOMAN IN STREET COSTUME	135000	10%
28	G ✓	"	PORT. OF MME. GALANIS	150000	
29	G	VILLON	MUSICIENS CHEZ LE BISTRO	350000	
30	G	"	"	180000	
31	A ✓	MARIN	BROOKLYN BRIDGE No.6 SWAYING	247500	10%
32	A ✓	FEININGER	VILLA ON THE SHORE, 4	315000	10%
33	A ✓	HOPPER	EAST SIDE INTERIOR	607500	10%
34	L ✓	DELAUNAY	LA FENETRE SUR LA VILLE	1050000	11%+
35	G	ROUAULT	SELF PORTRAIT	200000	
36	A ✓	SIQUEIROS	PEACE	42750	10%
37	A ✓	DAVIS	HOTEL DE FRANCE	108000	10%
38	A	"	SIXTH AVENUE EL	450000	NET
39	A	"	STUDY FOR DRAWING	216000	10%
40	A ✓	WOOD	HONORARY DEGREE	81000	10%
41	T ✓	PICASSO	WEEPING WOMAN	450000	NET
			SUB TOTAL	28487750	

E of ORK	TECHNIQUE	MEASUREMENTS	ITEMS FOR FURTHER CONSIDERATION; PRICE
1859	ETCHING	6 × 8¾"	
1859	ETCHING & DRYPOINT	10 × 7"	
1880-83	M O N O TYPE	M 8¼ × 6⅛"	
1885	DRYPOINT	8 × 6¼"	
1888	ETCHING		
1886	ETCHING, HAND COLORED	9¾ × 7½"	
1898	ETCHING, HAND COLORED	9¾ × 14"	
1892	COLOR LITHOGRAPH	8¼ × 10¼"	
1895	COLOR DRYPOINT & AQUATINT	11¾ × 9½"	
1895	LITHOGRAPH		
	COLOR LITHOGRAPH		
	LITHOGRAPH		
	COLOR LITHOGRAPH		
	COLOR LITHOGRAPH		
	LITHOGRAPH		
	LITHOGRAPH		
	COLOR LITHOGRAPH		
	LITHOGRAPH		
	COLOR LITHOGRAPH		
	COLOR LITHOGRAPH		
	WOODCUT		
	COLOR LITHOGRAPH		
1897	COLOR LITHOGRAPH	17 × 22 9/16"	
1896	LITHOGRAPH	20½ × 16"	
1897	COLOR LITHOGRAPH	16⅛ × 12⅝"	
1895-1905	MONOTYPE	M 6⅞ × 8⅛"	
1903	DRYPOINT	5¾ × 4"	
1914	DRYPOINT	3¼ × 2¼"	
1912	ETCHING & SOFT GROUND: TP	10 3/16 × 9⅛"	
1912	" : Trial Proof	"	
1913	ETCHING	10¾ × 8¾"	
1920	WOODCUT	10½ × 13⅜"	
1922	ETCHING	8 × 10"	
1925	LITHOGRAPH	22 × 17"	
1926	LITHOGRAPH & BOOK		
1947	LITHOGRAPH	11¾ × 9"	
1928	LITHOGRAPH	14 × 11"	
1932	LITHOGRAPH	11⅞ × 17⅞"	
1955-59	COLOR SILKSCREEN	7¼ × 7¾"	
1938	LITHOGRAPH	11¾ × 7"	
1937	ETCHING & AQUATINT		

PRINTS AND MONOTYPES

CODE SOURCE	ARTISTS NAME	TITLE OF WORK	DISCOUNTED PRICE ($)	DISCOUNT OFFERED
42- U ✓	JOHNS	0-9 (PORTFOLIO OF 10 PRINTS)	225000 00	10%
51 52- U ✓ 58	"	1ST ETCHINGS (PORTFOLIO OF 7 ETCHINGS)	10800 00	10%
		TOTAL	318177 50	
59 T ✓	VAN GOGH	AT ETERNITY'S GATE	6500000	NET

NOTE:

A	ASSOCIATED AMERICAN ARTISTS, 663 FIFTH AVENUE, NEW YORK
G	LUCIEN GOLDSCHMIDT, INC, 1117 MADISON AVENUE, NEW YORK 10028
L	R.M. LIGHT & CO. INC, 190 MARLBOROUGH STREET, BOSTON MASSACHUSE
T	E.V. THAW & Co. INC. , 726 PARK AVENUE, NEW YORK
U.	UNIVERSAL LIMITED ART EDITIONS, 5 SKIDMORE PLACE, WEST ISLIP, LONG-ISLAN
*	EXTRAORDINARY QUALITY
✳	ESSENTIAL TO COLLECTION — MUST ACQUIRE

TE OF ORK	TECHNIQUE	MEASUREMENTS	ITEMS FOR FURTHER CONSIDERATION:	PRICE
1960-63	LITHOGRAPHS			
1967-68	ETCHINGS			
1882	LITHOGRAPH			

INDEX

Page numbers in Italics refer to illustrations

Achaemenid Empire, c. 550–330 BC: 13, 14, 24
Aghdashloo, Aydin: 89 (note 12), 155, 156, 166, 178, 182
Aichi Prefectural Museum of Art, Nagoya: 9
Alcosser, Murray: 177
Algiers Accords, 1975: 14
Ali Qapu Palace, Isfahan: 24, *25, 172*
Alvar Aalto: 48 (note 9), 106, 200, 203
 Museum of Western and Iranian Contemporary Art, Shiraz: 48 (note 9), 106, 200, 203
André, Roger: 88
 Pierre Bonnard in his Studio, n.d.: 88
Appeal of Conscience Foundation: 170
Arabshahi, Massoud: 171
Arbus, Diane: 79
 Patriotic Boy, 1967: 79
Ardalan, Nader: 170
Atget, Jean-Eugène-Auguste: 78
 51 Rue de Montmouracy, c. 1910–20: 78
 Quai de Grands Augustines, c. 1910–20: 78
Ayatollah Ruhollah Khomeini: 15, 16, 178, 179, 198

Bacon, Francis: 131, *135*, 136, 150 (note 14)
 Reclining Man with Sculpture, 1960–61: *135*, 136
badgir: 34, 193
Bagherzade, Iradj: 158, 165
Bahadori, Karim Pasha: 9, 16, 27–29, 31, 37–39, 44–47, 48 (notes 7, 16), 50, 52–54, 78, 89, 95, 100, 103–106, 110, 111, 115, 118, 119, 124–126, 127 (notes 16, 35), 129, 131, 136, 138, 147, 148, 150, 150 (notes 15, 16), 153, 154, 160, 161, 166, 178, 181, 185 (note 30)
Balassanian, Sonia: 130
Banham, Reyner: 34, 48 (note 4)

Barth, Jack: 165, 177, 184 (note 7)
 Untitled, 1977: p. 177
Basel Art Fair, 1976: 136, 138, *138*, 139, 150 (note 11), 207
Bechtle, Robert: 35
Beckmann, Max: 172
Behshahr Industrial Group, Tehran: 170, 171
 Ladjevardi, Ali: 171
 Ladjevardi, Hamid: 171, 184 (note 3)
Bellmer, Hans: *cover*, 79, *86, 183,*
 Poupée dans l'escalier, 1934–36: 79, *86*
Benedek, Richard A.: 46, 48 (note 13), 50
Beyeler, Ernst: 9, 115, 150 (note 11)
 Galerie Beyeler, Basel: 113, 150 (note 11), 179
Bicentennial of the United States, 1976: 136, 139
Bill, Max: 181
Blake, William: 169
Bonfils, Félix: 79
 General view of the Mosque of Omar, Damascus, c. 1860: 79
Bonnard, Pierre: 72, 73, *75*, 88, 167 (note 4)
 Cover, *L'Album de la Revue Blanche*, 1895: 73
 Femme au parapluie from *L'Album de la Revue Blanche*, 1895: *75*
 Scène de Famille, 1902: 72, 73
Bourke-White, Margaret: 78, 88
 Locket, Georgia, 1936: 88
 RCA Plant, c. 1935: 78
 Rolling Optical Glass, n.d., 88
 The George Washington Bridge, New York, 1933: 88
Braque, Georges: 36, 39, *41*
 Hymen, 1957: 39, *41*
bribery: 109, 131, 164, 166
Brown, Robert Delford: 177
Browne, Aldis: 100, 115, 139

Cadot, Farideh: *171*
 Farideh Cadot Associés, Paris: 177
 Galerie Farideh Cadot, Paris: 165
Calder, Alexander: *60–61*, *62*, 181, 194
 The Orange Fish, 1946: *60–61*, 181
Callaghan, James, Prime Minister: 111
Carter, Jimmy, US President: 11, 65
Cassatt, Mary: 72, *74*, 139
 Peasant Mother and Child, 1895: 72, *74*
Castelli, Leo: 9, 11 (note 1)
Central Bank of Iran (Markazi Bank): 19
Chagall, Marc: 147, 194
Chillida, Eduardo: 181
Chrisney, Judson: 157, 176
Christie's: 9, 180,
Close, Chuck: 35, *144*, 146
 Keith, 1972: *144*, 146
Cohen, Steven A.: 180
Colacello, Bob: 7 (note 3), 147, 184
 (note 25)
Cole, Sylvan: 72
 Associated American Artists (AAA): 72
Colnaghi Gallery, London: 139, 150
 (note 22)
Cooper, Andrew Scott: 14, 17 (notes 4, 9,
 15, 17), 102 (note 5)
Cornwall-Jones, Paul: 100
 Petersburg Press: 100, 136, 150 (note
 15), 161
 Tamie Swett: 161, 167 (note 8)
Cottet, Charles: 72
Cragg, Tony: 181
Crown Point Press, San Francisco: 146
Curtis, Edward: 79, *84*
 Geronimo, 1905: 79, *84*
Cyrus the Great: 13

Daftari, Fereshteh (Feri): 25, 26, 28–30, 31
 (notes 4, 5, 8, 12), 33–37, 39, 44–47, 48
 (notes 5, 13, 15, 17, 18), 49, 50–52, 54, 89
 (notes 3, 4, 5, 9, 10), 90 (note 14), 94–96,

104, 109, 110, 127 (notes 14, 16), 177,
 178, 181, 182, 184 (note 17)
Daitz, Howard C.: 54, 79
Darius I or Darius the Great: 24
Darroudi, Iran: 106
Dater, Judy: 78, 90 (note 23), 177, 182, *193*
Davis, Stuart: 73, *77*
 Hotel de France, 1928: 73
 Sixth Avenue El, 1931: 73, *77*
 Study for Drawing, 1955: 73
De Andrea, John: 35
DeBone, Anthony and Mary: 165
de Kooning, Willem: 65, *168*, 179, 180
 Light in August, c. 1946: 65, *65*
 Woman III, 1952–53: *168*, 179, 180
de Segonzac, André: 65, 129, *152*
 La Soupière de Moustiers, 1938–39: 65,
 129, *152*
Degas, Edgar: *122*
 Coming from the Dressing Rooms,
 1880–83: *122*
Dejam, Jila: *cover*, *8*, 181, *183*, 271
Delacroix, Eugène: 63
Delaunay, Robert: 62, *64*
 Window on the City, 1925: 62, *64*
Denis, Maurice: 72
Derain, André: 62, 63
 L'Age d'or, 1904–5: 62, 63
Diba, Kamran: *8*, 34–37, 49, 50, 88, 106,
 155, 156, 160, 164, 167 (notes 5, 8), 169,
 182
Diba, Layla: 33, 36, 37, 39, 48 (note 1), 100,
 146–148, 157, 182, 185 (note 32)
Diba, Mahmood: 33, 37, 148
Dine, Jim: 79, 161, 177
Dubuffet, Jean: 188–189
 Inhabitant of the Oasis, 1947: *188–189*
Duchamp, Marcel: *124*, 125, 127 (note 38)
 Study for The Large Glass, c. 1915:
 124, 125
 The Bride Stripped Bare by her

Bachelors, Even (The Large Glass), 1915–23: 125

The Green Box (The Bride Stripped Bare by Her Bachelors, Even), 1934: 125

Eakins, Thomas: 145, 146
 Boy Jumping over Hurdles, 1885: 146
 Portrait of Walt Whitman in his New Jersey Home, 1892: 145, 146
Elliott, Jim: 47, 104
Éluard, Paul: 140
Ensor, James: 62, 143, 148
 Entrance of Christ into Brussels, 1898: 62
 Mariage des masques, 1926: 143
 The Cathedral (first plate), 1886: 62
Ernst, Max: 130, 140, 141, 142, 146, 181
 Capricorn, 1948/63: 140, 141, 146
 Histoire naturelle, 1923: 140, 142
Ettinghausen, Richard: 53
Evans, Frederick: 78
 French Cornfields, c. 1900: 78
Evans, Walker: 88
 Kitchen, Truro, Massachusetts, 1931: 88
 Negro Barber Shop Interior, Atlanta, Georgia, 1936: 88

Farabi University, Tehran: 177, 211
Farah Diba Pahlavi Shahbanou: 6, 7, 7 (notes 1, 3), 8, 14, 17, 29, 30, 37, 39, 103, 106, 111, 112, 146, 147, 150 (note 4), 172, 178, 180, 181, 183, 191–213, 193, 202
Farmanfarmaian, Abolbashar Mirza: 147, 156
Farmanfarmaian, Monir Shahroudy: 54, 147, 156, 166, 177
Federal Bureau of Investigation (FBI): 52, 105
Feininger, Lyonel: 73, 111
 Villa on the Shore 4: 73
 Zirchow II: 111
Feldman, Robert: 146
 Parasol Press, Ltd: 146
Finkbeiner, David: 177
Fischer, Wolfgang: 111, 127 (notes 17–21)
 Fischer Fine Art Limited, London: 50, 111, 127 (note 17)
Flack, Audrey: 35
Flandrin, Georges: 178
Fox Talbot, William Henry: 80
 Single Fern, 1836–37: 80
Francis, Sam: 72
 Five Stone Untitled, 1968: 72

Frankenthaler, Helen: 67, 72
 Connected by Joy, 1973: 72
 Persian Garden, 1965–66: 67, 72
Freed, Hermine: 177
Friedman, Martin: 164

Gagosian, Larry: 180
Galerie Bernheim-Jeune, Paris: 131,
Galerie de France, Paris: 39
Galerie Denise René, Paris and New York: 39, 166, 177
Galerie Durand-Ruel, Paris: 139
Galerie Isy Brachot, Brussels: 146
Galerie Malingue, Paris: 48 (note 13)
Galerie and Fondation Maeght, Paris: 34, 36, 36, 39, 44, 207
Galloway, David: 8, 136, 150 (note 16), 170, 173, 177, 183 (note 2)
Gauguin, Paul: 115, 130, 132, 150
 Still Life with Japanese Print, 1889: 130, 132
Geffen, David: 180
Genthe, Arnold: 78
 The San Francisco Earthquake, April 16, 1906: 78
Getty [J. Paul] Museum, Los Angeles: 62
Giacometti, Alberto: 36, 39, 42, 43, 114, 117, 165, 166, 181
 Grand buste, 1956: 39, 43
 La Cage, 1950–51: 39, 43
 Standing Woman I, 1960: 114, 165, 166
 Walking Man I, 1956–60: 114, 117
 Yanaihara, 1960: 39, 42
Golestan Palace, Tehran: 19, 142
Goedhuis, Michael: 139, 140, 150 (note 22)
Greenberg, Clement: 164
Grigorian, Marco: 54, 166
Grosman, Tatyana: 53, 72, 90 (note 15), 177
 Universal Limited Art Editions (ULAE), Bayshore, Long Island: 53, 54, 67–70, 72, 177
Grosz, George: 187
 Unexpected Guest (The Man Who Ate Himself to Death), 1925: 187

Hafez: 24, 146, 209
Hajizadeh, Ghasem: 54, 101, 130, 165
Hamilton, Richard: 161, 162, 177
 Interior, 1964–65: 162
Haraguchi, Noriyuki: 181
 Matter and Mind, 1977: 181
Hartung, Hans: 36, 39, 45
 T 1973 E13, 1975: 39, 45
Hayedeh (Ma'sumeh Dadehbâlâ): 102

Helms, Richard: 139, 156
Henninger, John: 177
 Bust of a Woman: 177
Herbert F. Johnson Museum, Ithaca,
 New York: 65
Hightower, John: 129
HIH Crown Prince Reza: 29
HIH Prince Ali-Reza: 29
HIH Princess Faranaz: 29
HIH Princess Leila: 29
Hill, David Octavius and Robert Adamson:
 78, 79, *81*
 Edward W. Lane as a Persian, 1845:
 79, *81*
 Miss Justine Munro, c. 1943–47: 78
Hine, Lewis W.: 78, 79
 Barker Cotton Mills, Mobile, Alabama,
 October 1914: 79
 Heart of the Turbine and *Worker in*
 Shrine, 1930: 78
 Young Girl with Baby, n.d.: 79
Hitchcock, Henry Russell: 169
Hockney, David: 161, *163*, 177
 A Hollywood Collection, 1965: *163*
Hopper, Edward: 73
 East Side Interior, 1923: 73
Hopps, Walter: 49, 89 (note 1)
Houghton, Arthur A. Jr.: 180
Hoveyda, Amir-Abbas: 15, 139, 201
Hoving, Thomas: 53
Hughes, Fred: 147
Hugnet, Georges: 125
Hultén, Pontus: 164
Huntington T. Bloch Fine Art & Musical
 Instrument Insurance, New York: 65
Hussein, Saddam: 14, 16

Imperial Bazaar, Isfahan: 24
Ingres, Jean Auguste Dominique: 63
International Art Fair (Exposition
 Internationale des Arts de Téhéran): 36,
 36, 39, 207
International Council of Museums (ICOM):
 37, *38*, 172
Iolas, Alexander: 146
Iran America Society (IAS), Tehran: 136,
 165, 166, 169, 177
 Nature 12 Americans, 1978: 177
Iranian Academy of Arts: 171
 Saba Art and Culture Institute
 (SCAI): 171
Iranpour, Manouchehr: 149
Islamic Marxism: 15

J. H. Guttmann Picture Frame Corp.,
 New York: 54
Jackson, William Henry: 78
 Mount of the Holy Cross, Colorado,
 1873: 78
Jacques Kaplan/Mario Ravagnan Gallery,
 New York: 54
Jaleh Square, Tehran: 16
 "Black Friday": 16
Janet Lehr Inc., New York: 146
Jenney, Neil: 55
Johns, Jasper: *68*, 72, 136, 177
 0–9, 1960–63: 72
 1st Etchings, 1967: 72
 Corpse and Mirror, Petersburg Press:
 136
 Decoy, 1971: *68*, 72
 Painting with Two Ball II, 1962: 72
 Passage I, 1966: 72
 Pinion, 1963–66: *68*, 72
jubes: 19, *24*
Juda, Annely: 172

Kahnweiler, Daniel-Henry: 62, 131
Kandinsky, Wassily: 36, 39, *40*, 46, 48 (note
 13), 50
 Der Blaue Reiter Almanach, 1912: 53
 Frühe Stande, 1906: 46, 50
 Tensions claires, 1937: 39, *40*
Kasebier, Gertrude: 79
 Joe Black Fox with Face Paint, c. 1898:
 79
Khatami, Seyyed Mohammad: 179
King, Antoinette: 170
 "Care and Preservation of Prints,"
 Modern Art in Prints: 170
King's (Blue) Mosque, Isfahan: 24
Kirchner, Ernst Ludwig: 119
 Erna, Reclining Nude Seen from the
 Back (Portrait of the Artist's Wife), 1911:
 119
 Frau im Zimmer: 119
 Fünf Kokotten, 1914: 119
Klapheck, Konrad: 35
Klee, Paul: 111, 124, 131, 167 (note 4)
 Astrale Automaten, 1918: 111
Knight, Christopher: 107
Knoedler Gallery, New York: 39, 50
Koshalek, Richard: 156
Krims, Les: 78
Kunsthaus, Zurich: 115
Kunstsammlung Nordrhein-Westfalen,
 Düsseldorf: 140

Surrealismus 1919–1944: 140

Kupka, František: *186*

 Mechanistic Series, 1923–26: 186

L'Album de la Revue Blanche, 1895:
 75, 72

Lacy, Peter: 136

la Fresnaye, Roger de: 172, *174*

 Study of Heads, 1923: 174

LaNoue, Terence: 177

Laurencin, Marie: 172, *174*

 Self-portrait, 1906: 174

Lavier, Bertrand: 181

Lichtenstein, Roy: *149*, 177

 Hot Dog, 1964: 149

 Roto Broil, 1961: 149

Lieberman, William S.: 49, 89 (note 1), 111,
 127 (notes 155, 184 (note 23)

Light, Robert M.: 54, 62, 118, 119, 124, 127
 (notes 30–34)

Lindner, Richard: 111

 The Street, 1963: 111

Lucien Goldschmidt Gallery, New York:
 53, 54

Lucie-Smith, Edward: 175

Ludwig Collection, Aachen and Cologne,
 Germany: 136

Lunn, Harry H.: 79, 100

 Graphics International, Washington DC:
 55, 79, 100

Lynes, Russell: 109, 127 (note 12)

 *The Tastemakers: The Shaping of
 American Popular Taste*: 109

Maar, Dora: 62

Macke, August: 131

Macroulakis, Michalis: 130

Magritte, René: 130, 146, 150 (note 4), 181

 La Thérapeute (The Healer), 1967: 146

 Le Ciel, 1934: 130

Man Ray: 28, 79, *85, 87, 88*, 136, *137*

 Dust Breeding, 1920:

 *Egg Beater and Abstract Interior, 1947:
 79, 87*

 *Gertrude Stein and Alice Toklas in their
 Drawing Room, Paris, 1922: 85, 88*

 Last Object, 1932–42: 136, 137

Marin, John: 73, *76*, 84

 *Brooklyn Bridge No. 6, Swaying, 1913:
 73, 76*

Marini, Marino: 181

Matisse, Henri: 63, 73, 76, 115, 131

 Bonheur de vivre, 1905–6: 63

Harbor at Collioure, 1907: 115

Luxe, calme et volupté, 1904–5: 63

*Persian Woman (Return from Tahiti),
1929: 73, 76*

Messer, Thomas: 172, 173

Miller, Lee: 136

Ministry of Culture and Arts, Iran: 10, 48
 (note 2), 181, 201, 202, 211

Miró, Joan: 35, 112, *113*, 167 (note 4), 194

Modotti, Tina: 78

Mohammad Reza Pahlavi Shah: 11, 13–17,
 24, 29, 30, 54, 100, 103, 147, 153, 170,
 172, 178, 180, 192, 197, 198, 201, 203,
 204, 207

 Coronation, October 26, 1967: 14

Mohasses, Ardeshir: 101, 130

Mohasses, Bahman: 180

Moholy-Nagy, László: 79, *86*

 Lyon Stadium, 1930: 86, 88

Mondrian, Piet: 46, 48 (note 13), 167 (note 4)

Monet, Claude: 130, 139, 140

 Le Bassin de Londres, 1871: 139

Monreal, Luis: 172

Moore, Henry: 111–113, *113, 116*, 171, 181

 Reclining Figure Curved: Smooth, 1976:
 113

 Three-Piece Reclining Figure: Draped,
 1975: *116*, 112

 Two-Piece Reclining Figure: Arched Leg,
 1969–70: *116*, 112

 Two-Piece Reclining Figure: Holes,
 1975: 113

 Working Model for Oval with Points,
 1968–69: 113

Morandi, Giorgio: 53

Morsches, Richard: 53

Motherwell, Robert: 72, 184 (note 23)

 A la Pintura, 1972: 72

 Gauloises Bleues: 72

Mucha, Alphonse: 79, *83*, 88

 *Study for a Painting of the Artist's Wife
 and Child, 1901: 79, 83*

Munch, Edvard: 118, *123*

 Self-portrait, 1895: 118, 123

Murphy, Kim: 180

Musée Picasso, Paris: 63

Museum of Ancient Iran (Iran Bastan),
 Tehran: 19, 199

Museum of Anthropology, Tehran: 19

Nahavandi, Houshang: 153–157,
 160, 164

Naqsh-e Jahan Square, Isfahan: 24

National Gallery of Art, Washington, DC: 179

National Iranian Oil Company (NIOC): 109, 201, 205, 211

Negarestan Museum, Tehran: 33, 48 (note 1), 146, 147, 157, 199, 202, 203

New Brutalism: 34

New York School: 9, 131, 179,

Niavaran Palace, Tehran: 146, 155, 178, 182, 200

Noguchi, Isamu: 49, 52

Oldenburg, Claes: 136, 161, 177
 Ice Cream Desserts, Petersburg Press: 136

Oldenburg, Richard: 102

OPEC, Organization of Petroleum Exporting Countries: 14

Oppenheim, Dennis: *171, 172, 172, 173*
 Death Hole 2: Proposal for Tehran, 1977: *173*

Panahi, Nahid: 150, 153, 165, 166

Parke-Bernet, New York: 28, 130, 131, 150 (notes 5, 10, 13, 17), 151 (notes 30, 35)

Pars American Hospital, Tehran: 101

parti bazi: 164

Paul Rosenberg & Co., Paris: 62

Pechstein, Max: 131

Perls, Klaus G.: 150 (note 1)
 Klaus Perls Gallery: 50, 54, 62

Persepolis: 14, 15, *18, 20–23*, 24, *27*, 53, 208, 209
 Celebrations, 1971: 14

Picasso, Pablo: *34*, 35, 55, *56, 57, 58*, 62, 63, 111, 115, 118, *120*, 124, 125, 149, 169
 Arlequin – Le Fou, 1910/39: 111
 Baboon and Young, 1951: 55, 62, 63
 Bust of a Woman After Cranach, 1958: 111
 Composition (Composition with Heads), 1933: *57*
 Guernica, 1937: 118
 Minotauromachy, 1935: 118
 Open Window on the Rue de Penthièvre in Paris, 1920: 55, *56*, 62
 Portrait de femme II, 1955: *34*
 Secrets (Confidences) or Inspiration, 1934–35: 62
 Suite Vollard, 1930/37: 124
 The Painter and His Model, 1927: 115, *120*
 Weeping Woman, 1937: 55, *58*, 149

Pissarro, Camille: 53, 115, 118, *119*, 125

Les Maisons de Knokke, Belgique, 1894: 115, *119*
 The Plough, 1901: 115

Political Islam: 17, 179

Pollock, Jackson: *8, 9*, 10, *10*, 55, *55*
 Mural on Indian Red Ground, 1950: *8, 9, 10*, 10, 55, *55*

Prendergast, Maurice: 73
 Telegraph Hill, 1895–1905: 73

Private Secretariat of Her Imperial Majesty, the Shahbanou of Iran (Daftar-e Makhsus Olay Hazrot): 6, 7, 9, 25, 27, 33, 37, 39, 46, 47, 49, 50, 54, 63, 72, 95, 100, 103, 105, 106, 109, 115, *129*, 130, 149, 154, 156, 158, 161, 170

qanat: 98, 100

Queen's Mosque (Lotfollah), Isfahan: 24, 25

Ramos, Mel: 177

Ranson, Paul: 73

Rasmussen, Waldo: 172

Rastakhiz (Resurgence) Party: 15

Rauschenberg, Robert: *69*, 72, 177
 Booster, 1967: 69
 Kitty Hawk, 1974: 72
 Landmark, 1968: 72
 License, 1962: 72
 Water Stop, 1968: 69, 72

Redgrave, William: 136

Redon, Odilon: 73

Renoir, Jean: 178

Renoir, Pierre-Auguste: 125, 178, *178*
 Gabrielle with an Open Blouse, 1907: 178, *178*

Rex Cinema, Abadan: 16

Rezvani, Shahrokh Hobbeheydar: 130

Richter, Gerhard: 35

Rippl-Rónai, József: 73

Rivera, Diego: 172

Rivers, Larry: 72, 177
 Bike Girl, 1958: 72
 Stravinsky III, 1967: 72

Robbin, Tony: 165, 177, 184 (note 8)

Robbins, Daniel J.: 47

Robert Schoelkopf Gallery, New York: 54, 79

Robertson, James and Felice A. Beato: 79, *82*
 Constantinople, Door to Seraglio, 1850–54: 79, *82*

Robinson, Henry Peach: 79, *82*

Landing the Catch, 1890: 79, *82*
Rockefeller, Nelson Aldrich: 55, 172, 173
Rodin, Auguste: 62, 78, 88
 Henry Becque, 1885: 62
Rosenberg, Harold: 164
Rosenquist, James: *70, 71, 72*, 161, 177
 Campaign, 1965: *72*
Expo 67 Mural–Firepole 33' x 17',
 1965–66: *71*
 Off the Continental Divide, 1973–74:
 70, 72
Rosensaft, Josef: 130
Rothko, Mark: 65, *66, 72*, 131, *134*, 136,
 150 (note 11), 194
 No. 2 (Yellow Center), 1954: 65, *66*, 131
 *Sienna, Orange and Black on Dark
 Brown*, 1962: 131, *134*
Rouault, Georges: 115, *121*, 130, 131, *132*,
 150 (note 15)
 Clown, 1923: 115, *121*
 Trio (Cirque), 1938: 130, 131, *132*
Roudaki Foundation, Tehran: 181
Rouhani, Hassan: 181
Rousseau, Théodore: 53
Roussel, Théodore: 73
Rubin, William: 9, 49, 55, 89 (note 1), 102,
 164
Rumi: 146

Saadabad Palace, Tehran: 154, 157,
Saadi, Shirazi: 24, 146
Sadeghi, Habibollah: 180
Saman Gallery (Negarkhaneh Saman),
 Tehran: 130, 166
Saman Residential Towers, Tehran: 35, *92*,
 93, 93
Sander, August: 78
 Jockey, 1932: 78
SAVAK (Sāzemān-e Ettelā'āt va
 Amniyate Keshvar, the National
 Organization for Security and
 Intelligence): 105, 126
Schlamminger, Karl: 181
Scottish National Gallery of Modern Art,
 Edinburgh: 136
Seattle World's Fair, 1962: 136
Sébah, Pascal: 79
 Palmier Forêt, n.d.: 79
Seibu Department Store Museum,
 Tokyo: 65
Sernet, Pascal: 140
Sert, Josep Lluís: 34
Serusier, Paul: 73

Seyhoun Gallery, Tehran: 101
Shah Abbas: 24, 25, 176,
Shah Cheragh, Shiraz: 24
Shahnameh of Shah Tahmasp by
 Ferdowsi: 179, 180
Shiraz Arts Festival, 1967–77: 30, 46, 147,
 173, 208–211
Shirvanloo, Firouz: 49, 106, 147, 153–155,
 161, 164
Silver, Stuart: 53
Simon, Norton: 62, 90 (notes 17
 and 21)
Siqueiros, David Alfaro: 73
 Peace, 1945: 73
Smith, Colin: 16,
Solomon R. Guggenheim Museum,
 New York: 34, 65
Sonneman, Eve: 177
Soto, Jesús Rafael: 36, 39, *44*
 Canada, 1969: 39, *44*
Soutine, Chaïm: 50
 Woman in Red, c. 1922: 50
Steichen, Edward: 78, 88
 Auguste Rodin from *Camera Work*,
 vol. 34, 1911: 78, 88
 Pastoral, Moonlight from *Camera Work*,
 vol. 19, 1907: 78
Steinberg, Saul: 72
 The Museum, 1972: 72
Stieglitz, Alfred: 73, 78, *84*
 Gallery 291: 73
 *Portrait of John Marin Hand Tinting
 his Issue of "291,"* 1915: *84*
 The Steerage, 1907: 78
Stuart, Michelle: 165, 177
Szeemann, Harald: 156

ta'arof: 105
Tanavoli, Parviz: 171, 176
Taylor, Lisa: 172
Tehran Journal: 48 (note 2)
Tehran Museum of Contemporary Art
 (TMoCA): 6, 7, *8*, 9–11, 26, *35*, 38, 89,
 93, 104, 113, 129, 131, 136, *158*, 140,
 146, 148, 155, 161, 164, *168*, 169–173,
 176–181, 192
 Berlin–Rome Travelers, 2017: 10,
 184 (note 27)
 *Creative Photography: An Historical
 Survey*, 1977: 88, 170, *176*
 Comprehensible Mentality, 2015: 10
 *Expressions of Contemporary Art
 in the World*, 2014: 10

Farideh Lashai: Towards the Ineffable, 2015: 10

Graphic Art. The Movement Toward Modernism, 1977: 170, *176*

Inner Eye In Iranian Photography, 2008: 89

Pop Art Prints: 169, *176*, *177*

World Photography, 2010: 89

Thaw, Eugene V.: 55, *62*, 90 (note 18)
 E. V. Thaw & Co., New York: 54

The Metropolitan Museum of Art, New York: 28, 47, 51, 53, 89 (note 1), 106, 109, 131, 180, 200

The Museum of Contemporary Art, Los Angeles: *141*, 146

The Museum of Modern Art, New York: 19, 25, 26, 51, 52, 63, 72, 79, 89 (note 1), 102, 103, 107, 111, 115, 129, 155, 164, 167 (note 4), 170, 172, 181
 International Council: 115
 Sidney Janis Collection: 48 (note 13), 155, 167 (note 4)

The National Museum of Modern Art, Tokyo: 9

Tomb of Hafez: 24, 209

Tomb of Saadi: 24

Toulouse-Lautrec, Henri de: *62*, *63*, 73, *75*, 118, *118*, 125, 126
 Carnaval from *L'Album de la Revue Blanche*, 1895: *75*
 Fille á l'accroche-coeur, 1889: 125
 The Clowness Cha U-Ka-O at the Moulin Rouge, 1897: *62*, *63*, 126
 The Jockey, 1899: 118, *118*

Tuchman, Maurice: 100, 125, 127 (note 35)
 Exhibition proposal: 100, 125

Uecker, Günther: 181

UNESCO World Heritage Sites: 24

Vakil, Mehdi: 54, 89

Vallotton, Félix: 73

van Dongen, Kees: 130, 131, *133*, 150 (note 5)
 Trinidad Fernandez, 1910: 130, 131, *133*

van Gogh, Vincent: 55, *59*, 125, 131
 Worn Out: At Eternity's Gate, 1882: 55, *59*

Vasarely, Victor: 35

Villon, Jacques: *175*
 The Cards (*The Game of Solitaire*), 1903: *175*

Warhol, Andy: 147, 177, 180
 Portrait of the Shahbanou, 1976: 180

Wesselmann, Tom: 177

Weston, Edward: 78
 California Coastal Landscape, 1937: 78
 Sunshine and Flowers, 1914: 78
 Tina Modotti, 1924: 78

Westoxification: 166, 179

Whistler, James McNeil: 72
 Black Lion Wharf and *The Lime Burner* from *Sixteen Etchings of Scenes on the Thames and Other Subjects*, 1859: 72

White Revolution, 1963: 14, 16, 29, 198, 203

Whitney Museum of American Art, New York: 51, 65, 180

Wilson, Robert: 46, 48 (note 14), 52, 89 (note 8), 209

Witkin, Lee: *73*, 78
 The Witkin Gallery, New York: 73, 78, 79, 109

Wood, Grant: 73
 Honorary Degree, 1939: 73

Wood, Marilyn: 173, 177

World Bank: 14

Wright, Frank Lloyd: 34

yakhchāl: 98

Yanaihara, Isaku: 39, *42*

Yektai, Manoucher: 55, 166, 171
 Still Life, 1975: 166

Zand Gallery, Tehran: 130

Zand, Roxanne: 170

Zenderoudi, Charles Hossein: 171

Zervos, Christian: 115

ACKNOWLEDGMENTS

The account provided here about the near mythical reputation of Tehran Museum of Contemporary Art's Western collection has never been more accurate and relevant, challenging beliefs and falsehoods about the past by supplying documents and sources unavailable elsewhere. With the benefit of hindsight, I have tried to understand the pressures I endured, and how the texture of imminent revolution perceived through rumors, reading between the lines of official news and small pieces of information, affected my life and shaped my place in history.

I mined the California libraries at the Getty Research Institute in Los Angeles, the Huntington Library, Museum and Gardens in Pasadena, and the Brand Library in Glendale to corroborate my memories, supply dates and confirm information about the art and artists central to this narrative.

To clarify information and add details I had forgotten, I interviewed several friends whom I traveled with at the time and were familiar with my life in Iran. I especially want to thank Dr. Fereshteh Daftari, Dr. June Taboroff, Luba and Robert Staller, Doreen Gee, Catherine Thiou, Farideh Cadot, Manijeh Mirdamad, and Monir Shahroudy Farmanfarmaian.

Family, friends, and colleagues were first readers, including Henry Korn, Sophie Korn Gallagher, Jay R. Stein, Esq., Susan Berk, Judy Dater, Jack von Euw, Dr. Ellen Landau, Dr. Afshin Matin-Asgari, Maryam Afshar, Sandra Dijkstra, Ken Fritz, Gilah Yelin Hirsch, and Ruth Weisberg.

Special thanks go to Farah Diba Pahlavi and her private secretary Kambiz Atabai, who encouraged my project and Mina Schricker Atabai, Hamid Ladjevardi, Dr. Zahra Faridany-Akhavan, Lenore Greenberg, Gloria Williams Sander, Leonard Todd, Yousef Sosseini, Iradj Bagherzade, Bob Ellis, Mondana Najafabadi, Bob Goldfarb, President, Jewish Creativity International, Debra Sokolow, on behalf of the Jewish Artists Initiative, Tamie Swett Cornwall-Jones from Peterburg Press, Debra Burchett-Lere, Jack Barth, Tony Robbin, Amy Plumb Oppenheim on behalf of the Dennis Oppenheim Estate, Sophie Orpen, archive research coordinator of the Henry Moore Foundation, Stephan Kaol, curator of Freieraum in der Box, Berlin, Jila Dejam, Ehsan Aghaei, director of the Tehran Museum of Contemporary

Art, Nahid Evazzadeh, my contact at the Tehran Museum of Contemporary Art, Sally McKay, head of research services at the Getty Research Institute, and Emily Park, library assistant at the Getty Research Institute.

From the outset, Edoardo Ghizzoni at Skira enthusiastically supported and encouraged me as I developed and wrote this book. The production team at Skira—Emma Cavazzini, Emanuela Di Lallo, Marina Boer, Marcello Francone, and Paola Lamanna—deserve special thanks for supervising the final draft of the manuscript and the subsequent design and realization of the book.

It is an honor and a pleasure to warmly acknowledge the generosity of those who have helped make the publication of *The Empress and I* possible: the Y & S Nazarian Family Foundation, Tobey Moss, and Deborah B. Beck. My friend and colleague Shulamit Nazarian and her endlessly philanthropic family are championing art, artists, and academic research in many fields all over the world. Tobey Moss, a pioneering Los Angeles gallerist and doyen of West Coast modernism, has been a treasured confidant and supporter for five decades. Deborah B. Beck is both a mentor and a friend who inspired me to successfully integrate the dynamics of a vibrant professional career with the challenges of motherhood and family life. Like William Butler Yeats, I think where glory begins and ends and say my glory was I had such friends.